Debbie Rowe & Tracey Larcombe

50

OVER

50

LEARNING
RESOURCES
CENTRE

dewi lewis media

in association with

When Dove was first approached about getting involved with this fabulous collection of portraits and interviews, we knew immediately how well it would complement Dove ProAge, our new range of products designed specifically for women aged over 50.

Dove ProAge is part of the wider Campaign for Real Beauty, which aims to inspire and educate women to feel better about their body whatever their skin tone, size, shape or age.

The inspiration for our ProAge advertising campaign came from research which highlighted the common misconceptions held about women in their 50s. It also illustrated the need for media to do a better job of portraying realistic, yet aspirational women of this age group, especially within the beauty industry.

Just like the individuals featured in this book, the women in our ProAge campaign are all over 50 years old. All of them appear naked, illustrating that this age group can be body confident with a positive attitude and should no longer be deemed 'invisible'. They have never done any modelling, so are very much 'real' women in their prime, living life to the full, proving that there's no age limit to looking great.

Our philosophy is about celebrating your age, and making the most of your unique look, rather than trying to defy the clock and turn back time, with false promises and short-term miracle cures. Dove ProAge and the Campaign for Real Beauty challenge these myths.

I hope you enjoy reading this book as much as I did and find it inspiring. Remember – beauty has no age limit.

Estelle Alty

Dove Brand Manager

Notes On A Journey

In the practical sense, Debbie and I started this journey to discover 50 amazing and inspirational women over 50 in the summer of 2005; in that our first real date with destiny, a tape recorder and camera, was with Baroness Valerie Amos at the House of Lords – heady stuff. But for Debbie it all began the summer before, not long after the death of her father from Parkinson's Disease. She was photographing a woman who claimed to see angels, and to say that Deb was sceptical would be somewhat of an understatement.

At the shoot, the woman asked why she kept seeing London Bridge in her mind. She then said, 'You are thinking of doing a book of portraits aren't you?' This stopped Debbie in her tracks. Only a few weeks earlier, her family had scattered her father John's ashes from London Bridge. And yes, Debbie had been thinking about doing a book of portraits. In a very matter of fact way the woman continued, 'Well, you must know then that your dad is going to help you and the book is going to be a huge success.'

From then on failure was not an option, or even a consideration. Despite having no budget, no publisher and no idea how it would all work, she picked up the phone to her adjoining neighbour. (I could actually hear her through the wall as she was speaking, which was something we did far too often I'm ashamed to say). 'Fancy doing a book with me?'. As a freelance writer at the time, how could I refuse an idea so exciting? After all, how hard could it be interviewing a few women and playing at being photographer's assistant? It wasn't until we found ourselves in the middle of Delhi airport at four in the morning surrounded by 300 'taxi' drivers, 11 bags of equipment and, what we suspected were a pack of rabid dogs, that I began to rethink this decision. By then it was too late.

The idea of doing a book about women over 50 came about from a couple of shoots Debbie had already done. One was of

Barbara Robson, an asthmatic marathon runner in her 70s, and the other of Susie Cornell, who has lived with MS for 31 years and helped thousands of people to do the same with a unique exercise programme. These women really got Deb wondering how many other women in their 50s were doing extraordinary things. We chatted it through across the dinner table, over the garden fence or through the wall, and as we did the more ideas came up, so we started building our wish list.

Virginia McKenna was one of the first to be photographed, a wonderful woman who led us towards our first major trip to India, to meet her friend Maneka Gandhi. Talk about six degrees of separation; as our list of women grew and we found out more about them, the more we realised how many were connected, some professionally, others in friendship, many by coincidence. Looking back, the one thing they all had in common was vitality, positivity and enthusiasm. Every time we left somewhere and got back on a plane or into the car to go home, it was difficult not to be affected by their energy. In so many ways the women found us, as opposed to the other way around; it was as if the book was moving us along, not the other way around.

Debbie's contacts from a previous trip to China meant we also had the chance to interview and photograph a couple of women there. So the chaps from 'Dial-a-Flight' were called into action, the key phrase being, 'we need to go to these places but we don't have very much money…'. They worked wonders and, as a result, in November 2005 it was Delhi via Shanghai here we come. Clearly not the most direct route, but it was affordable and, as with all of our travels, the more conventional routes often went out of the window. Thank goodness neither of us is very good at geography or we wouldn't have even contemplated most of our journeys. As a warm-up trip to see how we got on as travelling companions, I roped Debbie into her first sports photography assignment, doing a feature on Moldovan rugby with a charity

called SOS Kit Aid that supplies rugby kit to children in poorer countries. After some hairy flights and dubious aircraft food, a brush with a rather large roadside ditch and some enthusiastic bed bugs, we survived friendship intact and embarked on the really big adventure.

Since then we have giggled and whinged, laughed and cried our way around ten countries with rarely so much as a cross word – aside from when Debbie inadvertently wrapped herself in the only blanket we had in a very wintery Cape Town. I have just about forgiven her for that. We've had an incredible experience, and learned tons along the way; including how important, fantastic and everlasting real friendship can be.

We also picked up a few tips on travelling. For example, ensuring you take the right equipment for any eventuality. As well as the obligatory mosquito nets and Immodium, we also discovered that a reel of gaffer tape is absolutely essential. Given Debbie's phobia of cockroaches and our cut price hotel options in the centre of Shanghai, taping up the skirting boards was a good way of keeping out most of the little blighters. That was until the lights went off and all we could hear were loud scuttling noises behind the bedside cabinet. As Debbie hid under her blanket I had a quick check, to find what can only be described as the Arnold Schwarzenegger of all roaches staring back at me. Deb poked her head out and asked if there was anything there; I looked at the size of my shoe and realised that this fella would probably just throw it back at me. It was time to upgrade, regardless of the cost. TAXI!

In its professional capacity, gaffer tape is also invaluable in crisis situations. Having arrived in a very snowy Ohio to do Dr. Kathryn Sullivan, in an airplane that can only be described as a toilet roll on some luggage wheels, we got to the Science Museum only to discover that the lights we had hired from New York hadn't turned up. We gave it as long as possible, but were flying back to London that evening. There was no choice but to improvise. It is true testament to Deb's lighting talents that me standing on a stepladder, in front of arguably one of the most intelligent and respected women in space technology, holding three torches gaffer-taped together and an industrial strength road-works lamp

worked just as well. As Debbie quite rightly pointed out to Dr. Sullivan, it wasn't unlike what they had to do on Apollo 13 was it?

After our close encounter with roach-kind, and our first B&B in Delhi with no windows, a bucket for a loo and a resident sacred cow out front mooing all night long, from then, where possible, we chose our hostelries a little more carefully. But when it comes to who or what you encounter outside the safety of your hotel room, you are rather at the mercy of the gods, as we discovered during a five hour wait at Delhi airport before our onward flight to China. We had to wait in a kind of holding warehouse where the toilets were governed by a little old lady in a cupboard with whom you had to barter to get any toilet roll. You would hand her some money, she would reluctantly hand out one piece of loo roll and then slam the door and await the footfall of her next desperate victim.

The only food in the place was a little restaurant, where we ordered beer, sandwiches and chips and sweet and sour sauce (classy chicks). As we were supping our warm beer and Deb was chewing on an almost see-through, fat-soaked, uncooked chip, I glanced at some movement under her seat. A pair of beady black eyes stared back. I very calmly explained it would be a good idea to lift her feet up as there might be a rat nestling by them. 'Waiter,' we said, 'not only is this the worst food we've ever had, but there's a rat under our table.' 'Oh no ladies,' he said, 'that is not rat. In India rats are much bigger, that is a mouse and we call him Mickey.' In true British style, we laughed nervously, carried on eating, took a few snaps of Monsieur Mouse and, of course, still left the waiter a large tip.

It is also important to take appropriate clothing when visiting different places; it really makes you appreciate the intelligence of packing for every possible element… or not as the case may be. On arrival in New York at midnight in October it was windy but not too chilly. Chicago a few hours later, it was driving sleet and snow. The next day, we were off to the US Virgin Islands in boots and jumpers to be met by 80° heat. LA in the spring we were reliably informed, as with Shanghai in November, would be mild and sunny with the odd shower. In both countries it

rained non-stop whenever we set foot outside, causing heads to turn as we wandered around in our nice summer (see-through-when-wet) linens.

Footwear is also a key thing to get right; there are places to wear open toed sandals and there are places not to, like Maneka Gandhi's beautiful lush green gardens. I'm sure it was her wicked sense of humour that meant she only told us how they came to be so lush after we had sploshed our way through them. 'It must be the sewer water that makes them grow so wonderfully,' she said with a chuckle. Getting the right shoes for conducting interviews in boggy paddy fields in Cambodia, where it is unbearably hot, is also a bit of a challenge. But by wearing some hardy walking boots I thought I'd cracked it. After enquiring about a rather pungent smell in my general vicinity, I realised that the firm bit of bog I'd found to stand on was in fact a pile of water buffalo poo. Much like fox dung, once there, the smell never truly goes away, which is a shame when your next stop is a crowded aircraft cabin.

I think we would both agree that, aside from a few fashion and functional faux pas, in general, we have become quite wiley travellers – particularly when it comes to boarding planes. It begins with an innocent enquiry at the check-in desk of how busy the flight is and, if it's not full, delaying taking our assigned seats until the minute the airplane doors are shut. Upon which we have no qualms about racing other frequent flyers, including wizened old Chinese ladies, to take over empty rows of seats at the back in order to have a fighting chance of getting some sleep.

On the whole, it has been a life changing experience never to be forgotten. Some of the most amazing aspects have been the unexpected acts of kindness from total strangers, the willingness of people who have nothing to still give half of what they do have to someone else, and the joy of human contact and conversation with people you would never get the chance to meet in normal circumstances.

One of the most overwhelming memories I think for both of us, after which we decided to make a donation from the royalties of this book to ActionAid, was when we visited an AIDS village in Malawi. Out of 138 people nearly 100 had HIV, including at least four babies. They had nothing but mud huts to live in, the clothes on their backs and a basic water supply. They had little medicine and no access to HIV treatment, and, some might say, no hope. Yet they greeted us with songs and laughter, smiling faces and an enthusiasm that was infectious. We were totally in awe of these amazing people and were determined to try and help if we possibly could. So when we got back in the car I announced to Deb, 'By the way, I've given the head of the village all of our money.' 'Great', she said, 'Good scheme.'

It certainly has been a very good scheme.

We hope you enjoy the journey as much as we did.

Debbie & Tracey

dedicated to John Rowe

$$\frac{50}{50}$$

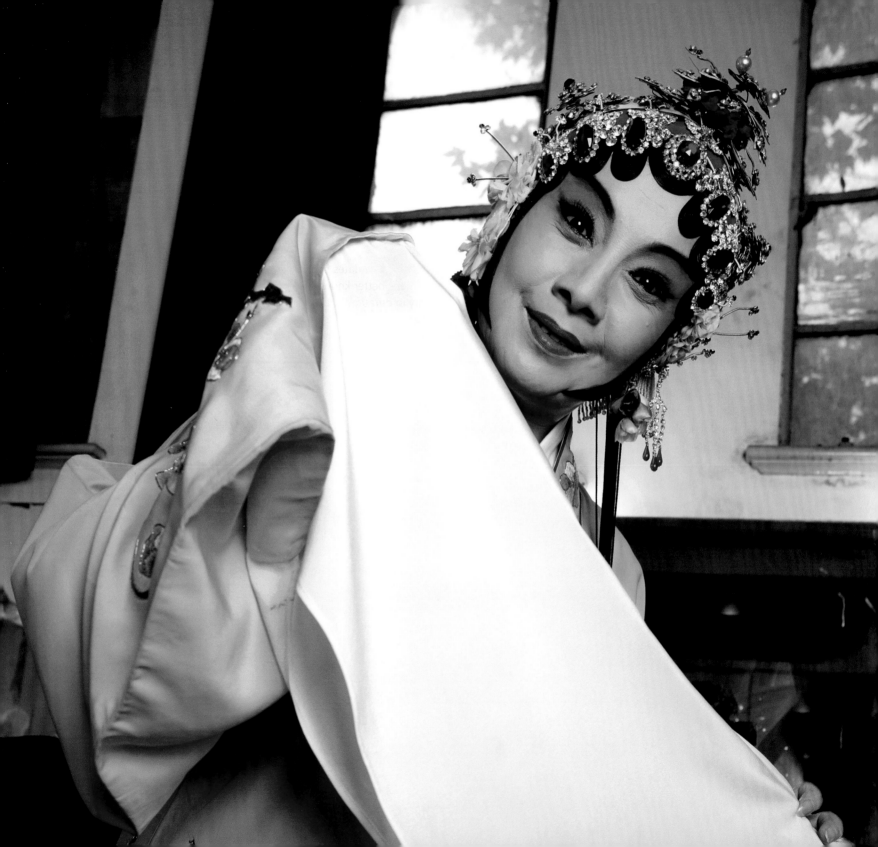

Zhang Jingxian

Who: Mrs Zhang Jingxian
When: 30th April 1997
What: Performer in the Kunju Opera, Shanghai

'The beauty of Kunju Opera is that it can change an old lady of nearly sixty into a young woman of sixteen.'

I began my life in the Opera aged 12, having grown up with a love for drama and music from when my parents took me to performances as a little girl. I passed the entrance exam for the Shanghai Academy in 1958 and spent the next eight years living, breathing and learning traditional opera, singing and acting.

When I remember those days it makes me very happy. I made no sacrifices; I learned and gained so much. I miss that period in my life, being at school getting a cultural education and working together as a team. Campus life was even better than outside, we had good activities and accommodation, and the school advocated good discipline, competition and team spirit. We all worked hard and valued our collective reputation.

My first performance was in *Peoni Pavilion* two years after I started at the academy. At first I was very nervous, but after a few minutes I felt nothing but calm; I knew this was where I belonged.

In the 1950s the cultural climate was good for drama and the arts but during the Cultural Revolution, from 1966-1976, it was considered that Kunju Opera was too genteel and soft and would weaken the spirit. So when I was 20, I spent ten years with a Peking Opera troupe in Shanghai performing what was seen as a stronger, more assertive art. But in 1978 I returned to Kunju when the Shanghai troupe was formed.

During the Cultural Revolution many people's personalities changed completely, including my own. Now I cherish life, I have stuck to my beliefs and this has made me very strong.

Kunju Opera dates back 600 years, 400 years older than the perhaps better known Peking (Beijing) Opera. Performances can vary in duration but can consist of 55 acts performed over two days and two nights, or over six consecutive days. Artists need stamina, concentration and lots of energy to last the distance, starting with over two hours in make up (skillfully applied for the last twenty five years by my best friend Li Yuen) to bring the elaborate characters to life.

I suppose I am most famous for my role as the traditional heroine, Du Li Ning, the character in *Peoni Pavilion* that I began my career with. The role means I initially portray a girl of 14 years old, and as the story unfolds, I play the character at 30, 50 and finally 78. I perform less now than in previous years, but I also lecture at the Academy and teach my peers at the Opera Troupe.

As I get closer to the age of retirement I am very satisfied with what I have accomplished in my career and life. Although I have had a bumpy career, I am very proud of what I have done. But perhaps if I had my life again I may have done some of it differently.

My advice to young girls is don't be greedy. Enjoy life, but first you've got to work hard to win the life you want. I believe there are three factors for a successful career: diligence, opportunity and a gift. To women turning 50 I would say look at your worries in a positive way. Don't be a trouble finder. Be optimistic and positive when you look at your own life. Obviously I am at a mature age but I still have lots of life left.

Carol Sing

Who: Carol Sing
When: 24th August 1992
What: At 57, set record as oldest female to swim the English Channel in the fastest time: 12 hours 32 minutes.

'It's something that nobody can ever take away from you – people can put you down and say whatever they want but you can always say, "Well I can swim the English Channel, can you?!" As you get older you kind of disappear. It was my way of not disappearing quite yet.'

Fifty is a hard age, it was for me; kids are growing up and leaving home and you feel like your life is diminishing. I could have had a face lift or a tummy tuck or whatever, but this was better than any kind of work I could have had done. My advice is find something you like to do and throw your heart into it.

I've always swum, I spent my life by the ocean. The water was always a lovely place for me to be. Once my three kids were in school I started teaching water aerobics and swimming classes, but the turning point was when I got divorced and my mum died very suddenly. That was very hard – it was probably the reason I got into the water. There's something about thrashing around in salt water that is very calming and healing, the movement of it and being so buoyant, it's incredibly therapeutic.

I first started in the pool doing Masters (pool competitions) and then graduated into the ocean and joined the San Diego La Hoya Coast Swim Club. I did the Maori Channel when I was 53 and people in my club had done the English Channel. So, when I came to England to support one of the guys, I thought I'd like to do it, though I did think it was so cold I'd never be able to! I was 57 when I swam it, but no-one really thought much about it, because in my club everyone is retired – in fact I think I'm the youngest. People didn't really question why I was doing it.

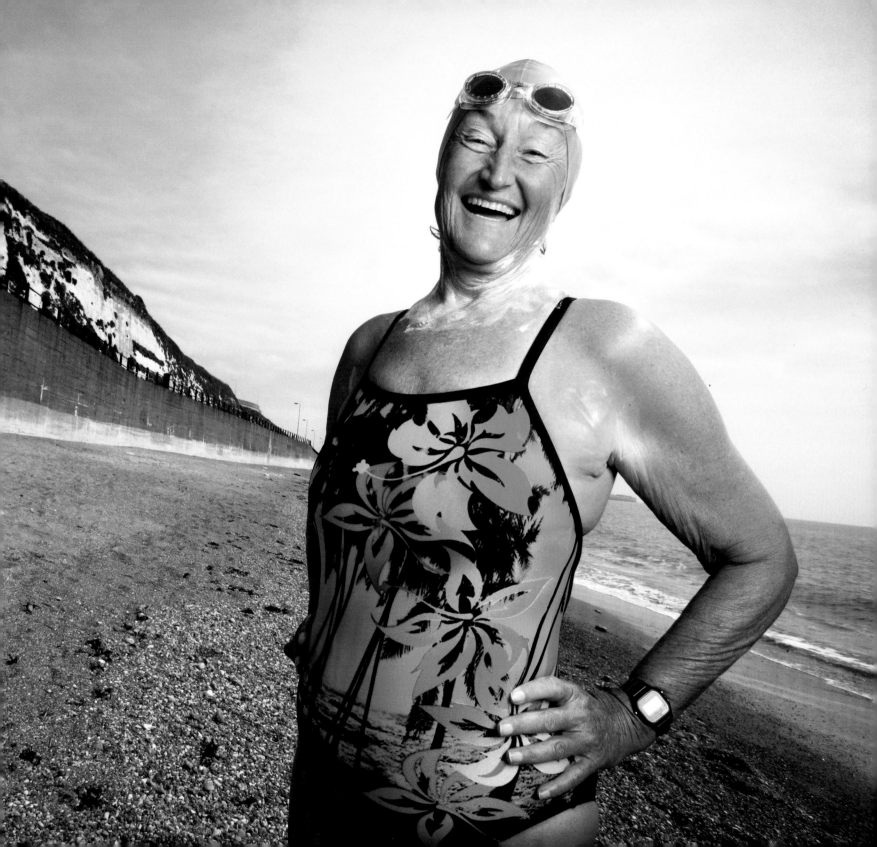

On the day, I was seasick for the first six hours as I had a following sea. It's good because it pushes you, but it's not so good physically. At no point did I ever consider giving up. There's that place at the end where, depending on the tides and whether you're in exactly the right spot at the right time, either you have a few more minutes or a few more hours to go. I had prepared myself for not being in that spot, but I hit it just right and swam right in.

When I finished it was a wonderful feeling. I can't really describe it, it's unexplainable. I trained a long time for it and I was totally focused. Although I was scared and had butterflies, it was a great feeling. It still is. It's something that nobody can ever take away from you – people can put you down and say whatever they want but you can always say, 'Well I can swim the English channel, can you?!' It gives you confidence I guess and sometimes older females need that little boost. Probably everybody needs that boost but I found as I got older you kind of disappear and it was my way of not disappearing quite yet.

When I got back to San Diego there were people waiting for me at the airport like I was some kind of star. I'd been on the front page of the newspapers for 3 days running while I was in England and got a lot of publicity because I set this record. I hadn't really planned on that but it made it a lot of fun. I gave a lot of talks and people wanted me to come and speak at their clubs. I definitely had my fair share of those fifteen minutes.

The sad thing is that my family are not too impressed with what I've done, I'm pretty much estranged from a brother and a sister – since after my mum died – you know how that happens in families. Actually my sister was impressed initially but not now. It's very sad but that's the way it goes. I blame my older brother. He said he thought that it was just a means for me to get attention. But it could have been worse – there are other things I could have done to get attention, I could have been an alcoholic or something! I'm sure there's a little bit of envy there, he's always tried to keep me in my place so maybe he was right, I did want a bit of attention. I've tried to make peace with both of them because you have to move on, but they weren't interested so I just have to accept that.

My dad and my kids are very proud, but what I find interesting is that I get more interest and feelings of pride from people other than my family.

I love my life and my new sport (paddle boarding). The people are so laid back, it's something about doing distance sports, it's not for an adrenaline rush or any kind of publicity, it's just about doing something for yourself.

Next up is the Straights of Gibraltar and I would really like to swim around Jersey but we'll see. I really like relay swims too, it's much more social; swimming can be quite solitary. It's been just great for me though, and I'll keep doing this kind of thing until I feel like I'm done.

The other thing about turning fifty is that you know yourself better, I am more accepting of myself now than at any time in my life, which is a lovely thing. There are no expectations of what I am trying to be which makes life so much simpler. Now I'm over the angst part of my life I feel so much more free, I don't sit around and brood about things in the past, I look forward, never back. We are all just little specks on this planet, ants in time. It used to really upset me that we are so insignificant, and then all of a sudden I stopped worrying about it, which was a very liberating feeling.

I live on my own, I get up in the morning and workout, I have a lot of friends that I do different things with, and I just love my life.

Reverend Julie Nicholson

Who: Julie Nicholson
When: 26th June 2003
What: Church of England priest, Director of Theatre Arts, Bristol Diocese

'I've always said that when I'm on my deathbed I'll be screaming "No, no I haven't learned to play the saxophone yet, I need more time!"'

Before my daughter Jenny was killed in the London bombings on 7th July 2005 I was what you would have called a vicar, but the official title is priest in charge. So I was priest in charge of the local parish church which was quite a large parish. My job was very traditional and a great privilege because you're working with or dealing with people in all aspects of their life. I can't tell you what a joy it is to be with people as they are preparing to be married – it's great working with all that hope and expectation, really wonderful. Even being with someone and helping them plan a good funeral for someone they love, or one of my favourite aspects has always been new life and baptism and celebrating all the possibilities that holds.

For those of us involved in July 7th it wasn't like facing the death of someone through an accident or an illness. Our lives suddenly were full of police and government departments, and the media: suddenly our lives were changed, transformed. In the first couple of months, certainly until after her funeral I didn't really think about anything, I was just so caught up in it.

Jenny had been on her way to work and was killed in the Edgware Road bomb carried by Mohammad Sidique Khan. Something I've asked myself over and over again is whether or not she would have seen him. She would have been standing just diagonally opposite. James, Jenny's partner, and I have discussed it. He's pretty confident that because she hated the tube and saw it as just a means of getting her from Paddington to work that she would have just had her head buried in her book. But I suppose she might have glanced up, you know if something had caught her eye. I've often wondered about that.

She was formally identified after five days. Some people had to wait longer. It was a living nightmare. I think I functioned on two levels. Deep down I knew by the evening of the 7th July. I was in Anglesey at the time, on holiday with my parents, and we were trying to gather information. The police were asking people to stay out of London but by the afternoon when we still hadn't heard from her and she hadn't turned up at work, I knew I had to go to London.

There aren't a huge amount of trains that go from Bangor, so I was getting a train in the early hours of Friday morning. I had a shower on Thursday evening and I was drying myself. It's very, very clear to me; I bent down to dry my toes and as I stood up I just knew that something big had gone from me. But I suppressed it; I didn't sort of go in and say, 'I know that Jenny's dead'. In my conscious state I wouldn't even give that thought any space. All I could think was 'I will not abandon my child, I will not abandon her to death; I will keep trying to find her.'

When I went to London and met up with her partner and other family members who came along we just kept hoping. As the time went by the goalposts shifted. I went from wanting her restored absolutely intact with just a bit of debris on her, I thought I'll accept you with dust and ashes because we can put you in a bath and give you a gin and tonic and restore you within an hour. Then it gradually shifts by the next day to, ok well you might have injuries, but we'll look after you, you'll heal, all will be well. Then it shifts again – I think on the morning of the third day, the police liaison officers came and told us that it was now officially a recovery operation. We just looked at them and my daughter said,

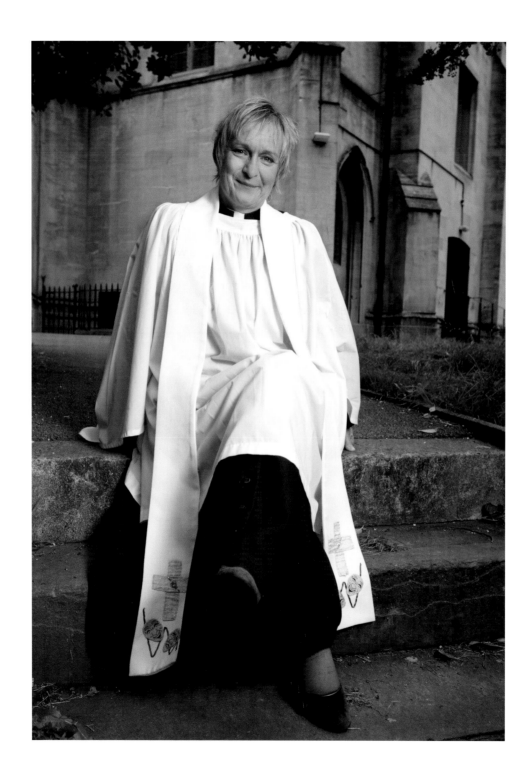

'What does that mean?'. I knew what it meant, that everyone who was alive was out, so what they were now doing was recovering the dead bodies. That was a very significant moment, because although there were still people who hadn't been identified, they were the people who were most critical and who had really serious injuries. So at that point we knew we were facing at the very least loss of limbs or brain damage. Then there's a little voice that says there are some people who are just turning up completely confused, so she could just be wandering around concussed, and of course you know you have to embrace all of this. But still somewhere deep down…

When you're a parish priest you have a public role so you have a public persona. So when it emerged that Jenny was one of the missing, the place was flooded with media. But I wasn't there; my sister lives in Hampshire so that was our safe harbour. By the end of the second day when we knew that Jenny's name was going to be released, we were all together as a family at my sister's house. Of course there was massive interest in me when it was known that a local priest's daughter had been killed. What a lot of media wanted was a headline from me saying something like 'Christian priest has no forgiveness for Islam'.

The Bishop and the press officer made all the statements as our spokespeople which was marvellous, but they had to start contacting us when papers started offering large sums of money for a story. I can't tell you how damaging that is when you're trying to hold everything together and people are trying to profit from you. Being offered money in that way was just utterly, utterly obscene. But I was guided all the time by the press officer and the Bishop who is very wise. Eventually he pointed out that if I carried on having no comment they would just start making things up; he said it was better to say something myself in a measured and controlled way.

The first thing I think I said myself, in my own words, was after I experienced immeasurable kindness from a taxi driver in London. After the two minutes silence in the days after it happened I was trying to get from St Paul's to Paddington in rush hour and I started to have a panic attack because I couldn't find a cab. I finally found one and he was just about to go off duty and didn't really

want the job, but he must have taken one look at me and seen I was in a state. He took me to Paddington and by then he knew why I was at St Paul's. When we pulled up outside Paddington it was heaving, he said 'Are you ready for this?' I said I'd be fine once I'd got my ticket and was on the train, and that I was going to meet my family in Reading. He said, 'Well why don't you get back in the car and I'll drive you there.' I thanked him and got back in the car. When he dropped me off he wouldn't take any fare, instead he asked if I had a picture of Jenny. He said, 'I'll think about her. You must have a very bleak view of the world at the moment but I'd just like you to know that there are still good people in the world.' It was after that that I thought actually Jenny needs to be honoured – the good people in the world need to be honoured.

I wrote a statement about this, telling this story, and then of course people wanted to interview me about it, but I didn't want any of that. We had hundreds of requests for interviews, *Richard and Judy*, all of those things, and I didn't want to do any of it. It wasn't that I was adamantly opposed to it; it was just that I didn't feel the time was right. I didn't feel I wanted to expose my emotions as a mother. I thought there was something slightly grotesque about that. I wasn't ready to talk or think positively.

People would write cards to me, and I know their intentions were good but they'd say things like, 'Jenny's in a better place,' and I thought, 'This place was pretty good for her.' Or 'God's holding Jenny in the palm of his hand,' well okay, shouldn't that have been happening in life? What happened at ten to nine? Did God get cramp? Don't talk to me about God in this way.

I've heard it said in the past that when you're going through great trauma you shouldn't be making big decisions. It's like being really cross about something and writing a letter, sending it and immediately regretting it, you should always give it a bit of space at the time. I think after a couple of months I started to think about when I would go back to work. I'd been advised and had agreed with the Bishop and the Archdeacon, my senior colleagues, to take proper time out and not even think about working until after Christmas which would be five or six months. The counsellor I'd seen recommended I should just completely take a

year out because it was a bereavement, but it was also a traumatic bereavement and it wasn't going to go away; there were going to be constant regurgitations of the day.

So I didn't think about work for a while. Then as time was going on I thought I couldn't face a year of not working, I'd go mad. I'm not the kind of person that could go and work in the garden every day, that's not me, I'm more sort of an extrovert, lively person who's always looking for new creative endeavours. I've always said that when I'm on my deathbed I'll be screaming, 'No, no I haven't learned to play the saxophone yet, I need more time!' I needed to do something and it needed to be creative. Creativity can be anything, giving birth, building a wall, but my way of being creative was to do with the theatre and community and working with a group of people to develop something in an artistic way. Theatre and the arts was also something very close to Jenny's heart. I'm still involved with the church though and to be honest it was something I'd been considering for a while. I've always been more comfortable on the edge of faith than I have in the centre of it, so working in an environment where I can help make connections and then leave people to make their own minds up is ideal for me.

The first time I spoke out and said anything about stepping down was on an ITV programme about religion and the issues of faith that emerged after July 7th. Suddenly I felt there was something I could do, that I felt comfortable with, because I'd been driving myself mad with different issues of faith over all of this. Then I did a little news programme for the BBC just after Christmas and was talking about the work I'm doing now and what I'd let go of. I don't know who got hold of it, or how, but I had a phone call at 7 o'clock one morning from the press officer saying that it was due to go out and that I might want to batten down the hatches because everyone had picked up on the fact that I was stepping down over issues of forgiveness.

Of course it wasn't the full picture that was reported, you know it was 'Vicar who can't forgive,' and so then I found myself on the front page of every newspaper without giving one interview. So people got their stories. Then I was making a programme for Holy Week for the BBC based on every parent's nightmare, which is to face the death of their child. It was using the Easter imagery of Mary at the foot of the cross so I felt again 'I can be a priest in this.' I've done a couple of things since, so I think what I've said is I can reconcile this professionally. I'm not interested in just being a mother exposing emotions.

If it had been the other way around and I had been killed, I'm not sure if Jenny would have felt the same way, I don't know. I might have said I can't forgive, but actually it's more choosing not to, because I don't think forgiveness in this situation is appropriate. When you look at the model from the Bible there aren't so many examples of Jesus saying 'I forgive you.' The words he used are 'Your sins will be forgiven.' It's not quite the same. On the cross he doesn't say 'I forgive you', he says 'Father forgive them.' My simple understanding of it is that actually some things are beyond our human capacity to deal with.

I think at the heart of forgiveness is when you can give somebody back their life for what they have done to you. So in these circumstances it is not possible. Mohammad Sidique Khan ended his life when he ended six others that day. He wouldn't want my forgiveness. It wouldn't mean anything to him. I think the most I could forgive would be the hurt that's been caused to my broken heart. I don't think I have the right to forgive on my daughter's behalf. Although I know my daughter absolutely wouldn't want a lack of forgiveness to eat away at me and make me bitter and revengeful, choosing not to forgive doesn't automatically assume that's going to be the case. I don't feel I need to forgive to get on with my life, I feel the need to reconcile myself to what has happened. That's not forgiveness.

I have no doubt I will always be angry. I'll be angry about it till the day I die and why shouldn't I be? I have a right to my anger. That's what I'd say to people who tell me I must let it go, that it will eat me up. Well actually I channel my anger; I use it in a healthy way. But I think we should all be angry. We should be full of rage that this is happening in the world – that lives are being lost indiscriminately. It's a great tragedy that young men feel they need to strap bombs to their backs and set them off among groups of people to make their point. There's got to be a better way.

My views on religion haven't really changed or maybe I've just become more confident in articulating them. I think if religious identity is put in front of common humanity and we get to a place where it's ok to have suicide bombings and atrocities in the name of religion then I think it would be better that there was no religion.

I don't think we can ever go back. If I use the analogy of an earthquake, buildings that are completely devastated in an earthquake can never be put back in exactly the same way that they were before. I think when you've had an experience of the magnitude many of us have had through traumatic bereavement, you can't go back to how things were before. We're not the same family, we'd been a family of five – we're no longer a family of five. In our hearts we are, in our hearts Jenny is still with us, and I never say I have two children, I always say I have three children but one of them has died. So I don't think you can ever truly go back. I think you have to always go forward.

I turned 50 just before Jenny was killed and though I try not to think about age too much sometimes it's other people that make us think about it. I went into town one day and hadn't bothered to dress up as much, or do my hair, or put my make-up on. My car was in for a service so I went on the bus, and somebody stood up to give me a seat. And I thought 'Oh no, oh no!' I was suddenly made aware, and I'm sure it's the same for other women over 50, that I don't feel any different now to how I felt when I was in my twenties or my thirties. My experience of life is different and my attitude's changed and I've got a few more lines – but I don't feel like I'm a different person because I'm 50.

I don't want anybody telling me that I have to slow down or think about retiring or, as in some continents, women take on a more grandmotherly role and start wearing black – everything changes. I thought if I have to wear black it will be with fishnet tights and high heels as well! The awareness of ageing can't be denied, but I think for women who are approaching 50 and over 50, it's like another rite of passage.

I think I am more confident about speaking out. I don't think that our characters or our personalities necessarily change through grief and trauma. I think they become more pronounced. So I don't think I'm a different person to the person that I was before but I think I'm not about to waste time, I think there's an urgency. That's what I feel, that I live with an urgency now; that we can't always be talking about what we'll do tomorrow because tomorrow can just be pulled away from you. We have to use today well. I know that the days I have to struggle out of bed and into the shower are the days that I need to wear some kick arse lipstick, because by making that effort I'm helping myself get through the day. Not every day's like that, but I still have black days.

My life philosophy I think can be summed up in the words of Maya Angelou. It's called *Keeping Going* and it says: 'The issue is not merely to survive but to thrive, yes really to thrive with some passion, some compassion and some style.'

Dr Kathryn Sullivan

Who: Kathryn Sullivan
When: 3rd October 2001
What: First American woman to walk in space

'You're riding bombs for a living – you have to keep that pretty clearly and bluntly in your mind, because that's what it is.'

I had a fairly general sense of ambition when I was young, but the one thing I can trace as far back as my earliest memory was that maps, geography and far off places were my burning curiosity. There was always some piece of me that's been an explorer – it came as part of the wiring I guess. That was a lot more interesting to me than dolls' houses and imaginary games.

I watched the early space programmes on TV along with everyone else and just absorbed, almost through my skin, all the different articles that came out about it, on the men, their families or whatever – it was just all fascinating to me. I really didn't think 'I want to do that', but what I can remember thinking or rather sensing as I watched Neil Armstrong land on the moon and the landing of Apollo 11 was that I realised I was watching a truly extraordinary moment of drama and adventure. I think the closest thing to it that happens more frequently in life is probably those twinges of inspiration and longing you get when you watch the Olympics. But it really reached me deeply and tapped the explorer in me and I recognised there were places and things you can get to in life that are out where no-one's been before, and that was what I wanted to do.

When NASA talked about needing scientists and engineers for the space programme there was a moment of opportunity. Despite the mathematical possibilities or probabilities of being chosen I had to try, it wouldn't have been possible to not put my hat in the ring.

After the interview process I went back to grad school and I knew three things: I knew I could do this job, I knew that among the other 19 people interviewed in my group there were some

fabulously talented people, and there were another 19 groups, and I also knew that I had no way of knowing how I rated among all the others. So I just had to wait. That was in October 1977. In January 1978 the phone rang in the house I shared with several other girls, at a curiously early hour of the morning. It was only when it was for me that I wondered if it might be NASA. The guy who made these calls in those days had an utterly laconic flat voice. You would have thought he was calling to confirm that they did indeed still need a secretary if I was available. Life as you've known it is about to become wildly different and turned on it's head probably almost immediately and he asks me 'are you still interested?' Oh, no actually, I thought, I've changed my mind – 'Of course I'm still interested!'

Lifting off in a space shuttle is like being embedded in an earthquake about 4 or 5 on the Richter scale; a lot of shaking, a lot of noise and rolling around, but that's only really in the first two and a half minutes. The main thing is you are really quite aware that the rocket engines have shoved your seat up off the launch pad, grabbed you and are pushing and accelerating your chair into your back continually for eight and a half minutes. So I remember being amazed and trying to record all of those sensations, sights and sounds of my first flight, while I was also trying to watch dials and gauges.

The next stage, after the solids have dropped off, is that the rocket is still pushing your seat into your back, but it's now like the world's smoothest electric train; it's continually accelerating and pushing you forward. But it's really smooth. I remember somewhere around the fourth or fifth minute a little thought came

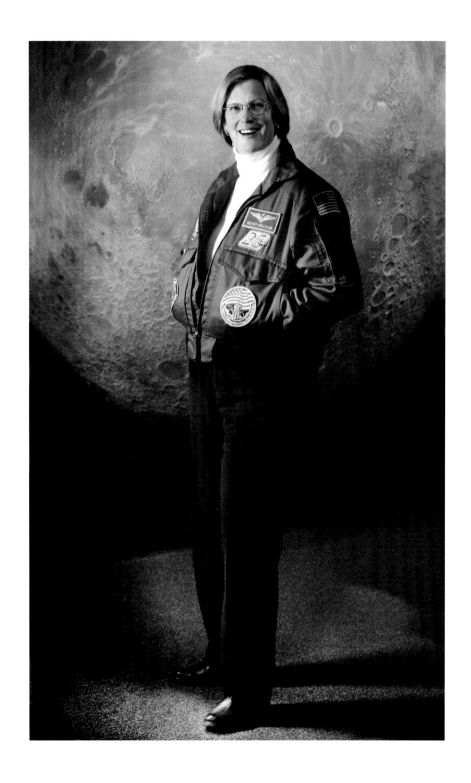

into my head that this had really been going on for a long time. You might have felt three times the force of gravity on a roller coaster for a fraction of a second but this goes on for eight and a half minutes. Then it goes really quiet. If you let your pencil go, you're now at zero gravity so anything you let go will just float. Some people asked if I was surprised that things float when the rocket engines cut off. My spontaneous reaction was that there was absolutely nothing normal about the preceding eight and a half minutes, so why would you expect to be in any known familiar place when it's over. You realise you are not where you were before – you are somewhere very, very different.

Walking in space is like swimming in the world's coolest gym with a fabulous view, because your feet are pretty useless. You can't walk on anything, you're moving hand over hand rather like a bad scuba diver crawling along a reef.

The real stuff you have to do as a crew member is get through and successfully survive lift-off, which is no small thing. But the bulk of what the astronaut crew is charged with doing during the 7 day flight plan lies between the launch and the 45 minutes of re-entry. So there's an hour on the front and an hour on the back end that are pretty dramatic and pretty dicey – and it could end up that none of the in-between really counts if that front and back hour don't go right. It's an interesting mixture of uncertainty, risk, anticipation and anxiety – you're riding bombs for a living and you have to keep that pretty clearly and bluntly in your mind, because that's what it is.

You have to be in the game whether things are going easy or getting rough; it's a team effort and there are only six of you. So if one of you feels the need to sit down and cry there are only five of you left and you can't do it with five. Happily, on my flights we never got really threatened or challenged by any dire technical problem or threat to our mission, but you have to know that your intent is that you will stay in the game and do your job.

The earth is a mesmerizing sight. It's like a gigantic beach ball going past. On one level I feel completely normal, I know where I am, it's a familiar environment and I feel totally composed. But the most different perspective of seeing the earth in that way is the big unifying picture you get when you see whole continents

and oceans, this great overview of all the different systems and atmospheres enacting together. You see trails of gigantic fields of wind when you watch dust storms off Africa; you can see tendrils of the dust thousands of miles out across the oceans so you get this very different awareness of how interlocked and interlaced all the systems of our planets are on so many scales. At the same time there's the myth that the only man made thing you can see from space is the Great Wall of China; that's not true.

I came back from space with a juxtaposition which was on the one hand a very encouraging, inspiring and somewhat idealistic awareness of the planet and solar system, but on the other hand you can't help but see signs of human effects. You see the thumb print type splotches that are cities, the grey against whatever the background colour is. You see plumes in the air and on snow you can see sediment flows. We in humankind can take the approach that chooses to say 'I will do what I want till someone can show me conclusively that it matters', or you could take the approach of 'I will be cautious until someone can show me that it won't matter.' Humans don't do either of those extremes.

The earth is in a post glacial period, the planet is warming and it has been for 40,000 years, it's heading towards a warm cycle and human beings are putting additional carbon dioxide into the atmosphere at large rates. It would probably be prudent to find ways to slow this down just because of all the things we don't yet know about the stability of the climate system that could really cause havoc for us. But if the earth obliterates us or we obliterate ourselves the earth is not at risk, it will go on. It's the way we have built our societies and our specific patterns on the planet that could be in serious danger.

Probably the achievements I'm most proud of since doing this job have been making new and previously unknown maps of the sea floor, and getting to name the different peaks and mountains that are on it. And also the programme myself and a small squad of engineers and astronauts designed to repair and maintain the Hubble telescope. I'm really proud to be a member of the Hubble team.

But I think the most satisfying thing is being able to inspire people to go after their dreams; I got a letter from the mother of a little

girl I met years ago after one of my first missions, to say that her daughter had just been accepted as an undergraduate at the Massachusetts Institute of Technology, Aeronautics and Aerospace programme and that she wants to be an astronaut. I can't imagine what I said to her, but how fabulous to think that I played any kind of a positive role in the life of a talented girl like that and that she and her parents traced me as a contributor. And how extraordinarily generous that that lady would sit down and take the time to write me a letter to let me know, because she felt it had come from what I'd said or done. That's the one you want to have set in bronze.

It's such an amazing coincidence of factors and forces that I have ended up in the little slot in the history of the American space programme – to be one of the first six women in space and, because of an assignment for a space walk, the first American woman to walk in space. It's delightful the kind of doors and opportunities that opens up to you. The ones that I particularly relish are the ones that allow you to inspire, encourage and motivate other people, whatever age, but especially young people.

When I was about to turn 50 I thought that after half a century, lots of friends, good health, great adventures, cool toys, neat travels, and a fabulous supportive family; that's like a real victory. So I decided that I couldn't possibly fit all this into one party and decided that my celebration was going to start the day after my 49th birthday and go all the way to my 50th. I also thought it would be a great year to focus on diet and exercise so I could make sure that on the day I crossed over to the second half decade all of the fitness and wellbeing curves were on a positive slope and heading in the right direction. So I strongly urge anyone heading towards 50 to think of it in those terms and don't let anyone tell you that a proper amount of celebrating can all be pressed into one cake, one party and one card; I think it's worth at least a year.

Never believe the number on the calendar. If you can feel and act a decent seventeen the number never actually matters. Probably most of us, if we look around our circle of friends, can see someone who has an immense number on the calendar and is the most delightful, eager, open, young-at-heart, vibrant soul you'll

ever meet, and you can find someone else whose number is very low and who seems to already have lost a lot of spark and elasticity, curiosity and vibrancy about things. Each of the different broad areas of life is quite fabulous; I think be enamoured with them and be dazzled by every moment; dare to dream, dare to strive, be yourself and keep learning.

In general, in life you can't be other than who you are at the moment you are; this is the moment you have and the only important choice you have is how you are dealing with this moment – what are you putting into it, what are you taking from it and how aware of it you are. Because, at the end of it all, it's just about a succession of those choices, most of them not consciously made, but choices none the less.

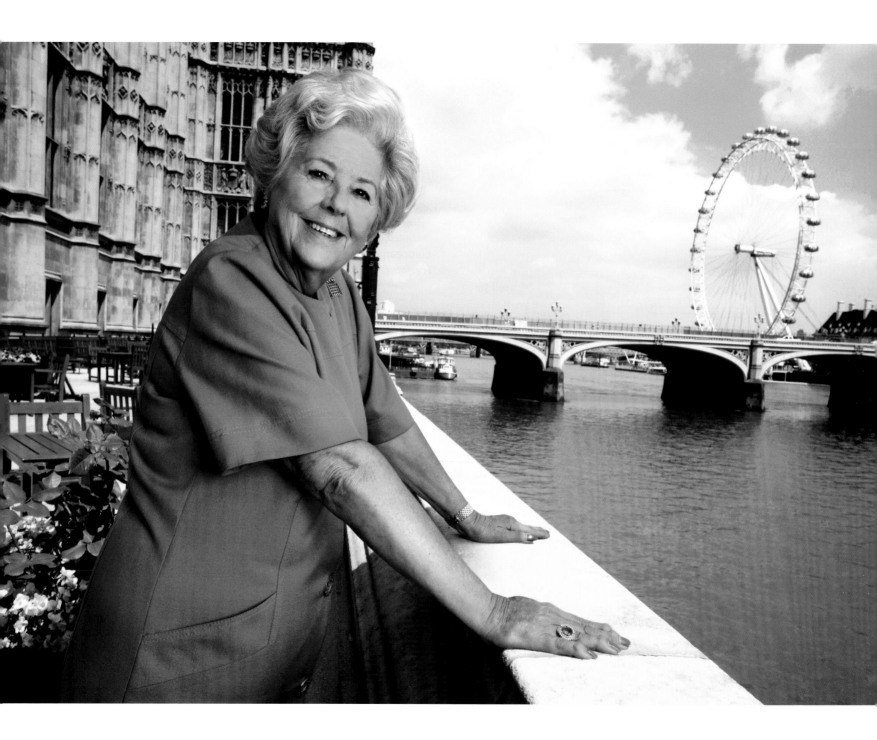

Betty Boothroyd

Who: Betty Boothroyd
When: 8th October 1979
What: First Lady Speaker of The House of Commons

'My success has been down to the inevitability of gradualness – I was a plodder.'

I was born in Dewsbury amid the dark satanic mills of Yorkshire, a big industrial area where my parents both worked in textile factories. When I was twelve, the height of my ambition was to be a window dresser in Bickers, the local store in town. Even from really young my father taught me to wear the best and most expensive clothes I could afford, or rather couldn't. He used to make me stuff newspaper in my shoes, before there were shoe trees of course, to keep their shape and keep them looking their best. Both my mother and father were huge influences on me, they were very strong characters for whom discipline was really important as well as education. I wasn't very good at school at all, I remember falling off my bike and breaking my ankle and thinking great, no more school for a while! But my father made sure that he went to my school every day to collect my homework so I didn't miss anything.

One of the reasons I wanted to get into politics was because I saw what happened in Yorkshire with my mum and dad and I wanted change. Mum kept her job because her labour was cheaper whereas my father ended up unemployed, yet they did the same jobs. Social conditions were poor and there were narrow means of educational support for young people.

I went a bit of a round about way of getting there, being a Tiller Girl, which was a wonderful experience and great fun, then working in Washington DC as a legislative assistant for Silvio Conte, a US congressman. When I came back I worked in London as a secretary and political assistant for various senior Labour politicians and then in 1965 I was elected to a seat on Hammersmith Borough Council.

I don't think life began at 40 for me, because I hadn't got into the House of Commons at that stage. It took me 16 years and 4 Parliamentary elections before I made it into the Commons. I worked as an assistant Government Whip, as a Member of the European Parliament, a member of the Select Committee on Foreign Affairs and I was on the Speaker's Panel of Chairman.

I never really had any ambitions, apart from the window dressing! But I was one of those characters who just plodded along. My success has been down to the inevitability of gradualness – I was a plodder. I never aimed to be a minister or Speaker; I'm one of those who just takes advantage of opportunities that come along.

So when the job came up to be Speaker it was a job that I really wanted to do. I had already been Deputy Speaker for five years so I didn't think anything of it. I mean, I didn't feel that I was in command, I just felt it was a duty that I had to do. I wanted to do it and there was no compromise from either floor of the Commons and I gave them no compromises either, I just enjoyed the job, and it was the best job in the world; I revelled in it.

Not only was I the first woman, which is important to me, but also I was the very first speaker to come from the opposition benches. It is usual that the member comes from the party in government because they have the most votes of course. It's an obvious one; it's rather tribal in that sense. But I broke down the tribal system and very many Conservatives voted for me as well as those in my own party, Labour, of course. But also the Liberal Democrats and all the minority parties in their entirety so that was quite an achievement.

I think they just felt that I was very fair and impartial and I would do a job. John Biffen, a Conservative and one time leader of the

House of Commons, nominated me so I think perhaps it had something to do with him as well, and there were some other Conservatives who followed his good judgment.

I think that's one of the things I will always be proud of, that I had respect from all the parties; that was very important to me. People used to come to me for advice, and still do, and I'm always very humble when people say I have influenced them and their careers, in whatever way. Whether it was encouraging them to go into medicine, education or to be a senior minister; I'm just glad I had some hand in getting people to do what they wanted to do.

People always ask me about the politicians who misbehave and, of course, there were always some politicians who were naughtier than others; when you get more than 600 people together of different sexes, there are always the mischief makers and the ones that are difficult. But I'd been in the House as a member, a back bencher and then Deputy Speaker for very many years so I knew the House and the make up of it. I knew the members and those who were tempted to create mischief, that was all, but you know when they do and it becomes very difficult. I think a speaker has to have a turn of phrase that reduces any tension there. When tensions rise and the atmosphere gets tough you have to have a smile on your face and a sense of humour, and that was how I was able to cope with it.

One of the other things I'm most proud of was being Chancellor of the Open University for 12 years which is a wonderful institution; it's the second best thing that happened to me after being Speaker of the House of Commons. Also I'm very proud of the 'Cause of Freedom' monument in Whitehall which I was delighted that the Queen consented to unveil in July 2005, the 60th Anniversary of the end of World War II. As president of the Memorial to the Women of World War II Fund, we worked for eight years to raise funds to have it built and it's a tribute to the seven million women who contributed to the war, either in uniform or on the Home Front.

It's not by nature purely a military memorial. It depicts the uniforms of women in the forces alongside the working clothes of those who worked in the factories, the hospitals, the emergency services and the farms. I hope that future generations who pass that way down Whitehall will want to find out for themselves what sort of women they were, and look at history for the answer.

I don't regret anything about my life or career. It was bloody hard work and I did neglect my friends. I didn't get married because at the time I was travelling around all over the world as a secretary to delegate groups, and I was a bloody good secretary at that, but no young man was going to sit on the sidelines and wait for me. But still, if I had a second innings I'd do it all over again.

I'd say anyone can get into politics if they want to, I had no higher education but it's the same with anything, I would say if you want to do something enough and you have the determination and will to succeed, then you will. Similarly if you are stuck doing something you don't want to do, change it and do what you want to do.

My philosophy, if you can call it that, is take issues seriously, but don't take yourself too seriously. And live every day to the full because I don't think life is a rehearsal and I think you just must make the most of every day. When you wake up, enjoy that day and do it to the best of your ability. I live my life every day and give a blessing that I'm still alive, so full of energy and able to do what I want to do and that's how I get through.

I think the best thing about being 50 and over is that you get more confidence than ever before and it just grows as you get older. The not so good thing is that I'm far less tolerant, as those who interview me tend to find out. I suppose the only bad thing about being over 50 is the wrinkles!

These days I'm just happy in my peaceful semi-retirement seeing the friends I neglected so much, and I can determine the things I want to do without the harness of a diary. I go to the theatre, enjoy doing my garden and I love travelling. When I was little I remember always asking why we had to go to Blackpool every year for our holidays when I wanted to go to China. Now I've been to China three times and I aim to go away as much as I can for as long as I can.

Cynthia Paine

Who: Cynthia Paine
When: 24th December 1982
What: Luncheon Voucher Madam

'The reason people say there's too much sex on TV is because they're not getting any!'

My family always worried that I would get into trouble and they were dead right. My mother said on her death bed that she thought my sister would be okay, but to 'watch Cinders because she'll have an illegitimate child before she's 15'. Though it didn't happen till I was nineteen, she was still right. I suppose I just had a lot of spirit and there was no birth pill then. I do regret having a child so young, in a way, because it ruined my teenage life. My father didn't help me much, he just said 'you made your bed, you better lie in it', because that's how it was in those days; and I did. From the age of 20 to 30 I did just that and it was bloody hard. I was really too young in the mind, having left a place like Bognor and coming to London I had no friends and just had to work as much as I could.

I started working as a waitress in Victoria and all the local prostitutes used to come into the restaurant where I worked. From the age of about 15 I had always been fascinated by sex so I thought I'd get first hand knowledge of what they did. At the time I lived in one room with a little washbasin in the corner and one day one of the girls asked if she could use my room to bring back a few clients. My room was three pounds a week and my wages were only three pounds a week plus tips. I was an unmarried mother and my little boy was being fostered out because I didn't have my own home. So the driving force for me from the start was getting my own home so I could get my son back. The girl said she'd be out before I got home so I thought there was no harm in it. After about 9 months people started to realise what was going on and the police were informed. I got my first conviction for girls using my premises – they called it habitual prostitution then – I didn't plead 'Not Guilty', which in hindsight I probably should have, I was too scared; so I pleaded guilty.

By then though I'd got the feel for it, lots of girls on the game were coming into the restaurant and asking me to get them a flat. This was about 1959 when the new Street Offences Act came to pass which said that all girls had to be off the streets, so I came about at the right time because they all needed places to go. That's how I got into it, I used to go up to Marble Arch or Park Lane and get a lovely flat for £10 a week and sublet it for £20 and that's how I became a prostitute's landlady. I started off getting flats for the girls, then I became a maid which I enjoyed because I was a good organiser. I was maiding for a girl who was 19 and she was making £200 a day in this flat of mine so I charged her rent and she paid me for maiding. That was a lot of money then; well, it's a lot of money now.

It was about that time I was starting to give parties but someone said to me, although they were great, there weren't enough girls. So an ex-boyfriend of mine suggested putting an ad in this sex contact magazine called 'Rendezvous' about the parties and inviting businessmen, saying men over 40 should apply because wisdom comes with age! I got hundreds of responses; literally thousands. I knew this was where the money was because they were willing to pay £15 or £20 a time. Also, because I'd spent six months as an escort I knew that men didn't want to just go to see a prostitute for half an hour, the men I met said they wanted company. That's when I hit on the idea of the parties where the men paid to come.

Out of all the hundreds of letters I got I only picked out the best. From the quality of the notepaper, what part of the world they lived in – I wouldn't have anyone from Streatham – I kept it away from home. I had Devon farmers, Irishmen came over on the early

plane and would be back in Ireland for 8pm – their wives and girlfriends were none the wiser. They were exciting days because it was all so daring, it was the 70s. We even knocked money off for pensioners. I picked nice men, men that the girls felt comfortable with.

My father even came to my parties in the end, and it was only then I suddenly realised he was no different to any other man. Once when he was very ill and I wanted to cheer him up I threw a party without telling him, he wouldn't have come to stay with me otherwise as he initially wanted to set an example to me. But he came along and realised what a nice atmosphere it was and saw that there were men there even older than him and felt very much at ease. He saw all these old men taking these young girls upstairs and he just sat there highly amused by it all. I remember one Harley Street doctor saying to him, 'You haven't got any more daughters like her have you?!'

It was all very successful and by the time I got raided the first time in 1980, as the judge commented, my brothel was well and truly known all over the country and was very well organised. I felt like shouting from the back of the court, it was only well organised because I liked doing it! When it happened the second time the police rushed into one of my bedrooms and there was this old boy with a young girl and the Inspector said, 'Excuse me sir, this is a raid and I'm a police officer, can you please stop what you're doing?' The old man was determined to get his money's worth and said, 'I don't care who you are, I'm not stopping now!' He didn't and the police kindly allowed him to carry on.

I was 50 when I went to prison. When they first sentenced me to 18 months I couldn't believe it. I remember asking the officer that took me down to the cells what it was like and she said it's alright, I thought she was kidding me, but she said if you behave yourself you'll be alright. I think I would have behaved myself anyway but I'm glad she advised me on that; it was an intimidating place and a lot of the people were on drugs in there so it was quite a shock to begin with. I'd seen a bit of life by then though and realised I could cope, which I did, but the four months I ended up serving was enough. I tried to look upon it as an experience to see what prison was like, but it was so boring, there just

wasn't enough to do. I was itching to get out because I just knew it would change my life.

People weren't as shocked as I thought they were going to be, I think they were more shocked that a 50 year old woman could get sent to prison for running a brothel or for anything to do with sex. The public really first started hearing about it after my raid and then when I came out of prison I was so ashamed and embarrassed, I couldn't even go out.

My friends told me not to worry because everyone was supporting me, but when you're in prison you don't realise that. There was a woman who used to live next door with her brother who was a catholic priest. She was a lovely lady and my first thought was; how am I going to face her? Funnily enough she was the first person who welcomed me back to society. She was an older woman and had a really good sense of humour. She said they really laughed when it happened, because when I used to have my parties on Wednesday afternoons, all the nuns used to go next door for bridge parties and when the police were watching my house, obviously they noticed what was going on in both houses so when they saw all the men come in to my house and all the nuns go next door they probably imagined us all meeting in the middle!

I was so surprised at the publicity I got. The public loved it. In 1987, when I won the trial, people went barmy to meet me – they went crazy. That's when I realised people in England are so inhibited. Sex is a normal thing, but I suppose I reminded them of a naughty seaside landlady and people just loved me. There was me worrying in prison what sort of life I was going to have when I got out and it just went on and on.

I didn't realise a book would come out of it but I'd seen the papers and I just knew I was going to be famous. I said to the other girls, 'You look out for me when I get out.' A journalist who helped me quite a lot advised me to get an agent, so I did and then came the book and it really went from there. The really brilliant thing was the film, *Personal Services*; I couldn't believe it and that Julie Walters was playing me, that was amazing. She came to a couple of parties I threw after I got out probably to see what I was like for her role. I think maybe the most exciting part aside

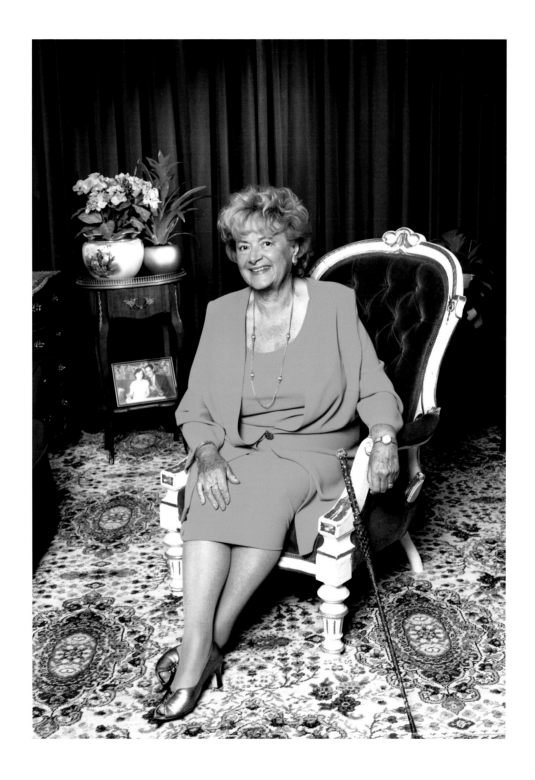

from winning that second trial, was the film première; that was really something.

Despite everyone else's reactions though the people I did worry about were my family and I tried to protect them as much as I could. My son was very worried after the first raid that the press were going to find him because he worked in security and was frightened about losing his job. So even then I remember when they first took me down to the police station the policeman taking down my particulars said 'Cynthia Payne – P.A.Y.N.E'. I said 'yeah, that's right.' I thought, if you're too bloody lazy to find out how it's spelt then I'm not going to help you! But it was quite deliberate because when it all came out eighteen months later all the journos were looking at my background and they never found my son because of the name difference. But now my granddaughter knows all about it and she thinks it's a real hoot. She comes to the odd launch or première with me and she loves it.

When I look back now at what happened, it's all a load of balls to be honest. I think about September 11th and terrorist bombs – and the police were worried about me. Perhaps there wasn't enough going on in London at the time for them to do. I don't even know why they bothered to raid me. Of course, it is against the law but let's face it, I'm sure the police would much rather raid a brothel than deal with muggings and the like; it's far more exciting.

Sex is so blatant now; it's almost gone too much the other way, though I still think the reason people say there's too much sex on TV is because they're not getting any! My attitude was healthy and curious; but people thought I was too forward for my age. I don't know why I was like it; must have been bored stiff where I grew up in Bognor I should think.

I've learnt so much all the way along and looking back one thing I am glad of is that when I had my parties I used to invite all the people that society shunned; whether they were disabled or transvestites, I was always kind to people whoever they were and never judged. I also came to appreciate my father as I got older because my mother died when I was eleven and he was left with two little girls, which was very sad because he worked away and we didn't

really know him apart from as a man who came home every six weeks bringing us lots of goodies. I didn't know him and certainly didn't love him. He was very strict and, I think because of how he was brought up, he never showed us any love or affection, but he did get better as he got older. As one of my friends used to say, life makes you humble if you live long enough, and it's true. My mother was a very kind and gentle woman and I think with her dying so young, at thirty eight, it made me realise from a very young age I didn't want to die without having done anything with my life.

People have never really lost interest in what happened. Even now I do a lot of after dinner speaking at some very respectable events, places like HMS Drake and The Savoy. And I love ladies nights, women actually come up to me and say that brothels are a good thing now, they are different now to then. When I came out of jail women were my biggest allies. I suppose I made them laugh; people liked me; I was the acceptable side of prostitution.

I've had a very varied life; almost two lives in a way and people ask me which of the two I prefer, the celebrity life or the parties and the people I met. Well the old life was marvellous, but then I've also enjoyed the new one because that has really given me a kind of self assurance that I would never have had. Even going to prison gave me a certain amount of confidence after I got over the initial shock and realised what life was all about.

I still can't believe I was made into a celebrity, only the English could do that; make a celebrity out of a brothel keeper. I remember being on the Dame Edna show and as I came down those stairs like the queen in a pink dress someone said to my sister, 'You've got to admit, she's made it.' All that gives you confidence and it broadened my horizons; so I've loved both lives really.

Carolyn Grace

Who: Carolyn Grace
When: 8th January 2002
What: Only current female Spitfire pilot in the world

'It's like putting your arms out and running round the paddock, your arms become wings and the dream becomes a reality.'

I think my initial interest in flying was ignited because we were brought up on a large property in New South Wales. We used to do crop dusting with Tiger Moths and we'd also get taken over to Sydney by plane to go shopping, which was a real treat.

What really set it off though was when I was eighteen. I'd just got this huge flock of sheep together when a Tiger Moth flew right over the top of them completely messing it all up. The pilot was an English guy called Nick. We all had a good gawp at him because we didn't see that many Poms about then, but I forgave him for messing up the sheep and we ended up keeping in touch.

The next year, when I was 19, I went to the UK. It was that sort of time when everyone was coming to live overseas from Australia; much like it is the other way around now. I met up with Nick again and after I'd travelled around a bit we ended up getting married and living in Guernsey where he and I set up a boat building company.

Until I got to Guernsey I hadn't actually done any flying myself, but being on an island we used planes as trucks really, to cart materials from the mainland for the boat building. Nick bought a Dove and I was his autopilot, flying the height and heading for him, but I got a real shock when I had to do anything more than that!

I was quite happy that way for a while but then I realised I really wanted to learn to fly myself. So Nick bought a Chipmonk plane and found an instructor to teach me. Although first he had to teach the instructor how to fly it who, strangely, was quite intimidated by that. I started learning there and finished

my licence, with the required 40 hours flying time, in Jersey. I'd done a bit of flying with him but nothing properly so I think I must have had a bit of natural aptitude for it, I think you either have or you haven't.

Nick eventually sold the company and we moved to Cornwall. I could never quite grasp that the whole of Guernsey was smaller than the property I used to live on back home, I always felt a bit restricted, so we bought a farm to renovate, and some cattle to rear so I'd feel a bit more at home.

One of Nick's dreams was to own a Spitfire, which I think came from being a young boy during World War Two. After much searching he managed to find the only two two-seaters left in existence, in Scotland, and bought them both.

He sold one and kept one, which I convinced him to keep as a two-seater, and stripped it down to bare metal and completely renovated it. We only found out later what an amazing history this particular Spitfire had had during the war and that it was recorded as shooting down the first enemy aircraft on D-Day. It took five years to rebuild and he made his first flight in it in April 1985. He then began to fly it in displays around the country and became very well respected for this.

In the meantime I had been cutting my teeth in a 'Stampe' bi-plane in which I'd managed to clock up around 150 hours of solo flying, but I'd not really had much time to join Nick in the Spitfire. With two young children and a farm to run, with by then a Cashmere Goat Stud included, I didn't get to fly with him so much.

One morning in 1988 I woke up with a start at 5.15am having had a dream that Nick had died. I didn't think any more of it and just carried on with the day. It wasn't until later on when the children and I were on the way back home in the car that we saw there were police up ahead blocking half the road. Some instinct in me told me to turn round and go a different route and I'm so glad I did; he had to be cut out of the car and for all of us to have seen that would have been just awful. I was later told he had died at 5.15pm that afternoon.

I felt like a glass that had been knocked over; I managed to get most of the pieces back together but there was part of me that never came back. I lost my soul mate, he was everything to me. That night I decided not to tell the children their daddy was dead, I remember going to bed thinking, in their minds he's alive for one more day, which was a nice thing for them to have.

People asked if I would sell the Spitfire because they knew I would struggle to keep it going – people who generally own these sorts of planes are millionaires and we were nothing like that. But I wouldn't have dreamed of selling it, it was part of the family, so that never entered the equation. The Spitfire represented everything Nick had achieved and was the embodiment of his spirit; losing him was enough, I was damned if I was going to lose the thing he'd worked so hard for. So I decided to fly the Spitfire in memory of Nick. He had always wanted me to fly it, so I did exactly that. I knew I had to keep it going and for there to be a Grace in the cockpit; Richard was far too young, so it was down to me. I sold the farm and the, by now, 750 strong herd of goats and we moved to Halstead.

Going from what I was flying to a Spitfire was like bumbling around in a Morris Minor and then suddenly driving a Formula One car! It was very hard, but one of Nick's pilots, Pete Kynsey, was fantastic, I learnt so much from him and within a couple of years I'd started flying the Spitfire in displays. As you can imagine, there's flying and there's doing displays, which are a whole different entity. I started off with fly pasts and then gradually built up manoeuvres, moving onto aerobatic displays and then formation flying.

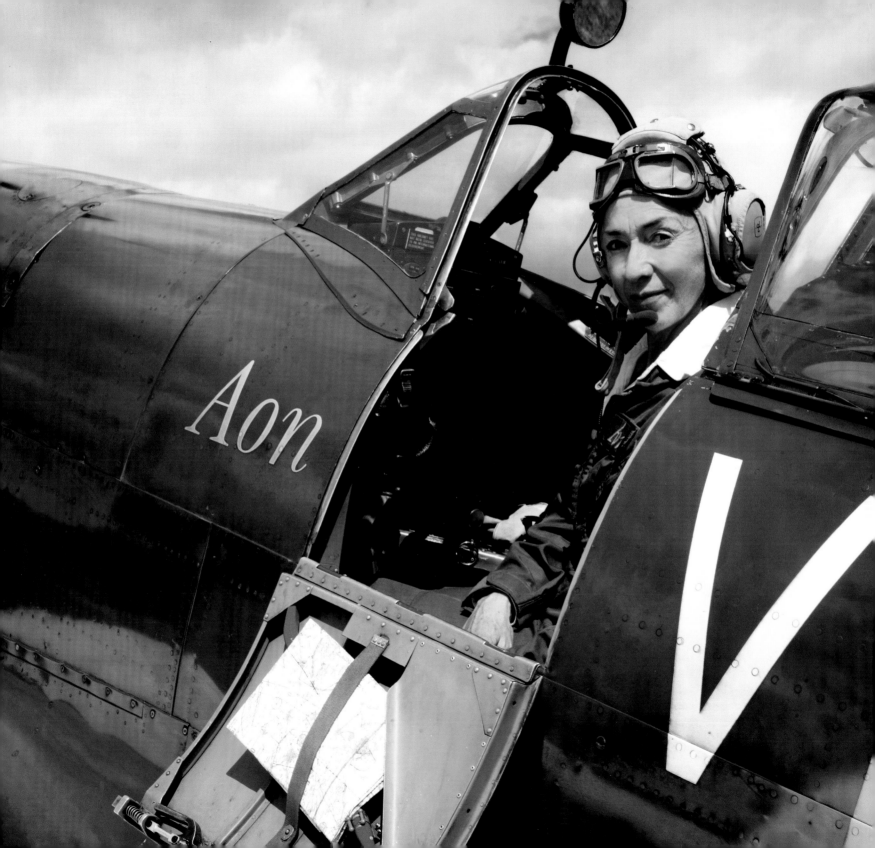

I wouldn't say that I was so much scared to begin with, though it certainly concentrated the brain. When you get in the cockpit all other thoughts and worries go out of your head and your concentration and focus level tend to override the enjoyment. It is exhilarating and there's a massive adrenaline rush that you only really notice afterwards once you're back on the ground. It's like putting your arms out and running round the paddock, your arms become wings and the dream becomes a reality. The Spitfire is something you put on and wear, you become part of it, you are like a bird and you *can* fly. There's no other plane like it, it's beautiful from every angle and it sounds superb too.

I was talking to a World War II Spitfire pilot and he was saying how powerful it is but you must have a delicate touch. If you become the least bit over confident or a bit slack it'll turn round and bite you; every flight she's trying to catch you out and get you, and it's just like that.

As I get older I feel I get more pleasure from the Spitfire and I can enjoy it more, I've got more confident and have learnt so much; I'm learning more all the time. In the last couple of years I've started doing displays to music like the *633 Squadron* and Walton's *Spitfire Prelude & Fugue*; I carefully choregraph the flying to the music and it's now something I've become quite well known for.

Of course I'm very proud to be the first woman ever to own and fly a Spitfire but there's so much entangled in it. I'm not just flying a piece of history, it's for the children and in Nick's memory; there is a closeness and an affinity with him when I'm up there.

The thing is, anyone can learn to fly a plane, there is no age limit or gender issue, so there's no reason why anyone can't do it. I know a woman who learnt when she was in her early 60s; women are generally good at flying because we tend to be more gentle, we're good at listening and following instructions.

My son Richard has his own plane, a Formula One Racing type and my daughter Olivia also loves planes, though she hasn't got her licence yet she enjoys running our website. So at least I know a Grace will carry on where I leave off.

To me, my children are my most satisfying achievement. They are wonderful people, great friends and a huge support to me. I'm so proud of them and glad to have been a competent enough team leader to keep us all together and make it work.

The time that has passed since Nick's death hasn't made me feel his loss any less – anyone who says it does is talking rubbish – it's just given me more time to adjust to it. But I still love him. Just because he's died you damn well don't stop loving him, it's a bit annoying really. I suppose the thing I've learnt most from this is that out of something negative there is always a positive.

Georgia Durante

Who: Georgia Durante
When: 9th July 2000
What: Ex-Mafia Wife and Get-away Driver, Hollywood Stunt Woman

'He said, "Are you going to go back with me?" I said, "No Joe, I'm not." He said, "OK. I'm going to do something to you I'm going to do time for."'

I grew up in Rochester in New York, home of the Eastman Kodak Company and I had a very normal upbringing. I had parents who loved me, dinner on the table at 5 o'clock every night, I had a lot of love and a lot of support; so there was really no excuse for me to turn out the way I did.

I was just a really adventurous kid, I also had a passion for speed and after some early experiments with my poor father's golf carts, I started drag-racing at 16 years old at the local race track. By this time my mother, probably in the hope I would be less of a tomboy, had introduced me to a photographer at Kodak and before I knew it I was modelling. At 17 I was the most photographed girl in the country and racing cars around didn't really fit in to that.

Being a model wasn't really what I'd planned, and a lot of my classmates seemed to dislike me for it. I now know it was jealousy, but then I just thought they hated me. As a result, I had pretty low self-esteem. It was at this time, when I was 17, that I was violently raped by my brother-in-law. I was a virgin. That totally wiped out any self-esteem I did have and I fell into a hole of blackness that took years to get out of.

Rochester was a big Mafia town in the 60s and 70s so growing up in that environment seemed quite normal. These guys were part of the neighbourhood. For some reason the guy who ended up being the 'Godfather' of upstate New York sort of took me under his wing when I was about 13, watched me grow up and protected me. So when the rape happened he was beside himself and told me he wanted to have my brother-in-law killed. I just had to say the word and it would have been done. Of course I didn't do it, but with everything that had gone on and the cruel small-

town gossip that suggested the rape had been my fault I had to get away. I escaped to New York City as soon as I graduated from High School.

Myself and two other model girlfriends rented a small apartment and hit the town in a big way. In between modelling jobs we worked in a small Mafia-owned after hours joint. One night, when I was behind the bar, just five feet away from me this guy pulls out a gun and shoots the guy next to him. He fell to the ground in a pool of blood and like a shot the owner of the club threw me his car keys and said, 'Georgie Girl, get the car and pull it up.' I ran down two flights of stairs and pulled the car round, they put him in the back seat and I drove him to Belvue Hospital. I wasn't even 18 but had been around these guys long enough to know that when I saw a cop I had to slow down and act normal. I pulled into the emergency entrance at the hospital, they opened the back door and dumped the body on the sidewalk. As we took off these guys couldn't care less if the man lived or died; all they could talk about was how well I could drive a car. They talked about it for months.

My involvement with them grew and I was asked to do more and more, take messages back and forth and collect and deliver packages to and from the airport. I later realised these packages contained millions of dollars in laundered money. While waiting around the corner one night, they came charging towards the car, flung open the door, jumped in and said, 'Step on it!' Then I heard the sirens. The cops were hot on our tail, but I lost them and from that point on, I became the key driver for their unlawful endeavours. I was just lucky not to have been caught.

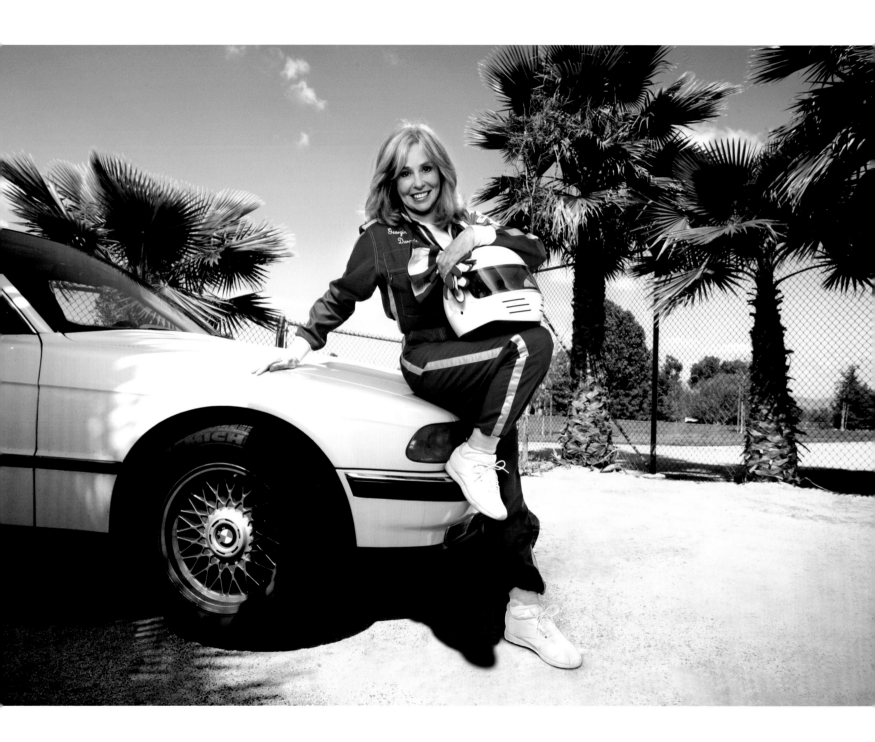

It was in a mob nightclub that I met Joe, he was good looking, charming and full of confidence. Unlike me. After the rape and because I already had a daughter, in my mind I was damaged goods. Joe and I fell madly in love and married as soon as we could.

The Joe I fell in love with disappeared soon after. He became irritable, aggressive and saw me as his possession, so wouldn't let me go out on my own or see my friends. He even prevented me from seeing my family as time wore on. Then came the physical violence. He once dangled me by my ankles from our apartment building window and threatened to drop me unless I swore I would never leave him. There were frequent and frenzied beatings when I would pass out, only to be woken with cold water for him to start again.

At times I didn't think I would come out of it alive. There were many occasions I tried to leave him and he didn't take it well. I really thought I was a gonner when he put one bullet in his gun, spun the cartridge, put it to my head and pulled the trigger. I was trying to convince him that I loved him, but he knew I was lying so he pulled the trigger again.

Another time I tried to leave was when we were living in Las Vegas, I was working part-time in a casino and when I came out he was waiting by my car. He said, 'Get in.' I started shaking and I got in the car. He said, 'Are you going to go back with me?' I said, 'No Joe, I'm not.' He said, 'Okay, I'm going to do something to you I'm going to do time for.'

He started driving out towards the desert. There was one traffic light, the light was red and he started to slow down for it. Seizing the opportunity, I opened the car door and flung myself out. Rolling along the pavement I looked up and saw he was backing up to try and run me over. I rolled out of the way and saw that there was a car sitting at the light. I ran over, jumped in and said to the woman driver, 'PLEASE take me where there are people.'

I got saved that night. He was going to kill me, no doubt. This was a guy who was no stranger to murder. When he said he'd kill me I knew he would.

When I finally left him we were in California in hiding because a mob war had broken out and they were killing everyone who knew anything. There was a contract out on both of us. At this time his abuse became unbearable; he was like a rat in a corner. My daughter and I used to run out of the house when he'd get in a rage. If I was lucky enough to grab my purse we'd go and sit in the movie theatre for the afternoon, but most of the time we were in our pyjamas and we'd go and sit on the beach, shivering all night long, too afraid to go home.

One day we were by the pool, I was reading a book and my daughter was in the pool playing with two other children. I heard her laughing and suddenly realised I hadn't heard her laugh in a long time. The other girls' father came along, jumped in and started playing with his daughters and sort of forgot about her. She sat on the edge of the pool with her hair all hanging round her little face biting her lip to stop herself from crying, thinking 'why can't my daddy be like that.'

At that point it hit me that I was so wrapped up in my own pain I hadn't seen hers. I didn't even think, I just got up, took her by the arm and hurried back to the apartment. I knew Joe was playing tennis so I had some time. I threw whatever I could into the car as fast as possible and took off down the driveway. But to get out of the complex I had to drive right past Joe. He stopped dead in his tracks when he saw me and looked at me as if to say 'you'd better turn around if you know what's good for you'. But I just kept on driving towards Los Angeles, not really sure where I was going and with only about seven dollars in my purse. We lived in the car until I finally got in touch with a friend who I used to model with in New York. He let us stay with him until I could figure out what to do. I couldn't do any modelling because the Mafia and Joe would figure out where I was; all I could do was sit in this guy's apartment and watch TV. The more I watched the more I began to realise how many car commercials there were, and the more I began to realise that you could never see the driver. I thought, that's perfect; I could do that.

But this was 30 years ago and women just didn't do that kind of thing. So after a long process of pestering directors on car commercial sets, one finally got fed up and hired me. He was pretty

shocked to see that I could actually drive. Word got out about my driving skills and I ended up turning down more work than I could take on. After about four years everybody in the mob who would have cared if I were dead or alive was killed off, including my husband – we had finally gotten rid of the maniac. He took my youth and the best years of my life. At last, I could set up my stunt driving company, Performance Two, Inc.

Things seemed to be going really well until one day a few years ago. I was doing a 'Bugle Boy' jeans commercial and driving this $250,000 Dino Ferrari for it. Somehow I mistimed a corner and ended up somersaulting at high speed toward a steep drop off into the ocean. Waiting for the impact and certain death I found that I wasn't thinking of my daughter, or having my life flash before me, or imagining the gates of heaven – all I could think of was that I was going to wreck this $250,000 Ferrari!

That was when I knew I had to talk to someone about what I'd gone through and started seeing a therapist who told me to write in a journal for 20 minutes a day. In doing so, all this buried trauma started coming into focus. It was really very painful to have all these events come to the surface again, things I didn't even know were there as I'd buried them so deeply. That's when I decided to write a book, *The Company She Keeps,* and in putting it down on paper I was able to sort through it all. It was like cleansing, it was amazing. When I finished it was like my life was just beginning. I was also so proud to have written it. I had no high school education – my worst subject was English – so to actually write a book that people bought and liked was pretty astounding to me.

The best thing that happened as a result was that I got emails from women all over the world who had been or were being abused. They didn't know they were in that situation until they read the book; through my words and experiences they could see themselves on the pages and see that it happens little by little. So many women have taken that first step to get away from their abusers and I continually get inspiring emails about their brand new lives and thanking me for showing them the way; I didn't anticipate that happening. But it's really put me on a totally new path and now I've started going into prisons and shelters to speak to the women and encourage them to make changes so they can lead a better life. I also speak at colleges and do a lot of charity work. It's not a life I ever expected to have and I really believe this has been all part of God's plan for me. I had to live my life this way so I could come out the other side and be able to help other people.

I don't see myself as a hero, but I am a survivor. When it's your life you live it, you just do what you do. I didn't feel any different when I reached 50, I just felt good physically, was still doing the crazy things that I do and had accumulated so many wonderful friends that life felt very full. This is the best part of my life, I know who I am, I understand what has happened and that it has brought me to where I am today.

If I could give any advice I would say believe in yourself, whether you're over or under 50. Everything goes, your looks go, but at 50 you should be at a good place in your head. I don't look anywhere near as good as I used to, but that's okay. It's who I am inside that I like. I never liked myself before, but today I do, and that's all that matters.

Gillian Ayres

Who: Gillian Ayres
When: 3rd February 1980
What: Royal Academy Artist

'I wish I could have my whole ruddy time again that's for sure!'

I was born in Barnes, which was a suburb of London back in the 1930s, so when war broke out in 1939 I was supposed to be evacuated. But when it came to it and we were almost in Oxford where I was to stay, my mother told my father to 'drive on' and they took me back to London where I spent the whole war. There were no schools open during the first year of it, so I ended up going to this church centre in Barnes Common. There were only eight of us between the ages of 5 and 18 years old, so we didn't learn a hell of a lot. Gradually, after that first year of war, kids started to dribble back to the city and we were taught in air raid shelters.

Before that, from the age of six, I went to quite a modernist school for the time. We did all sorts of things from making pots to cleaning out goats, but I did find out I was strangely good at maths! The school was quite advanced really but I liked it because it wasn't so disciplined – I realised from quite a young age that I didn't take too kindly to authority.

For that reason and because of the war I didn't learn to read until I was eleven years old when I went to St Paul's School for Girls which was far more disciplined. I knew from the age of around 13 that I didn't want to be there, I was wasting my time at school; all I wanted to do was art. When I was sixteen I finally left there and went to art school in Camberwell. My parents were supportive but I knew they thought a potential career in art was not wise, and at the time that wasn't an unusual opinion.

When I went to Camberwell in 1946 it was an extraordinary time for the country, the world had been at war and people just wanted to do what they wanted to do. There was an excitement and optimism in the air after what so many people had been through.

We were buoyant and positive, I suppose we realised we'd had a lucky escape.

Art school was good for many reasons, but I wasn't so keen on the teachers and the type of art they taught. I got a lot out of it in many other ways though. The one thing about being a student is that you have time and lots of it; you only really appreciate that afterwards when you realise how much time you don't get as an adult. It was there I met my husband, the artist Henry Mundy; I don't know about love at first sight or anything like that, but we'd known each other a long time and got married after leaving Camberwell.

After college we got a job at the AIA Gallery that we shared between us for £5 a week, which was the bottom wage at the time. But it was wonderful, we met so many interesting artists and some very famous ones. When I was off, I used to wander around Nile Street and all the galleries, just soaking it all in.

I began teaching at the Bath Academy of Art in 1959; as most artists did to make a living right from Henry Moore onwards! I had just started to have a bit of success and got my first solo exhibition at Gallery One. I was so pleased to have the chance but so nervous, and I still get just as nervous today when exhibiting my work. I don't paint because I think people will like it, and I don't really ever expect them to; but you always hope they will and are rather pleased when they do.

For a woman then to be successful, or have a good job, was not so usual. I could never understand this. The world is made up of half men and half women and we are not second class citizens, I always found it irritating and was amazed when people accepted

that we were. Even from the age of five, when people said I couldn't do something, because I was a girl, I felt real indignation and anger. It was wrong.

So I am proud of what I have achieved. I was very pleased when I was awarded the OBE in 1986 and I'm also very proud to be a Royal Academician. There can only be 80 of us so they have to wait for one of us to pop our clogs before the next person can be made one. The Royal Academy of Art is an extraordinary place and an enormous amount of people go there, so it's a great location for showing your work.

You never feel you're good enough and I suppose because we all do different things, not special or clever but just different, that's just what you do. I just want to work and am always pleased to do so. There have been times when I haven't been able to, so my main ambition is to keep working as long as possible; and do a wonderful painting! I had a heart attack a few years ago and now I can't walk around so much but I'm glad of what I've been able to do, the things I've seen, and there's still so many things I want to see and do.

I suppose I find it quite frightening that people can live quite happily without art. I could never imagine life without it and I wouldn't have wanted to live without it; the whole experience of it, even just looking at art.

When I lost a large number of my paintings, along with many other artists, in a fire at the Momart storehouse in 2004, I was devastated, I felt bloody awful. Paintings have more permanence than life in a way, but I would never put that loss above a life – the value of art is certainly not above that of life – but it did feel like a huge loss for me.

Painting is freedom and expression, art is the truth. You hope to paint what is true to your feeling at the time. My art changes all the time, whenever one ages, things change. What I liked at art school I may not like now, some things change, some stay the same but we must always be reassessing, re-evaluating and learning things. I wish I could have my whole ruddy time again that's for sure! For all the involvements, discoveries. It's an energy. Works of art don't exist until you create them.

In life there will always be things you love and things you hate and you must be positive over what you reject and what you embrace. The thing is having the choice; don't utterly accept everything, be strong enough to formulate choices.

I think that it's important we all do as much of what we want to do as we can. People should be involved and keep being involved. Age doesn't come into it at all, we only live once.

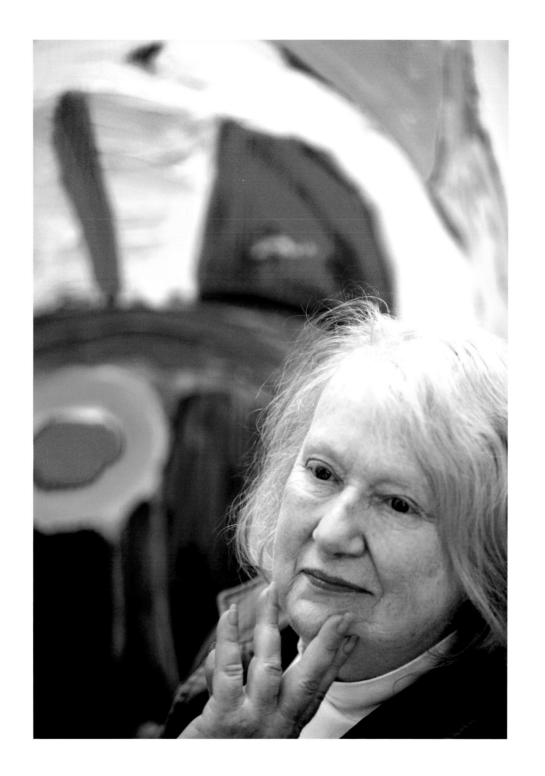

Ordell Safran

Who: Ordell Safran
When: 11th December 1988
What: Llama Farmer

'Llamas are very mystical creatures – there's something about them – when they look at you it feels as if they are looking into your soul.'

I was born in Sioux City, Iowa, a small town straight out of a Judy Garland and Mickey Rooney movie. It was a wonderful place to grow up, but I knew when I was young that I didn't want to live there forever. My parents stayed, but in 1972 my husband Henry and I thought it might be fun to move to England, so we took our three boys and went to live in London.

Despite being in the city I kept a couple of horses in stables in Hertfordshire and commuted every day to look after them. When I was little the one thing that I always wanted for Christmas was a pony. Every year I looked at my presents and longed for a little box that had a little key and a note in it saying, 'You should go to such and such a stable and there is your present.' It never happened – but my dad, not wanting to go to his grave knowing he had deprived his daughter of anything, sent me over the money to buy my first horse! I started competing in Eventing and eventually, after ten years, we moved out of London to Ascot so I could keep the horses at home, and it was my husband's turn to do the commuting.

He never really had much of an interest in animals, particularly looking after them, but he did have an interest in llamas and had only recently shown me an article in an American magazine which said they were big business over there. I didn't think anything more of it until one morning I heard the horsebox go out and then, a few hours later, it came back and my husband shouted for me to come outside because he had a surprise for me. I went out and saw this llama that Henry informed me was called Larry; I was not happy. At the time I had three boys who were

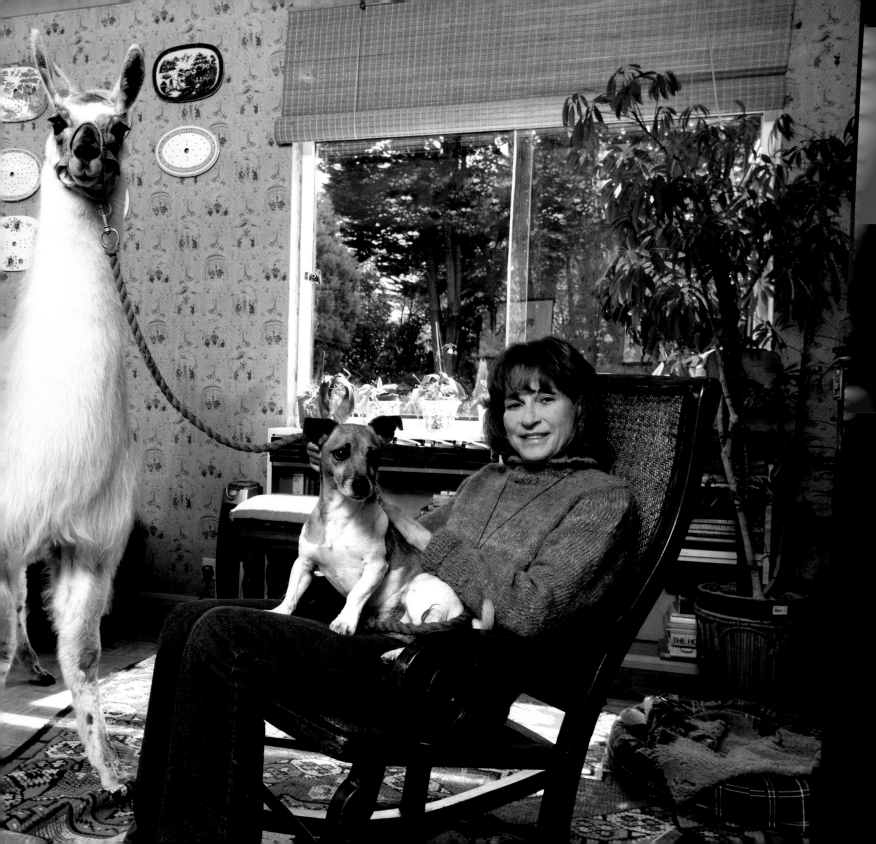

into every sport imaginable and my hands were full with the horses and my competing, so I was not impressed to have yet more to do.

But then I felt sorry for Larry, he was very lonely because he had no partner, so I decided to try and find a mate for him. It proved harder than I thought. At the time, llamas were not too easy to come across and most from England were being shipped over to the US because people were paying thousands of dollars for them. But I found one in the end – she wasn't the most attractive but then beggars can't be choosers. As it turned out, despite having a partner Larry didn't get on with us because he hated horses; he'd come from a safari park originally but then he'd had to share a field with horses and had to fight for his food. I put an advert in *Horse and Hound* to see if anyone wanted a horse-hating llama and to my surprise someone found a home for him. I found another male and then really got hooked on them; I've come to the conclusion since that they are addictive. I got some more from Nesborough Safari Park when it closed down and the animals were to be sold or put down. So I bought a stud male for breeding, two females, and a baby.

That little baby turned out to be a star stud male and he's been at the foundation of my current herd of around fifty. I tend to sell them to private buyers who just want something a little different. It's amazing the mix of people we get, it's right across the board. Some of the nicest people come to buy from us and we've made some fantastic friends because of it.

As well as selling some, we've also had the opportunity to show them off every year for the past few years as llamas have been popular in agricultural show competitions. They're judged on temperament, fur, and compilation – how they are put together – it's only a bit of fun really.

The family think it's great. Though my sons don't live at home anymore, when they did they thought it was great to chat up women at the local pub and then invite them home to see the baby llamas – it never failed! Llamas are very mystical creatures, there's something about them; when they look at you it feels as if they are looking into your soul. They are very sympathetic animals, I think, because they believe in flight not fight so you have to be

very gentle with them. If I've had a particularly bad day and feel like doing something drastic I just have to take a deep breath and relax before I can go near them. Otherwise, they can sense your tension and you can't handle them like that or they'll just run away. They are very therapeutic though and always put you in a better mood. I can't imagine not having them now.

They've even been used to help sick children. A man called Michael Bassett, who had leukaemia himself, took some llamas to Great Ormond Street Hospital. They are very clean animals and don't make any mess, so the hospital were fine about it. The llamas seemed to know the children were ill and sensed what they had to do – just allow themselves to be petted and made a fuss of.

They are also being used more and more with disabled and disadvantaged children, because the children feel a bit of responsibility to look after them while they are there and the llamas show them unconditional love, which these children, who more often than not come from troubled backgrounds, may not have experienced before. I'm a firm believer in this sort of thing and I'd really like to organise more of this at our farm as it seems to help these children an awful lot.

It really was a life changing experience setting up the llama farm aged 45, but I have to do different things all the time. I think it's really important to have new ideas and not think you can't do new things. Age doesn't enter into it at all, I still feel there's nothing I can't do if I want to, obviously within my own reasonable boundaries; I have no desire to climb any mountains, for example, but I think it's important to have new projects, because if you don't your life may start to close in on you. As one door closes another one opens; for example, I can't ski anymore but I have a new interest in making jewellery, which is brilliant fun and very rewarding.

Susan Sarandon

Who: Susan Sarandon
When: 4th October 1996
What: American Actor, Campaigner and Representative for UNICEF

'It's not hard to be an actor, but to survive for a long period of time and not be bitter or fucked up might be more difficult.'

I came of age at a time when, being catholic, I was waiting for the communists to come and hang us on the cross and test our faith. It was only when I finally left my catholic womb and went to public school that I realised that none of the Jews in my class were the least bit apologetic about killing Christ; that was a big turning point.

Mine was a working class high school – there were 500 just in my class – I knew that the world was a lot more diverse and there must be something outside of my little insulated environment. I had to get out of New Jersey, so I went to college, although it never occurred to me to have a career goal. I just knew I wanted to go into higher education of some kind. Also, being the oldest of nine I definitely wanted some time by myself.

Being from such a big family really grounded me. I always had a child on my hip and was responsible for people and that definitely carried over to my later life. Trying to figure out how to love someone and have my own boundaries took me a while: it was the realisation that in my romances I shouldn't take on taking care of a guy so much. But I had a happy childhood, it was certainly good training for show business; not being used to privacy, focusing among chaos, not having time to yourself. You get to be pretty resilient with so many other children around and don't expect a lot of attention.

That's probably why I married very young, to Chris Sarandon, while I was in college, which is where my name comes from. Coming of age in DC in the 60s and 70s was really fabulous because so much was going on. If you had any mind or empathy at all you were in the middle of demonstrations. The issues were

much clearer than they are now. The war, women's rights, civil liberty issues – anybody with any connection at all to anything outside themselves was there. It was just part of being young.

Politically I remember the first time I stood in front of a huge crowd; I had no idea what I was going to say and I had to speak about the equal rights amendment. There were about 40 microphones on me and my friend just said, 'It doesn't matter what you say, they just need a sound bite.' I then realised what it meant to be in a position to be able to do that.

Taking part in some of the demonstrations and feeling that they worked was very empowering. So the little bit of putting my body on the line that I've done has been mostly about dealing with people's anonymous hatred and losing time in jail. It's not been really life threatening, just good to know how lucky we are to be able to use disobedience as a tool and make your moral bottom-line known.

I also caught the stage bug at college. I had no formal acting training, but they were putting on *Richard III* and said I had 'undoubtedly the wrong kind of voice for acting on stage', so I was put in as an extra. I remember I came to the front in my little corset and I heard a gasp; it was a real buzz to be on stage and get a reaction. So I joined a theatre company outside of school, in DC, and got my first acting job, actually at an audition Chris had gone to. It pretty much went from there.

I have to say it's not hard to be an actor, but to survive for a long period of time and not be bitter or fucked up might be more difficult. It's a dehumanising, fickle process and largely you are at the

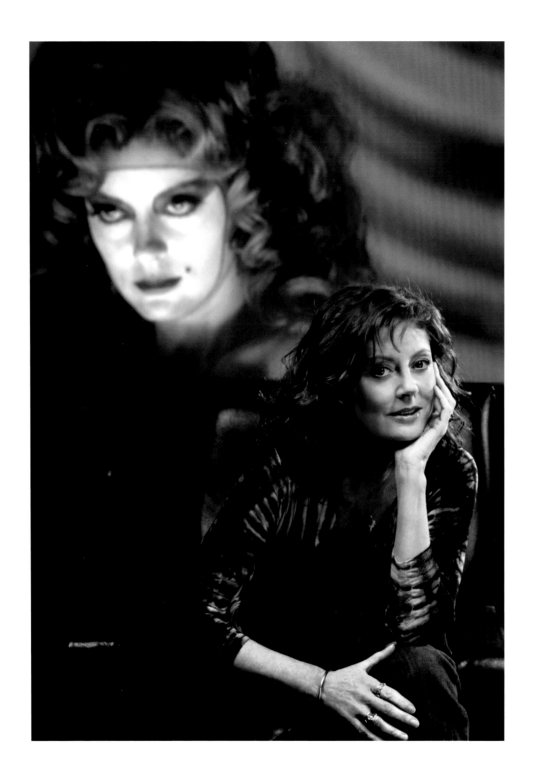

mercy of people who are business minded rather than creative. The actual working of it I love. The family that you build, the fact that you never know what's going to happen, the surprise of it, it's so acute and so extreme. You find out immediately who the good and bad guys are, it brings out the best and the worst in everybody.

Emotionally, the time I hit the bottom was in my late twenties. I'd not been acting for that long, I was divorcing my best friend, I had pneumonia which I caught doing *The Rocky Horror Show*, I had lost a lot of weight and a lot of the belief systems I had were not working. So in trying to make that transition I really crashed and burned. But once I'd embraced that I was completely psychotic, I got through it really quickly and came out the other side in a much better position.

As a woman, and especially a woman of that time, when you understand that love does not conquer all, then your world's much more out of control and you have to start to understand when to walk away from things. I think for a lot of women their struggle in their late twenties and early thirties is that so many smart women end up with bad men over and over again. Then finally when you figure that out, then you have all your power to accomplish more positive things when you're not with someone who's constantly asking you to minimise yourself and not celebrate who you are.

Another major turning point was working on the film *Bull Durham* and meeting Tim Robbins. I had a part I wasn't overqualified for, a really well written interesting female character who defied all the clichés of that kind of genre. I was, ironically for a locker room based movie, treated with more respect than I had been in most of the films I'd done before. So for me it was very empowering and during the process of going through the film Tim was interesting, because he was political and he had his own theatre company. He knew I was political, he was well read and he was really fun, so we became friends first. Because of that film, not just Tim, but really because of that part, and Mark Sheldon the director and Kevin Costner, it made me re-evaluate a few things. When I left, I looked at other areas of my life I felt I had been compromising on and I decided to leave my daughter's father, an Italian film

director. Tim, who was also in a relationship when we met, went through a shift in his life and then came to New York. He contacted me and we started to see each other, but he was definitely someone really fun and smart and our moral bottom line was the same in a lot of things. So it was nice that it started as a friendship; it gave us a broader base and it went on from there.

I wasn't surprised how Hollywood reacted to us when Tim and I did the thing at the Academy Awards about the Haitians. When we sat down no one would make eye contact; we were banned from them after that. I got letters afterwards thanking me and there were people like Robin Williams who also went forward and got chastised in defence of our right to speak, but I'm telling you if you're in a business that's about your popularity it's a very hard thing to risk that kind of shunning. Hollywood for better or worse is not political, but what I was surprised and moved about was that people like Kevin Costner and Clint Eastwood came to our rescue and started to publicly issue statements, which was really nice.

Everyone was frightened to speak out in the lead up to the war, especially being in New York through 9/11. It was so cleverly done, they made it so unpatriotic, so anti the soldiers, so anti your America, to ask any questions; not even to disagree but just to ask a question. You were seen to be undermining the troops, or a Bin Laden lover, and nobody wants to be put in that position.

I'm pretty shy actually and not that comfortable with controversy; it's a last resort for me. When all the hate talks are going on about you, they're writing things in the paper and lying about you and your kids are having trouble at school; it's not cool or comfortable – it's a very lonely, scary place. In hindsight, when you're vindicated it really isn't much of a reward, but finally I guess it's a kind of moral egotism that makes you do it, because you really don't have a choice, especially when you're visible and you have an opportunity – so you just have to say something.

I do feel though like I'm suffering from outrage fatigue. I've not mellowed, I just didn't realise how tough it was in the lead up to the war, how under fire we were and what a toll it took. Now I just feel like it's someone else's turn because people have started asking questions and there's a discussion. I think I've got to

recharge a bit and there are other things I'm dealing with that are constructive – to do with health, women, children and Aids and those kinds of things. I'm also really tired of being screamed at by strangers so I'm on a break from the really heated strident issues.

I got involved with UNICEF because I've always been interested in people and I just assumed it was my job as a human being to leave the world at least having tried to make it a better place. That started really early, even before college. Then, as I became more media connected, I realised I had a responsibility to use that before it used me. So I've never felt that I was at the mercy of being a celebrity, I've never made those complaints people make about lack of privacy, I've used all of that to try and shine a little light on problems the voiceless have.

By the time you're turning 50 you're either really in trouble or you're in pretty good shape. If you've lived your life and claimed your life then your life isn't over at 50. I had my kids really late; I had my daughter at 39 and my third child at 45.

What's remarkable about women in my generation, the ones slightly younger than me and certainly my daughter's, is that they know they don't have to choose between a career and a life. And although you don't have to have children now, you also don't have to make that decision. You can have it all; it's complicated and difficult but women's choices have got better now. When I look at my mum's generation there were so many women who just felt that their lives had happened to them and that they didn't claim their life, so now they're bitter or they blame their miserable husbands or children. I think we're choosing our lives and so I think it's easier for us to get along with our daughters without being resentful and envious.

You do feel things more deeply at this age, but I'm trying to become more porous and to just be awake in my life. I think that one of the great pluses about acting is that you have to be a great listener, you develop compassion just by being in a lot of different skins and empathy and imagination are really important and that's the rule of activism.

If you're a good actor you should be awake when you're working and that spills over into your everyday life too. Do you feel things more when you're not distracted and when you're not afraid? Yeah, and as you get older and as you survive catastrophes you can be less afraid, because somehow you know you'll get through it and the next morning you will be alright. You might be different, but you'll be alright.

My mantra is to keep moving forward, keep asking, keep questioning, keep trying to be present and awake, and to enjoy as much as you can during that process.

All the people I know who are older than I am and who I really respect, like Paul Newman and Joanne Woodward, are people that still have that fight in them, and that enjoyment of a tomato or a piece of music. They still have an enthusiasm and they're not trying to play it safe, they've learned and they don't want to keep making the same mistakes, but they're still asking questions and are so enthusiastic about the little daily treats of life.

The other thing is to remember to have fun. Have fun and know that you know you have the answers. I think that's what gets lost in the shuffle: you know who you are; you know you're powerful, you have all these options and you're busy. But you have to make the space to enjoy it, otherwise you can get carried away and miss the opportunities.

Pom Oliver

Who: Pom Oliver
When: 17th February 2002
What: Arctic and Antarctic Explorer

'Whatever age you are, do not be afraid of life. And if there are things you haven't done that you want to do, go out and do them – now.'

I've never seen myself as an adventurer, though I have always liked to travel and see new places. My brothers and I were always encouraged to do that by our parents, so I suppose it's instinctive. I still get itchy feet and every five months or so I need to go somewhere and do something else.

Not wanting to stay in one place started from when I went to boarding school at around 7 or 8 I think. We were given four pence to use in an emergency to make a phone call – only if life was awful and we were absolutely desperate. So I used my four pence and called my parents because I was so miserable and told them I'd see them soon because I was going to run away. I would have made it if it hadn't been for not wanting to leave behind the most expensive thing I'd ever bought – a bottle of Vosene shampoo which cost me seven shillings and sixpence – I wasn't leaving that behind. I put it in my pocket and tried to climb out of the window, but it fell out, landed on the ground and broke, so I got caught. I was dragged in front of the housemaster in order to explain myself when my parents arrived and were absolute heroes. They put me in the car and took me home. I had a lovely time at home for a few weeks… until they put me in a convent school.

As soon as I'd finished my A levels I went off to trek round South Africa where my two older brothers were living at the time, so I thought I'd go and see them. From there I hitchhiked to Australia where I started working in TV and Film production, right up until 1997 and I was in my forties.

It was then that I got the opportunity to do something totally different. My friend, Caroline Hamilton, contacted me and asked if I wanted to go as part of a relay team to the North Pole. Why not?

I said. The expedition was being planned through the Pen Haddow Travel Agency who were asking for women to apply to make up five teams of four to do the trip. Three or four hundred women applied and it was quite a rigorous process that took about a year before the teams were chosen. None of us had any experience but we thought the only way we were ever going to learn was by going out there.

It was a wonderful experience, if a little hairy. The Arctic is an amazing place. Because it's frozen sea, it changes all the time. It melts and shifts around, so you are always travelling on these huge great lumps of ice which don't just move they can also tip up on a 30° angle. You think you are where you were before but then you realise you are somewhere completely different. One day you wake up and you're in the Isle of Skye, the next you can be in Colorado because everything has shifted miles; it's quite unnerving.

From that expedition five of us wanted to go to the South Pole in 1999. Antarctica reminds me very much of where I grew up in Norfolk because of its big skies, I thought of Norfolk a lot when I was there. Antarctica is land and ice caps. One day it will be beautifully clear and the next completely covered in cloud. I find it very meditative there, you are just quietly walking, but it's hard work physically and mentally because you have to keep your mind alert and active. A few of us felt, while we were there, that we were being watched while we were walking, that someone was with us; it's a fantastic feeling.

Both places are just as dangerous as the other, but in very different ways. It's like sailing in many ways, one minute you can be

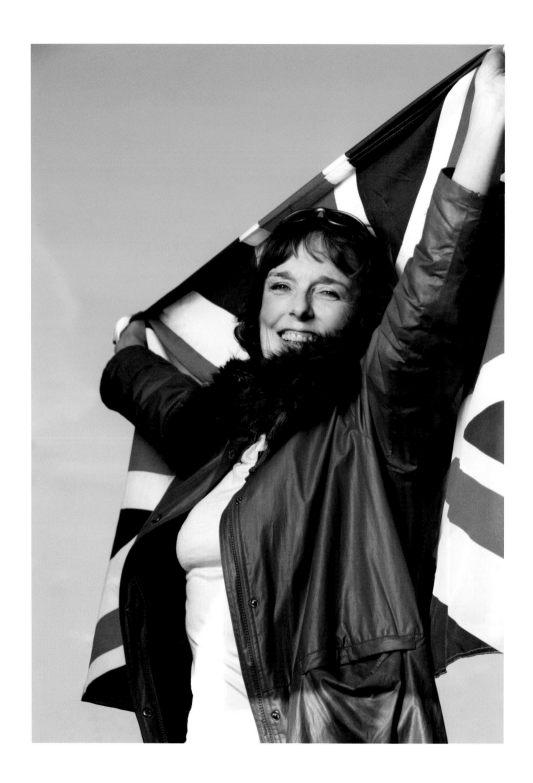

sitting there with a G&T in gorgeous weather and half an hour later it can be treacherous, but that's what I love about nature. I think out of the two I like the Arctic more, because of the way it changes.

But there is a fine line between awe and fear. On the last trip I went on in 2002 I really thought my number was up. We woke one morning and it was -53° and all we could hear was what can only be described as the sound of a train crash, a very loud shrill screeching sound which was the ice breaking. We realised that the ice we were on was splitting and that our guide was on one side of this huge crack and we were on the other, so we had to hurry and get onto the safe ice. It took us an hour and a half to get to safety by which time the wind had picked up and we couldn't get our tent up, so we ended up having to roll ourselves up in the canvas where we stayed for three days with no shelter, food or water until the storm had died down. I remember thinking firstly, how do I go about handling this, and then what on earth am I doing here?! I also remember thinking about what people say nowadays that with all the technology and gadgets anyone can go to the North or South Pole unlike when Scott did it. It occurred to me then that it doesn't matter what you have with you – gadgets, radio equipment, whatever – it is useless in that situation as no one can come and get you. You are at the mercy of the elements.

I think the thing I'm most proud of is having long term friendships and particularly being very good friends with the people I went to the North/South Poles with. This is amazing really because you do go through all sorts of stuff, so I'm very proud to be friends with them. On the last trip, which was really physically tough, I got bad frostbite and because of the difficulties of the terrain I could only manage a mile a day. So I had to decide whether to continue or not and on one of the fuel drops I made the decision to leave the expedition. I'm pleased I made that decision, though it was very hard, because I wouldn't have made it to the end which would have meant they would have failed.

I have loads of future ambitions, mainly to stay healthy and to go to all the places I haven't been yet, I'd like to ride through Chile on horseback, experience Syria and Jerusalem. Religion plays such a big part in the world that it would be fascinating to visit those places, not just on holiday, I want to do it properly. This is one reason I got into property development because it's a very transferable occupation and there's more scope to move about, or take three months out, to do what I want to do.

It's interesting that once upon a time 30 was seen as old, because many years ago people didn't live much past that age. Now 50 is seen as young. It's a long time to be alive so it's never too late to start exploring, whether it's going somewhere or just keeping the mind inquisitive. I think whatever age you are, do not be afraid of life and if there are things you haven't done that you want to do, go out and do them – now.

Sally Morgan

Who: Sally Morgan
When: 20th October 2001
What: Celebrity Psychic

'For the best insight into what my childhood was like, watch the film 'The Sixth Sense'. The difference was I was never frightened by anyone I saw, but it was just like that for me.'

I suppose I refer to what I have as an ability. I call myself a medium, someone who is in touch with the spirit world. I can trace it back to incidents from when I was about 9 months old. One in particular was when I started walking and had ventured through the wooden legs of my mum's ironing board towards the fire. Someone from somewhere, who was neither my mum nor my grandmother, smacked my hand. After it happened the second time I started to cry. My mum couldn't work out what was wrong but I was obviously being warned to stay away from the iron and the fire by someone.

It really became more noticeable when I was at school. Once, in class, our teacher was hitting this little boy with his slipper, which he called Charlie. All of sudden I shouted out, 'You're just doing that because you hit your wife this morning!' He ran straight over to me and put his face so close to mine I could see every vein in his face bulging. 'You wicked, wicked girl,' he shouted. Before he could say anything else I shouted out, 'You also threw a cup and saucer at her and it was yellow with black spots.' I was sent straight out to see the headmaster and by this time I was crying, he gave me a drink of milk and I told him what happened. He asked me how I knew, and then he said that in future I must never say it, but that I must come and tell him.

It has never really been a problem to me in my life, I've always just accepted it as something natural. It's more of a problem to others; the wart on the end of my nose I like to call it. My mum used to call it my knowing, and she used to think it only

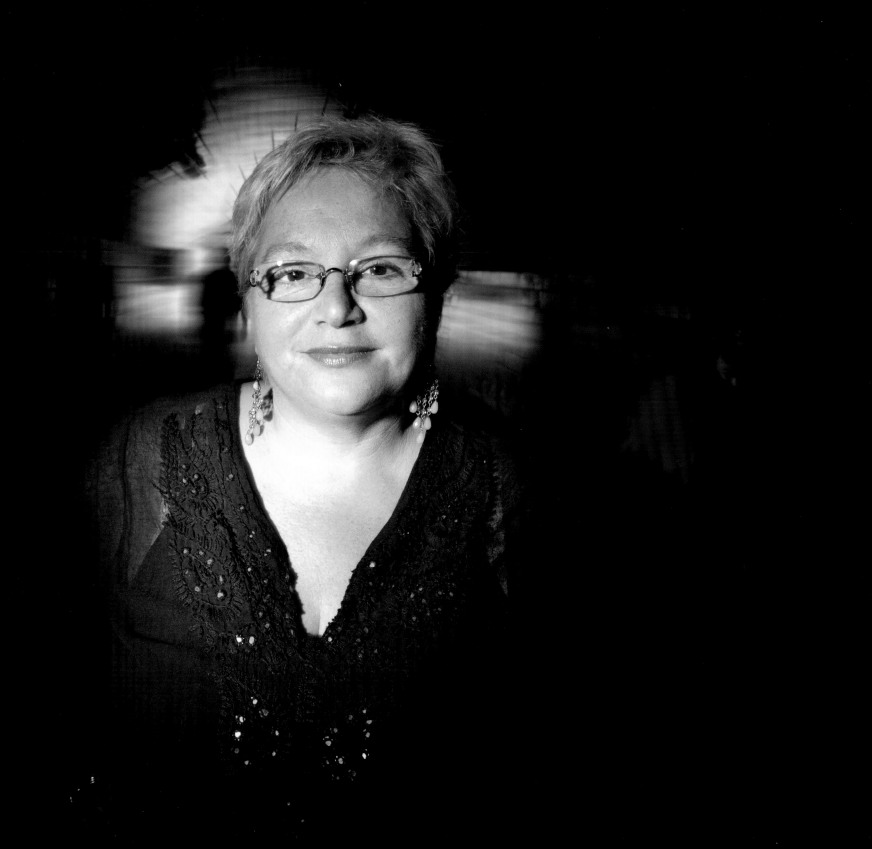

happened when I wasn't well. As soon as anything happened she would panic and think I was getting sick. For the best insight into what my childhood was like, watch the film *The Sixth Sense*. It's not as gory, you generally see people normally and the difference was I was never frightened by anyone I saw, but it was just like that for me.

I started doing it for a living about 15 years ago, really by accident and, I suppose, necessity. My husband and I owned a laundry and factory business and I worked in the factory with the other women. I loved the social side of it and sometimes during lunch I would give little readings. Well we ended up losing the business because someone stole £90,000 of our money. We were pretty desperate, it's a lot of money now, but it was our whole lives then. Then one day a wealthy Indian lady came to see me who was friends with a woman I worked with who had told her what I did and she asked if I would do a reading for her. I told her she'd made a mistake and I didn't do readings but she insisted and afterwards she gave me £20. I couldn't believe it. It went from there really. Despite getting older, my ability is exactly as it was when I was three, I can articulate things better now obviously, but nothing else about it has changed.

I was Diana Princess of Wales' psychic for four years; she was a very lovely lady, very kind. Since her death I have been in touch with her through her sister – it was to Sarah a year before Diana died that I predicted her death. I was confused to begin with because I kept hearing 'the queen' so I initially thought I was predicting the Queen's death but it was only after that, when she was known as the 'Queen of Hearts' that I realised it was her. I saw a dark tunnel, then someone giving heart massage with lots of people around and camera flashlights going off. I have no doubt in my mind that she was murdered, but I don't think the people responsible were out for her, they had no idea she would be in the car, they were after Dodi Fayed.

I think the most satisfying thing about my work is that it makes people happy; they may be sad or upset when they think about relatives or friends who have passed on but they are pleased to know or hear about them. Probably the thing I worry about most is that every day I question what I do, I believe in God and I think that what I do is not normal. So often people criticise what I do and say it is evil, but I have experienced real evil and I know I'm not it, so I can't be that bad. I do also question whether I am doing enough, could I do more for people?

There is no doubt the spirit world has shaped my life and been the single biggest influence, but I think in the last two years as I've turned 50 I've felt more comfortable and less at odds with my work; I'm happier with myself and my existence in general. I don't feel any different mentally, physically I feel fuller and heavier and when I catch a glimpse of myself in the mirror I think, 'Oh my God', is that me?!

Once you've hit 50, it's the opposite of being in decline I would say. 50 is the new 30, because we know most of us aren't going to live another 50 years so we've got to get a spurt on, we should be doing more adventures. I want to cram everything in that I want and I want to be the first to do everything, it's all a challenge. One thing I really want to do is walk across every bridge along the Thames, apparently there are over 400, so it's do-able for someone like me.

I also want to go to Antarctica, Peru and Russia, I look on life now as in decades, in blocks of ten, so I'll say before I'm 60 I want to have gone to these places and done all this.

I definitely think we evolve quicker and more often at this age than when we're young. I am more of a chameleon now than I ever was. My life philosophy is simplicity, don't complicate your life too much, it's good to remember that we reap what we sow; we create our own monsters. For so many people it's all want, want, want. I've seen people with so much excess and yet they are really sad. There are things you long for that you think you need, and when you get them they rarely make you truly happy.

I would say never settle for 'that's fine'. Never take no for an answer. Your grasp needs to outstretch your reach, always stretch yourself; set goals then push them back.

Deidre Sanders

Who: Deidre Sanders
When: 9th June 1999
What: Agony Aunt for *The Sun* newspaper

'There was a woman who had her first orgasm ever in her 60s, so definitely you're never too old to have good sex!'

Right from when I was a child I was really interested in journalism – I don't know why because it doesn't run in my family – but I was producing newspapers for cats when I was about eight years old.

I eventually got the opportunity to get involved in it when I was in my thirties, for *Woman's Own*. It wasn't a problem page to begin with – it was more practical. It was the 1970s, so it was during the development of women's rights and all the changes of legislation, that sort of thing. I had been working in production in newspapers and magazines and I remember one day talking to the editor of *Woman's Own* about the range of pressures people were under – from how to lay a table to managing their divorce. She said that what we needed to give people was advice on how to find the answer to everything. I'd done a bit of freelance writing before, but that was the first time I was actually given a writing project professionally. I just loved it and produced a guide called *How to find the answer to everything,* which covered both emotional and practical problems. That was the foundation really, because I loved the research, then I ended up being employed to be an agony aunt, first at the *Daily Star* and then, eighteen months later, at *The Sun*.

I'd always been interested in family dynamics and things – I think partly because my mother was a falling-down drunk – she was an alcoholic – and in those days nobody talked about what was going on in families. You know, I never talked to my friends. It's funny now meeting up with old school friends, now we discover what was actually going on in each other's homes. We never said anything – whereas today's kids do actually share what's going on.

My mum died when I was 24 and though I was young it did make me very conscious of how much people often suffer behind closed doors. I'm sure that was a big motivator for me to be an agony aunt. I get a lot of satisfaction from the fact that it's somewhere people can turn – it's confidential, your friends and neighbours needn't know you've written to anybody. Obviously, there are a lot of people who can find out information for themselves, but an awful lot, particularly young, inexperienced people, don't know what self-help groups exist. They don't know what structures are in place to help them and they just need someone who feels like a mate, quite informal, who they can turn to.

It was actually quite scary at first, because it felt like a huge responsibility – it still does. But I've done a lot of training with organisations like Relate and the British Post-Graduate Medical Foundation and in issues such as child abuse. I was on the National Commission of Enquiries for the Prevention of Child Abuse, so I know a fair bit about it and have had a lot of contact with survivors. I also try to make sure that my team of six counsellors does fresh training every year because it's really important to keep up to date.

I think having my second child at 42, and therefore having a teenager in the house at the age of 60, also keeps me up to date and better able to deal with some of the issues raised in the letters and emails I get from young people. It's good to be connected. I consciously do try to stay very much in tune. It doesn't mean I feel like a teenager – of course I don't – but it's good to understand what life feels like for them now. They're growing up in a different environment, certainly from the one I grew up in or

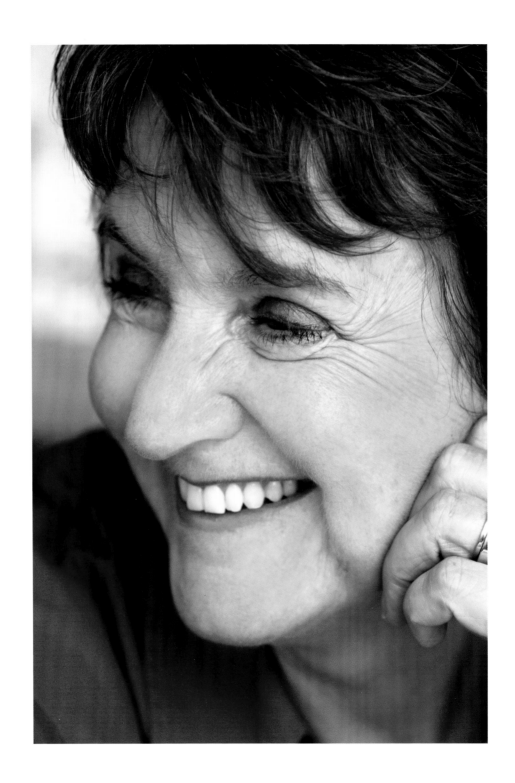

the one my older daughter, who's now 30, did. There's been a considerable shift.

I'd say in the last twenty five years things haven't really changed that much with regards to the sort of things people write to me about – in reality human behaviour changes very slowly. I didn't start doing this job until after the advent of the pill and the 1967 Abortion Act – that did change some issues. Sexually, people are just doing things younger but the changes were quite gradual actually. The thing I have seen that has made a huge difference, like nothing else in my entire career, is the Internet, which is having an absolutely staggering effect on human behaviour on lots of different levels. It's affecting how young people behave, it's affecting long-term relationships. It's been a huge change.

Things do get to you sometimes, especially where children are concerned and where you can't do anything to help. There was one man, it stayed with all of us for ages – it was a while back. He was a miner who lost his job. He was devastated by that, his marriage broke up and he lost custody of his two children, but he still used to have them at weekends. One weekend when he had the children he suffocated both of them, then tape-recorded a message to me, posted it, went home and shot himself. So we got this tape-recording after he was already dead. It was just awful, awful.

I still absolutely love the job. When you're in a team it makes a huge difference. We do offload on one another. They obviously do the initial answering then come and talk to me if they've got any doubts about things. I think sharing it and talking to one another makes a big difference. Also I have a fantastic network so if I'm not sure about something I will talk to someone at the NSPCC or whoever and say 'Look, this is the situation – this is what we think, what do you think?'. I won't go out all by myself, carrying what can literally be a life and death situation, without checking it out with other people.

There are lots of lovely success stories. Something we see a lot of is marriages when you've put people in touch with one another, which is great. Then there are babies from couples who were struggling with fertility problems who just needed some practical advice and they write and say they're having a baby and that's

lovely. There was a woman who had her first orgasm ever in her 60s so that was good, so definitely you're never too old to have good sex! There was a girl who was suffering from really bad post-natal depression. She was so bad she was actually talking about killing the baby, but we managed to get her to ring in to the helpline and get practical help. There are also lots of saved relationships which is really nice.

In general I think I've learnt a lot from this job, and one thing I live my life by is that none of us are perfect. I think just by allowing yourself to be wrong and admit to making mistakes and saying sorry is a huge thing. Men and women find it so difficult in different ways to say 'Sorry I've got it wrong'. It is hard, but it really eases the way a lot and it's such an important thing, in work situations and in relationships.

One of the things I'm really proud of is our answering service in *The Sun*. I know a lot of people have got rather sneering attitudes about the newspaper, but when you think it's actually read by something like 1 in 3 adults in the country, it's hugely widespread and does have a lot of respect for its readers. I'm just about the only agony aunt now who actually answers all the emails and letters we receive. It costs *The Sun* a fortune and there was a point where the accountants were saying 'Oh that's somewhere we could save money, we could stop answering the letters' – which is what's happened at virtually all magazines and most newspapers – but they have been totally supportive. So I'm just pleased that I did fight for it. It's a fantastic service and the readers know that, so it feels safe for them to write and they know they will get an answer.

I think what I'd like to do next, maybe, is to work with prisoners. I actually can't fit it in at the moment with a full-time job and still having a child at home but it is a project that I'm mentally putting on one side. I hear from quite a lot of prisoners and I'm really conscious of the fact – these aren't hard and fast statistics – but something like two-thirds of our prisoners have got very poor literacy and numeracy skills and I would say a good 50% suffered abuse when they were young and probably more if they'd admit to it. So you've got this huge damaged population, we bang them up in prison, do nothing really to help sort them out, then just

chuck them back into the community again in the same predicament they were in in the first place. It's appalling – everyone moans that people come out and re-offend but no-one ever actually tackles the real problem. I'm not sure whether it's going to be me as an individual trying to work in my own local prison, or if I will try to do some high-profile campaigning on the issue.

I've always had new projects. For me, I have to have something on the horizon in both my personal life and with work. I've been doing this job now for 25 years and obviously I'm really careful not to get very samey about it so I thrive on change; it's part of staying alive and being adaptable. Part of that is looking at doing new things but I also think you have to try something you can tangibly achieve.

People often say that when you age you allow your comfort zone to narrow, so you've got to keep pushing your comfort zone out. One way I decided to avoid this was by learning to drive a 7.5 ton lorry. My daughter loves horseriding, which takes a lot of input from parents, so although initially it was a terrifying thought, I've just built up my confidence and driven bigger and bigger lorries. Now I'm driving the biggest one you can drive without an HGV licence.

We were in Sri Lanka when the Tsunami struck, which obviously was completely horrific. Everything that happened around us was dreadful, but probably the only good thing that came out of it was to discover that we as a family coped and I as an individual could cope. We spent the first couple of nights just sleeping out rough, with just lights and a bit of land and I thought to myself, 'I can do this'.

I'd say getting older is nothing to be scared of; don't see it as a huge thing. In days gone by age-related issues for women like the menopause used to be a big black cloud waiting for you in life and it really isn't like that now. If you're lucky, and look after your physical health well, the energy levels don't have to drop really at all and so you can just carry on enjoying life and relationships as much as ever. I also think though that as you get older it's a good idea to find something new. It's a good stage of life to think 'Right, what dream have I never dared to tackle?' – even if it's something quite small scale, just to get on that path.

Joy Way

Who: Joy Way
When: 1st April 1991
What: Founder and Queen of the Bournemouth Chapter of the Red Hat Society

'I've always been a bit loud. My mum said that it was probably down to the fact I was born during an air raid!'

I joined the Red Hat Society after I was watching *Coronation Street* one night and my friend Sylvia called me and told me to turn the TV over to BBC1 where there was a feature about a Red Hat Society convention in the Isle of Wight. There were all these women in red hats and boas, dressed up in purple outfits having a right good laugh. I thought it looked so much fun.

I found out more information and some of the women from the craft class I go to had also seen the piece on it, so we thought, 'why not?' We set up the Scarlet Belles of Bournemouth Chapter of the Red Hat Society in February 2006.

The Red Hat Society was originally set up by a lady called Sue Ellen Cooper who one day, for no particular reason, bought a red fedora from a thrift shop. A couple of years later she read a poem called *Warning* by Jenny Joseph about an older woman wearing a red hat and purple clothes. Sue Ellen bought one of her friends the poem and gave her the red hat for her birthday. When she realised how much it made them laugh she bought the same thing for all her friends. It occurred to them, as there were a few ladies by then, that they should all go out in their red hats for tea and complete their outfits by wearing purple as described in the poem. It all grew from there.

It wasn't that life for me wasn't good before, it was. I had two very dear friends, a daughter and sister I did things with. Then, in 2005, I was taken very ill and had an emergency hysterectomy. When that was being operated on they discovered I also had ovarian cancer. It was obviously a huge shock and I cried when they told me. Then I told my husband and my kids and I said from this moment there are no more tears, they are stopping right now.

Things like that hit you between the eyes but I wasn't going to let it beat me. I suppose that's one of the things I'm most proud of in a way, that I coped with the cancer and wouldn't let it get to me. I realised I had to make the most of what I had now, life was passing me by and I had to go out and do things.

I've always been a bit loud. My mum said that it was probably down to the fact I was born during an air raid! She and my dad were the biggest influences in my life. They were always there for us, they never had very much money but they made sure that me and my brother and sister never knew that. They were always generous with their time, taking us on picnics, playing with us. Mum in particular loved a laugh, she always used to cheat at cards and you knew the one card you wanted she'd have hidden under the table. I think that's where I got it from.

I'm also a very sociable person and love going out, my husband used to be a milkman so when we'd go to parties we'd have to leave early and I would always be pleading to stay a bit longer! But he's very enthusiastic about me doing this and is always saying he's seen a brilliant red hat in a shop somewhere or a fantastic purple outfit I should have.

In the Red Hat Society we do lots of things, there are around 27 members in Bournemouth and we meet mostly once a month, sometimes more, and do all sorts like ten pin bowling, going to the theatre, lunches, parties. One thing we do more of than anything is eat, so we've decided we must exercise more too! Next year we are planning on doing the 'Walk for Life' to raise money for cancer research.

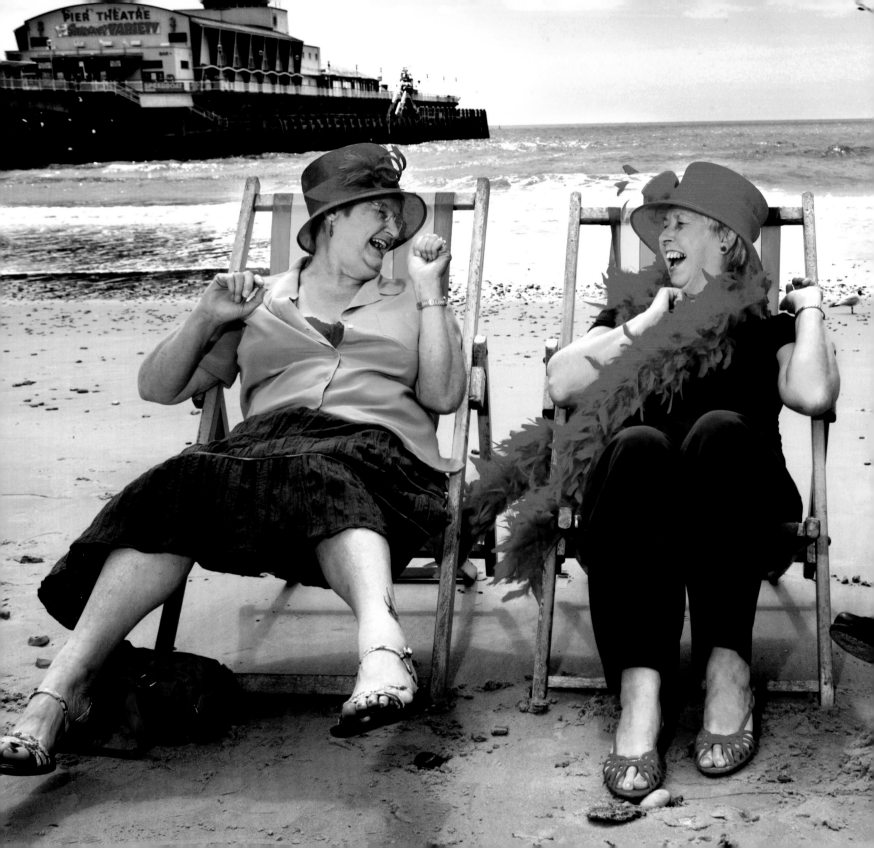

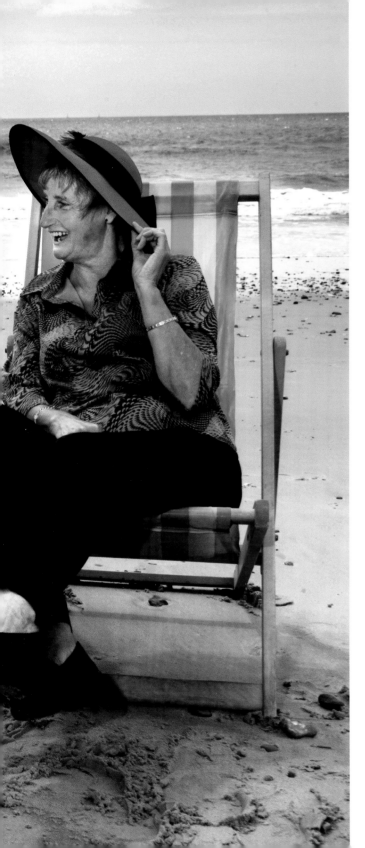

The lovely thing about Red Hat also is that you are in contact with so many women from around the world and the 'Queen Mother', Sue Ellen Cooper, sends out a newsletter each week with an update of news from all the chapters.

The other thing is that you have to be fifty or over to be able to wear the red and purple. It's meant so that you look forward to getting to that age and wearing it – a way of saying that getting to 50 shouldn't be something to dread, it should be celebrated.

When I hit 50 I was determined that despite what people said about life beginning at 40 that mine would begin at 50. So I did all kinds of things I'd always wanted to do, like going in a helicopter and getting a tattoo – I had a little dolphin on my ankle. My granddaughter calls it Grandma's little fish and tries to copy it by drawing on her ankle with felt-tip, which doesn't make me too popular with my daughter. There are so many things that I still want to do too, like abseiling. Despite my massive fear of heights I'm determined to do it. One of our ladies did a parachute jump at 74 and raised £1,000 for charity, so I think I should just stop talking about it and get on and do it.

I'm a big believer that if you think positively and try hard you can achieve anything. Don't turn into an old lady. Go out in your red hat and purple outfit and have some fun.

Elizabeth Schofield

Who: Elizabeth Schofield
When: 5th January 1970
What: Learned to read and write at 76 years old

'I was sitting in my front room one morning and I was listening to a coloured man on the television, and he said when he came to England he didn't have a penny or nothing. So he decided to go to a restaurant and wash up and save his money so he could go to college, and he became a solicitor. I thought if he can do it, why can't I?'

When I was younger, my mother and my father were both dyslexic. My father could read a little bit, but mum couldn't. They weren't brought up in the world to push me forward, all my mother did, God bless her, was work on her sewing machine from nine in the morning to ten at night to put food on the table because dad only earned 12 shillings a week. I didn't go to school till I was ten because my mother couldn't take me, it was too far, and she had to work on her sewing machine to earn money.

I've had a very dull life, I never thought I'd get married and when I did, he was in the army, and I never went outside the door for anything other than work for twenty eight years. I used to work in an aircraft factory from seven at night to seven in the morning, that was my life.

I didn't really have a happy marriage, but I'm much happier now, I found happiness when I was about 80. I was getting on so well and I didn't have anyone nagging at me. My husband tried hard to stop me reading and I would try and do it anyway at the risk of getting a slap.

But we had three children – two boys and a girl – although now I only have two. My eldest was very good at school, I made him do his homework, the other two were both dyslexic like me – they can read and write, though they aren't very academic.

One day, after my husband had died, I was sitting in my front room one morning and I was listening to a coloured man on the television, and he said when he came to England he didn't have a penny or nothing. So he decided to go to a restaurant and wash up and save his money so he could go to college, and he became a solicitor. I thought if he can do it, why can't I? I was 72.

So after I saw this man I tried college for three years but because of my dyslexia it was difficult, the teachers weren't really geared up to deal with me. Then my son was killed and I couldn't do anything, I was so heartbroken, so another two years passed.

Then, when I was 76 I went back and there was a lovely teacher called Ruth Marks and she put me right through it. She got me writing addresses on business envelopes. And she gave me a test with loads of words that were all jumbled up and I had to put them all in the right order. I passed that with 85%. It was the best thing I ever did, go to college; it's the greatest thing on earth. I've even been able to go travelling now to places I never dreamed I'd go, like America and all over Europe. I've learnt a lot of things by going to college, and I've earned a lot of things. Being able to read and write has changed my life.

Carol Bowery

Who: Carol Bowery
When: 28th February 2006
What: Headmistress, Meriton Education and Support for Young Parents, Bristol

'A few years ago if the girls at school asked if I was a granny yet I'd be mortified, but now I couldn't give a stuff; which is actually quite liberating.'

I was a bit of a rebel at school, I had a real problem with unfairness and teachers who said one thing and did another. I passed my 11+ and went to Grammar School but as you got to 16+ the teachers were only interested in you if you were planning on going to University, everyone else basically got ignored. I did my A levels but I was determined that once I left school I wouldn't do any further education, almost to make a point. I went to work at the local hospital as a clerical assistant and lasted six months. It was awful and so boring. It was probably then I realised I wanted to be a teacher.

As a child I'd always looked after people, whether it was keeping my brother out of trouble or looking out for my cousins at junior school. I suppose it was an unconscious career trait even then. I went off to teacher training college and really wanted to do sociology but ended up doing geography instead and got my first job teaching in a big comprehensive school in London. It was the year that the school leaving age went from fifteen to sixteen and I was teaching young people who were in their non-exam last year and were desperate to leave. They were very challenging kids but I was amazed to find that I could get through to them and they did what I wanted them to; it seemed the more difficult they were, the better. I'm not really sure why, but I am very honest and open and didn't talk down to them or have any airs and graces – so maybe that was it.

During my time in London I worked with a large number of ethnic

minority groups. It was an awfully unfair system, but it seemed that there were more black and ethnic children in the lower streams in the schools. Sometimes I would be the only white face in the class.

After the St Paul's race riots happened in Bristol in 1979 I decided I would return there and apply for a job at the St George's School because they wanted a teacher with experience of working with minority groups. During my interview they asked what I planned to do to resolve racial tensions there, so I felt a bit under pressure to begin with. I started teaching geography and, though I'm not sure I was a terribly good teacher of that particular subject, I was good at communicating and making good relationships with the students.

When the section of the school I worked in closed, I took the opportunity to work in a special school for children with emotional and behavioural difficulties. It was a huge challenge and I really enjoyed the first two years, but then things there got worse. I was only in my twenties when I started, so quite young really, and it was a terribly rough school. There would be groups of boys standing around and myself and another young female teacher would walk past and hear the most disgusting comments. I'm quite a polite person and come from a fairly sedate background so I really struggled with the constant sexual insults we were subjected to. We weren't sure the other teachers really understood how bad it was, so one day we wrote down some of the comments being said to us and one of the male teachers stood up in the staff room and read them out. We could tell they were shocked and would have found it difficult to cope with themselves. I even took some extra training to try and help the situation, but after another year I became very ill and my vocal chords went into paralysis due to stress. It was definitely time to leave.

So I applied and got a job at the Meriton School in Bristol and have been there now for twenty years, becoming Head in 1993. The school is purely for young and expectant mums and I mainly teach the more troubled girls and those with special needs. As well as the usual subjects, we teach them about being good parents through confidence and information, without judging or talking down to them. There are a range of problems the girls have to overcome, no two are the same and it really annoys me when young mums are stereotyped. For many, just being a mum is not the only issue they have in their lives, they may have been abused mentally or physically or have other family problems which have meant they haven't been able to join a mainstream school. Or they tend to get lost in the system and don't feel valued, nurtured or respected in the education system, so they come to us.

For many girls it may be the first time they experience and enjoy adult company. Their only other dealings with adults up to that point may have just involved being yelled at or insulted rather than being talked to and treated as an equal. We don't molly-coddle though, we let them know we have high expectations and will make their lessons as challenging as possible by getting in fantastic teachers with great skills who can bring out the best in the girls.

There have been a few girls who have really tested me. One in particular was always challenging me for some reason, so much so that I would send her home every so often for her behaviour. She would always get there, and, having thought about what she'd done, call me to say sorry and ask to come back. On one occasion she called to say she'd gone to a nightclub the night before and that when her bag was searched the security guy found a plank of wood – Lord knows what she was doing with that, I didn't ask – but she called me because she was so worried what I would think of her. How sad is that; it wasn't her mother she was scared about letting down, it was me.

After she left us she had a very rough few years, terrible things happened in her life and I was really worried about what would come of her, until she called me one day to let me know she was okay. She said life was going well and she was on the straight and narrow; enough good things had happened to her while she was with us to keep her going and give her enough of a foundation so she could get past the difficulties and get on with her life.

I get a huge amount of satisfaction from the job; obviously there can be moments of despair and, at times, particular situations that have to be dealt with very sensitively and carefully. I've also had a few scratches and bumps from breaking up fights, but I

love their openness and honesty and they are also very grateful for what we do; often you will get a box of chocolates or a card as a thank you, which is lovely.

I've learnt a tremendous amount from them, there are no pretensions and it's an extremely grounding environment. You realise how complex people's lives are and how different they can be from your own. I am always disheartened by how the media portrays young mums. They get so much negative press and yet nine times out of ten they make fantastic mums and they love their kids. Even if the child they have has special needs you will find there is something in their spirit that makes them incredibly caring people.

It's the same, in many senses, where age is concerned. For some reason society judges people on what they do and when they do it. I got criticised for having babies later in life; I was 35 for the first and 39 for the second. People also commented about the fact that my husband is five years younger than me; if it had been the other way around no-one would bat an eyelid. I've only just turned 50 and didn't really think anything of it, but my eleven year old son was mortified! I think he is quite sensitive about us getting older because both my parents died recently, so my birthday was very much played down at home. But I had a great celebration with the girls at school and really enjoyed myself; I wasn't really bothered about being 50, it's just that I find it impossible to believe I'm that age because I don't feel any different. I think actually reaching 48 and 49 was more difficult for me – being over 50 I feel far more at ease with myself. A few years ago if the girls at school asked if I was a granny yet I'd be mortified, but now I couldn't give a stuff; which is actually quite liberating.

What I'd really like to do next is progress the work we're already doing and keep on developing the curriculum pre and post 16. A main aim is to work with local employers to get meaningful work experience, improving their chances of getting a job after they leave. I'd also like to go round the country and run seminars with young mums and talk to people in general to try and change their perceptions that young mums are bad news.

I don't want my kids to grow up in a society where people are constantly being judged and taken apart because they are doing something different or seemingly wrong and stepping away from what is seen as the norm. Whether it's about age or anything else, I always try and stress to the girls I teach, and to my own children, that we should all be seen as equal, and be accepted for what and who we are, rather than trying to be something we're not in order to fit in.

One of the achievements I'm really proud of is that in 2003 we had the most extraordinary OFSTED Inspection and made it into the top 400 schools in the country, which was brilliant for the girls and the staff. It was a huge deal for them and their self-esteem.

The other thing I'm terribly proud of is being awarded the MBE in 2002. It was really all about my mum and dad, because when I left college I refused to go to the graduation. I've no idea why really, I think it was about the whole anti-establishment issue I had at the time, and probably still have. So the MBE was instead of that. I remember calling my dad and telling him to turn on Ceefax and look at the list when it was announced. When he saw my name he was so proud, that was my way of paying them back.

Alison Brading

Who: Alison Brading
When: 26th February 1989
What: Professor in Pharmacology

'The one thing I really have missed is dancing; it's the one thing my brain didn't accept so I've always dreamt and have only really recently stopped dreaming about dancing.'

I must have been 18 when I got polio because I'd just finished my A levels at school. In those days my father was building a hospital in Nigeria and I used to go out there in my summer holidays. I went out when the school term had ended and it was there I contracted polio. Eventually they flew me back to England, and the Churchill Hospital in Oxford, where they had a very good respiratory unit. I was very lucky because it was the only orthopaedic hospital in the country that took polio patients with what I had, respiratory paralysis, so I had the best possible treatment. I was in hospital for a year and a half.

All I knew about polio in those days was that you either died or you recovered and I hadn't really cottoned on to the fact that there was an in-between stage. I decided fairly early on that I wasn't going to die and so I just assumed that I was going to recover completely.

It was awful for my parents. My mother and father were married in India and my mother's first pregnancy was twins and she lost them; they were born alive but died soon after, then she had my brother and I so there was just the two of us. My brother was constantly in various trouble, accidents of various sorts, injuries from cars and motorbikes. He was always slightly unreliable and a constant worry to my mother. I was the one that was never a problem – I was good at school, she didn't have to worry about me – I think it was terrible when suddenly she did. But she was fantastic, absolutely fantastic. I thought to myself very early on that there was no way I was going to stay living at home; the one thing I would do, as soon as I could, was leave. It must have been so difficult for her to let me go and it was quite an effort to begin

with, but she let me do things and I just don't know how she had the courage.

When I went to study at Bristol University I had a little invalid car, one of these three-wheeler jobs with a sort of motorbike engine. One year it was an incredibly bad winter and there was snow in every direction and most of the roads were blocked, but there were one or two roads you could get through and I insisted on driving myself there in this little three-wheeler job. It was bitterly cold and treacherous driving conditions but she let me go, she also rang up the University, she didn't tell me until afterwards, and told them that I was on my way and warned them. I thought she was amazing.

Polio is a disease that kills your motor neurones and it's an acute disease initially so it's a bit like getting flu – you get a lot of symptoms and as a result a certain number of the motor neurones die and a lot of them are damaged. The damaged ones will recover and you can get back some function from them but the ones that die, that's it. I've got one arm that's pretty good, the other I've never had much movement above the shoulder, and with my legs, some muscles are completely paralysed, others still function. So initially when I was first in hospital I started getting around in a wheelchair and then they tried to teach me to walk and gave me a full-length calliper on one leg and a half-length calliper on the other and all sorts of corsetry and things. It used to take about three-quarters of an hour to get it all on, and then I felt terribly unsafe in it because if you fell over there was nothing you could do about it and you just fell down with a huge crash. It did seem to me at that stage that by being encased in all these things there

wasn't much chance for what muscles I had left of getting any stronger. So I came to the conclusion when I went to university that I couldn't spend all my time getting dressed up like that every day and decided to abandon all the equipment and use a wheel-chair. It was much easier. We had to move from lab to lab and place to place and all the other students on my course were tremendously good – they'd just pick me up.

I don't think it ever changed what I thought I'd do with my life. Right from when I was at school I always wanted to go into the biological sciences. I had always anticipated going to university to do zoology and I did that, being disabled didn't stop me and I ended up in Bristol which was fantastic.

After my degree I stayed on in Bristol to do a doctorate. I was always interested in how things work and I reckoned that if you were going to spend three years doing research for another degree that you might as well learn some new techniques and some new approaches. From there I went on to Oxford to work in the Pharmacology Department, where I still am, with a very famous woman, a zoologist and pharmacologist called Edith Bülbring, who headed up a big team there. It's a fantastic place. I spent the early part of my stay here just doing research and only got into teaching a bit later. There weren't really many women in that sort of area, Physiology, and the medical students in the women's college needed tutors so I got asked fairly early on if I'd like to do some teaching. I ended up, after some persuasion, tak-ing a full time job as a tutorial fellow to look after the medical students. Then a couple of years later I got a university lecture-ship, that was it as far I was concerned; I was really lucky.

I've never really felt cheated out of life but I do remember once, only once, when I realised I wasn't going to get better. There was an Almoner, as we used to call them, in the hospital whose duty it was to see people and make sure that they got home and that everything was alright. Well, the Almoner at the orthopaedic hospital, Nellie Kennedy, had had polio as a child and she walked with crutches and had callipers and things. I remember waiting for my physiotherapist to come and untie me from some bit of apparatus and watching Nellie Kennedy walk up some steps and I suddenly thought, 'That's me, I'm not going to get any better

than that.' That was the only time it suddenly hit me and I remember that, but having realised, I think it was just a case of coping.

In some ways though I'm amazingly lucky because I had a very good childhood and young adulthood – I was very athletic. We lived a lot of the time in the west of England, in Exeter, and had a lot of dances and balls and things like that and I loved dancing, so I had all that. I was a very good gymnast, swimmer, athlete, netball player; I did it all. It was great really because if I'd gone on with any of the sports, to be any good would have required an awful lot of time and effort and I don't think really I'd have ever come to anything much. But I had great experiences and I can bask on my laurels now without having to prove I can still do it!

The one thing I really have missed is dancing; it's the most extraordinary thing. It was the one thing my brain didn't accept, I always dreamt, and have only really recently stopped dreaming, about dancing. To begin with I would be sitting watching people and then somebody would come up and ask me to dance and I'd say 'Well I can't,' and they'd say, 'Oh yeah, come on, I'm sure we can help you,' and then I'd find myself dancing. It was really rather nice dreaming about that; it was quite fulfilling and quite a good substitute for me. Oh, and, of course, if I hadn't have had polio I'm sure I would have got married and had a family but I haven't regretted that either. I've had a lot of very good friends who have been men so I'm not totally deprived on that count but I've never really met anybody that I think I would have managed a good marriage with. I've got a big family – lots of nephews and nieces and cousins and I've always had children of neighbours in my life. So I haven't felt that I've needed to have any of my own. I don't think, to be perfectly honest, that I've missed out a lot.

The thing I'm really proud of is the research work we've been doing and I'm also extremely proud of my students. I've enjoyed teaching enormously and I've got a huge number of ex-students who are still friends and that's very unexpected. The research I've done – I sort of moved sideways in my research, from being a zoologist to physiology and now I've moved into an area which I suppose I've done accidentally. I got rung up by the hospital

neurologist saying, 'We've got somebody who wants to do some work on the bladder and we don't know anything about it,' and I said, 'Well I don't know anything about it either.'

I've got really interested in this – not good to talk about at meal-times – area of continence and I've done a lot of work on that in my career. We've got quite well known. We're called the Oxford Continence Group and I've had quite a large number of people working there. So I'm really quite proud of that and particularly proud because there's a British Association of Urologists and they've awarded me one of their medals. It's called the St Peter's Medal and it's given for an outstanding contribution in that field. They've never given it to a woman before and only once to somebody who wasn't medically qualified so I felt very, very pleased with that. It was very nice to have these professional people recognise me.

I never really think about my age; I always feel that old age is too good for the young. We can retire when we're 65 but I had the option of staying on to 67 and I compromised and stopped at 66. But I've still got an office at the laboratory. I stay most of the time in the department and I do bits of teaching when they want it and I've got a lot of writing and editorial work going on. It's nice not to have to work quite such long hours – a lot of academics tend to work very long hours I think because we're all trying to do about three jobs simultaneously.

In many ways my disability has been a huge help because I'm memorable. In my work everybody remembers me. Once they've seen me they know who I am and that's been a big advantage. I suppose you should take advantage of anything that you're given and I've taken advantage of my disability to a certain extent – I can park on double yellow lines for example! Basically I'm a fairly ordinary woman, I'm not really very special – it's only my circumstances that have made me different. I also like people, that's the other thing – I like people enormously. I very rarely find people I don't like and that's helped. My students have been fantastic, really they've been tremendously good to me, very faithful.

I think my main philosophy has always been to do the things that I can do, but if there's any conflict or tough decisions to be made it always seems to me that if you have to make compromises you should try and do it in a way which damages the least number of people. My advice to my students is to do what they enjoy doing, not to worry too much about the future – just concentrate on doing things that you enjoy and put your effort into that. Usually you find that things pan out and you end up doing something that satisfies you. I think it's surprising how things turn out in life; nearly always something happens and something valuable comes out of that.

There have been times I've wanted to give up but I certainly know that carrying on is much better. I'm far better when I'm doing things than when I'm not – as long as I'm useful to people. I think that's probably what gives me most satisfaction – having been useful.

Angela Baker

Who: Angela Baker
When: 24th October 1995
What: Women's Institute Calendar Girl

'If anyone had told me that I'd be in a nude calendar I'd have said NEVER!'

A group of us belonged to the Rylston and District Women's Institute and every year the National WI would ask each region for photos; things like churches, village greens, local scenes, that sort of thing. One night as we were asked for our photos Tricia Stewart, one of our group, suggested we do a Pirelli type calendar. Everyone laughed, we had a very funny conversation over supper and then we all forgot about it.

In February 1998 my husband John was diagnosed with Non-Hodgkin's Lymphoma. Again the subject came up about doing a calendar, we thought it would cheer John up if he came along and watched us all having our photos done but when we told him he shook his head and laughed and said we'd never do it.

A few more months went by and in July 1998 John died. Obviously I was devastated. All the girls got together and said we should do something that would keep me occupied during the winter months, so we decided to do the calendar to raise money for Leukaemia. One of the girls' husbands, Terry, was a photographer and he said he'd take the photos, so one night after a few glasses of wine the first seven of us had them done. It was one of those nights we'll never forget. I was really nervous about doing it, I was 54; if anyone had told me that I'd be in a nude calendar I'd have said NEVER!

I think the hardest thing wasn't telling the children, it was telling my mum and dad. I had to invite them over to dinner to break the news. I told them I'd done a calendar and mum said, 'Oh, that's nice,' then I said, 'The thing is I don't have any clothes on.' 'Oh my God!' she said. They were a bit shocked to start with but they've been totally supportive ever since.

By April 1999, we'd sold 88,000 calendars, which was double what the Pirelli Calendar sold that year. We were just amazed; it was incredible.

Then America found us and 240,000 more sold over there. We did three promotional tours, a documentary on *60 minutes* and even appeared on the *Jay Leno Show*. Then of course the film, it was fantastic, the stars that were in it, it was loved all over the world. The calendar really took on a life of its own; John would have been amazed.

Eight years on and it's still going, we're just as busy as we were, travelling around doing talks and raising money and we're doing a new calendar for 2007. It features six of the original photos and six new ones; the theme is bolder, braver and barer! We've even signed a contract with Disney to make a musical of *The Calendar Girls* which is really exciting.

The lovely thing is we're all still members at the same WI and nothing's changed, no-one really mentions it and we don't get treated any differently. The six of us have stayed great friends and carried on with the fundraising. We call ourselves the Baker's Half Dozen.

In our wildest dreams we could never have imagined it would turn out like this, our aim was to sell 1,000 calendars at £5.00 each; if we'd done that we'd have been happy. No-one had any idea what would happen. I think we've raised around one and a quarter million so far and a research and development unit at York University has been named after John, which is great for us as a family to have something so that his name can live on.

Things have moved on considerably since John was ill as far as research into this terrible disease goes, I'm sure it's just a matter of time before there are real breakthroughs in finding a cure. It may not be in my lifetime but at least I know that we've done something to try and make a difference.

When I sit back and think about it all, it's almost like it's happened to someone else, not us, and I think the thing I'm most pleased about is not just the success we've achieved but that we all still work brilliantly together as a team. Two years ago we were awarded the Pride of Britain Award which I'm also really proud of.

It's wonderful that out of something so awful, so much positive has come from it. We still miss John, of course, and still talk about him, I was terribly angry when he died, he was far too young. But since then my life has moved on and in November 2005 I got married to one of John's university friends, Charles. I was invited to go to a charity ball and my daughter said I should find someone to go with; Charles popped into my head. He went with me and it went from there. He was a great supporter of the calendar and it's nice because he knew John. I feel like we're being watched and guided, like he got us together. Charles is a vicar, though, so now I have to behave myself, I'm probably not the usual type of vicar's wife the congregation are used to! But for me, it's a real fairytale ending.

And now there are so many other things I'd like to do, I've been in a helicopter and a hot air balloon, what I really want to do is abseil off of a cliff. I might have to start small and build up to it but I'd love to do that. Also where we live we have a rod licence and I like the idea of putting on some waders, standing in a lake and fly fishing. It would be great to catch my first trout or salmon.

I must say even doing the calendar, and since then, I've never felt my age and, apart from after a day in the garden, I don't feel over sixty now. I'm just glad to have reached the age I am. I think as you get older you just have to not worry about anything; enjoy every day. If you have an idea, whatever age you are, if you have the right ingredients it will be a success, you just have to go for it and see what happens. Don't be shy; anyone can make a difference.

Barbara Robson

Who: Barbara Robson
When: 6th February 1984
What: Asthmatic Marathon Runner

'People would look at me while I was running and I'd shout, "Yes, I know I should be knitting!"'

I think my positive attitude to life and my asthma comes from the fact that I had undiagnosed twins. There I was in the hospital happy to see one beautiful baby girl come out, but then a few minutes later another one appeared! Not what I was expecting at all, so I suppose I got used to taking whatever life threw at me.

I was diagnosed with asthma aged forty four and was seriously ill with it. Tree pollen sets it off, which is obviously invisible but pretty much everywhere. I didn't realise until my mother died that she'd had it and so did my father. It's incurable but I tried everything the doctors and specialists threw at it and ended up living on steroids, but I knew there had to be a better way.

From when I was a little girl I used to run and was very good. At about fourteen when I was at a convent grammar school I regularly took part in the county and national athletic competitions. But it was when I was seventeen that I had the opportunity to be part of the Olympic Squad and we had to compete at a local school to get a place. It was the night before the race – I was running hurdles – that I realised our teacher had been coaching us on 80 yard hurdles instead of the standard 80 metres. As you can imagine the timing and technique in hurdles is not something you can change overnight so I ran the race and came third, just missing out on the two places in the Olympic team. I was devastated and when I got back to the convent, inconsolable. The nuns there were wonderful and really tried to comfort me, but I thought my life was over at that moment.

I carried on running as an adult but when I had my kids and we moved to London in 1972 I had to give up because of the children. It never occurred to me then that I could ask someone else to look after them for an hour or so while I went running. I didn't know anyone and had no family down here, so I stopped.

It was while I was trying to think of a way to combat the asthma that I decided to start walking a bit and see how I got on. The doctors said there was nothing they could do – I was rushed into hospital on a respirator at least once every few months – so I thought it was time to take things into my own hands. I'm a firm believer that if you do that you can beat almost anything and turn things around. I walked, then jogged round the block, then gradually went further and further. I joined a running club, The Metro, and thought I wouldn't be able to run with them but at least I could walk and do the refreshments. The club was no stranger to mature runners, I joined just after the jogging sensation in the 1980s had died down a bit and quite a lot of older people were members, so no-one blinked an eye that I was in my fifties.

I'm very competitive by nature so I just started running more and more, not with any particular goal in mind. I was just pleased to still be breathing so I never had any ambitions of a marathon or anything. I ran everything I could – the 100m, 200m, 400m, 800m, 1,500m, 3,000m – then a half marathon and I did my first full marathon in London in 1991. It was such great fun, the atmosphere was amazing. I did it in just over four hours which for my age and condition was pretty good.

My proudest moment, aside from being a grandmother, is that I ran the New York Marathon in less than four hours. That was my goal and I did it. I was so elated. I was sixty two. People would look at me while I was running and I'd shout, 'Yes, I know I should be knitting!'

I'm also really pleased to have inspired others to start running, I'm amazed how many people have started because they've seen what I've done with my illness and everything and it makes people believe that if I can do it, so can they.

The maddest thing that I've done so far, I think, is to run the Northumberland Causeway to Holy Island, the tide was coming in when I was doing it. When I think about it, it was a bit crazy really but great fun.

Running is something that gives you strength and confidence. The only regret in my life is that I gave up when I was young. My father did a runner and left the family when I was 28 and I'm sure I would have coped with that had I still been running. You pound the streets and realise how insignificant and small you are, you lose all your inhibitions and it makes you realise that all the worries you think you have are very small; I think there are definitely things I would have handled better if I had carried on.

I keep healthy now by doing Yoga, Pilates and running once a week. I still go to my club on a Saturday morning and help out with the refreshments. At seventy two I've done all my marathons, but I still help out at the London Marathon each year where our club has a water stopping point. My grand-children also like running with me, they shout 'Gran's got her runners on!' and come out with me. They all think I'm a bit crazy but they're very proud.

I find it incredibly sad that people feel it's time to give up doing things when they reach their fifties; I was only just beginning at that age really. That's one thing I would say, it really is never too late to start running, don't be scared. Start small and build it up, don't go mad. I think that whatever age you are the worst thing you can do is stop doing physical activity. Even if you have young children, find someone to watch them for an hour and get out of the house, that's really important. Be a doer, not a sitter. Never be a sitter. Having an illness like this makes you grateful for things others take for granted, like being able to breathe, so make the most of it.

Zandra Rhodes

Who: Zandra Rhodes
When: 19th September 1990
What: Fashion Designer

'There's nothing more glamorous than an older woman. A really older woman is far more glamorous than any man.'

I suppose subconsciously I was interested in clothes and colours and always enjoyed dressing up. My mother taught dressmaking at the local art college and she was very sort of dramatic. I enjoyed modelling in her shows as a child, from probably the age of about seven or eight, and I liked wearing the clothes. I used to love it when I got given the clothes after the show and on Sundays I'd dress up and wear them to go and visit my grand-mother. I used to have to run through the park and avoid the kids throwing stones and making fun of me because I didn't look like any of them when I was dressed up in a pretty dress and every-thing, but I still enjoyed wearing it.

My mother was probably my greatest influence, she was very colourful; definitely not black and white. I think bright colours are happy, why have it all dark? Bright colours make somewhere look happy and I think if somewhere looks happy, it's great; you're halfway there.

I grew up in Chatham, Kent, and I was there until I got into the Royal College. I loved school, I was very happy. I was a very boring child, I liked wearing school uniform and enjoyed work. I wouldn't have called myself a goody-goody and I was quite scruffy and everything but I felt that I joined in, I loved it. I liked art – it was always the one subject I came top in without trying, whereas all the others I'd come top but I had to try. I always was a workaholic so that's just carried on.

When I went to art college I didn't study fashion first of all, I thought I'd go into illustration, then I thought maybe I'd teach. But then I was influenced very much by this wonderful person called Barbara Brown who taught textiles. She said, 'Oh, you've got to go to the Royal College, I'll get you in, you just have to work and I'll tell you what you need to work on.' So I just worked and worked and got into the Royal College by doing exactly what she said. She'd set us our homework and if we didn't do it she wouldn't talk to us, so we made sure we did it.

I'm very disciplined, but my mother was extremely disciplined. She was always working, either teaching or at home, even my father, though he was a driver in the dockyards, he'd come home and be mending his bike or something. No-one ever sat and did nothing, whether it was repairing the stair rug which was in rags, or what-ever. Everyone did something.

I always assumed I'd make it. I trained and got a first class hon-ours degree in printed textiles, which I loved, but then I couldn't find people to buy the designs. At the same time I started teach-ing at Ravensbourne College of Art, I was about 22. It was the time when London's Carnaby Street was the fashion centre of London. I did some prints for Swallow and Tuppin – Sally Tuppin and Marion Swallow, who were wonderful and had this gorgeous little shop. So I did some prints for them, but I realised that the only way to get the best out of my prints was to get the clothes made myself.

I went into partnership with another girl called Sylvia Ayton who was also teaching at Ravensbourne and we put a collection together – in fact a couple of the things, particularly the printed paper dresses we did, ended up in the V&A 1960s exhibition. After that she got offered another job and I decided to put my own collection together. In the meantime, I'd met these two very exotic American models who said I should go to America and

make my fortune there. Before I could do that I had to get somebody to show me how to make dresses myself so I got a little studio of my own. I sold dresses to Britt Ekland and Sandie Shaw and then I went to America where Diana Vreeland, the high priestess of fashion, took me under her wing and photographed my dresses on Natalie Wood in *American Vogue*. They were the toast of New York and I suppose that was my big break really. When I came back to England I gave up teaching and just made dresses.

A bit later on, Norman Parkinson photographed one of my dresses on Princess Anne for her engagement photograph, I was very honoured. But I actually didn't know about it until it came out. I was told a very famous person had been photographed in my dress and I thought it was Elizabeth Taylor, and then the picture came out and it was Princes Anne and she was on the cover of everything.

I don't really have a favourite person to dress, I enjoy dressing all sorts of people as they come along. You know, it's great doing different things – I made clothes for Freddie Mercury, a one off for Paloma Picasso and I enjoy making things for Princess Michael of Kent. It's fun getting to know different people and dressing them. I used to enjoy dressing Princess Diana, she was really nice but very nervous. She'd come into the shop and choose something and then I'd go round and fit it for her. I'd be working on it and she'd say 'It's not like what you do for other people; I have to be careful how I get out of a car and things like that.' You had to make sure that if you made a dress with a slit in it, or something, that it wouldn't move too much and reveal anything. I think things were difficult for her.

Often the bit that I love most of all is after I've designed something. When you're doing it you're tied up with actually putting it on them and organising it; you're just getting on with it. It's when you see it afterwards, you know either when someone comes out on stage and takes a bow in it or when they're just wearing it and you feel so good because they look so great in it.

As different things happen, you feel great pride; I'm proud every time I manage to get a collection together! But it's not like something you live with, by the time you get it you're onto the next

thing. Though it was wonderful to get a CBE, it's nice when the establishment acknowledge you and acknowledges the work you do and see that it means something.

I'm also very proud of founding the British Fashion Museum which was opened in 2003 by Princess Michael of Kent. I sold my house in 1995 to buy the building in Newham. It took eight years to raise the money, convert the building, and then organise the exhibitions and everything, but it's great to have some form of legacy that will carry on. I hope that it will be representing British fashion for years to come and that we'll be able to make applications to get more things like this organised for the future.

I think my family are proud of what I've achieved, I'm probably the result of my mother's ambition but she never really realised it. She died when I was about 24 of lung cancer, she smoked a lot. She never knew that I went into doing my own collections. Probably my mother has been the biggest influence in my life.

My sister's quite wonderful and has a great deal of humour. Her son is a successful motorcycle racer. Somebody said, 'What's it like to be James Hayden's mother?' as if she had no character and she said, 'Well, first I was Zandra Rhodes's sister, then I was Dr Hayden's wife, so to be James Hayden's mother's not going to make any difference.'

As far as future ambitions go there are lots of things I'd like to do. I'd love to have my own make-up and perfume range, and I'd love to have a shop again. I've also really enjoyed being involved with the English National Opera, I've done a number of productions for them now and it's just so wonderful seeing all the costumes, just as you've imagined, actually on stage. But I do find most of the time there are so many projects going on at once, sometimes it's difficult to focus because a million things are happening. There are so many unfinished pieces and I hope that by the time I grow up I'll be able to sort out my life, because it's certainly not sorted at the moment!

Saying that, I think if I didn't have things going on all the time I would invent them. In the meantime, fashion isn't something that you can relax in, you have to do a collection and the collection

has to be done every season. You don't have time to breathe, you just have to get it done.

Funnily enough I didn't find turning 50 a particular landmark. I think if you're fairly happy in what you do – if you love your career and you're tied up in a million things – I don't think it really matters as you get older. I think you only notice age if you haven't got other things to do. I'm so much past 50 I've forgotten what it was like to be there, so I don't think about it. As far as being in fashion goes, to tell you the truth I don't know whether people consider me in a different way. I mean to some extent I tend to feel that I'm ageless, only because I don't have to look at any grey hair! Sometimes if I have enough time to look at myself slightly in the mirror I realise that my body changes, but I don't look often enough for it to make any difference.

I think you just have to stay on top of it, be vibrant enough and have enough going on in your life, whether it's cooking, family, whatever. For most women I think that middle period between 50 and 65 is very difficult, but once you've gone through that there's nothing more glamorous than an older woman. A really older woman is far more glamorous than any man, if you think of someone like Edith Sitwell or any of those, they're formidable.

Looking back I wouldn't do anything differently in my life, the only thing I'd like is to not have to bother about money and to have more spare time. I've got wonderful friends and I'd like to spend more time with them. I'd like not to call France Siberia. I've got about six friends who live in France and whenever I speak to them I say, 'How's Siberia?'. One of them eventually said, 'Why do you call it Siberia?' I said, 'Because I'm just as likely to get to France as I am to Siberia!'

Gillian Lynne

Who: Gillian Lynne
When: 20th February 1976
What: Dancer, Choreographer & Director

'Dancing is all about soul; you can't dance unless you have a soul and that's when your soul comes out.'

I danced around the house non-stop from when I was very young. My earliest memory is from when I was about five; because I had such an abnormal amount of energy my mummy took me to see the doctor. 'I can't keep her still!' she told him. He had a look at me and then said he wanted to talk to my mother outside. He put the wireless on in his room to keep me occupied. I remember it because it was one of those old doctor's rooms with mahogany shelves and an etched glass door. As soon as they'd gone outside I was like a little wild thing, up and dancing around, on his desk and all over the place. They pretended to talk but they were just watching me and the doctor said, 'Mrs Perk, there is nothing at all wrong with your daughter; she is a natural born dancer and you must take her to lessons immediately.'

Mum took me to a local dance class where we lived, in Bromley, Kent. Our teacher, Madeleine Sharp, was very forward thinking considering it was a little dance school in a small town, it was a very eclectic mix of ballet, mime and Greek dance. It was in her classes that I discovered that dancing is all about soul; you can't dance unless you have a soul and that's when your soul comes out. When you are dancing to music it is the most exhilarating thing in the world.

When I was twelve I won a scholarship to the Royal Academy of Dance which was a dream come true, I had wonderful friends there and our mums used to drive us there and back each day. Then when I was thirteen my mummy was killed in a car crash; she and my father had gone away for a weekend with their friends to celebrate her recovery from an ectopic pregnancy. There were three women in the car with my mum and all the husbands

had to come home and tell their children their mums had died. It was just awful; my father couldn't speak because he was crying so much and I just remember hugging him and telling him not to worry and that I would look after him. It was such a shock seeing the person you look up to, who disciplines you and is your pillar of wisdom and strength, be so shattered and sad. I remember feeling an almost sonic booming in my head at the time and it seemed from that moment my childhood ended.

It was 1939 and World War Two broke out and because my father was away in the Army no-one knew what on earth to do with me. Myself and some of the others from the Royal Academy were evacuated to a boarding school in Somerset but I was so unhappy; I was worried about Daddy, I had no mummy and no dancing. I was totally miserable. I was so desperate that I ran away and ended up at a farm in the area. They were really nice to me and let me stay with them for a week while they gradually tried to worm more information out of me as to where I'd come from. Meanwhile my father was demented with worry. He knew I was missing mum and my dancing and he'd heard of a theatre school called The Cone Ripman School and went to see them. He told them what had happened and that I had won a scholarship before, so they invited me to audition. My father said, 'If I can find her I'll bring her.'

I got in and although we were supposed to do schooling as well as dancing, I was better at dancing, one of the best in the school, so I was pushed more towards that. Lessons were kept to a minimum and I ended up with all manner of dance exams to my name but nothing academic. After mum died there was a big change in me from then on, when I danced something happened that was different from before. I knew I was good, but now it was like I was six times better than before; like I had her spirit in me.

It was while I was at the Cone Ripman School I made my debut aged 15 in *Papillion* at the Arts Theatre Club in London's West End and was just starting to get noticed by a few people. A formidable teacher called Molly Lake, who worked with Anna Pavlova, invited me to work with her at her studio in St John's Wood. She taught me the classic roles and devised many big performances for me. One of these was to celebrate the birthday

of A.V. Coton, the famous critic. It was attended by Dame Ninette de Valois, founder of the Sadler's Wells Ballet, which later became the Royal Ballet. On the strength of my performance of 'The Swan Queen' she invited me to join Sadler's Wells, which was unheard of then because they usually only took dancers they had trained. It was a dream come true for me but my aunt, who was looking after me in the absence of my father, said that as I was still in my formative stages and intensely small, thin and underdeveloped I should wait at least a year. The thought of turning this great woman's offer down made me want to slit my throat and hers. I was beside myself.

In hindsight it was the right thing to do, though it took me a long while to get over it. I carried on dancing with Molly Lake and became an exceptional dancer with all the wonderful roles she made for me and I went to every class under the sun to improve my technique and strength. Madame de Valois took me on the next year to dance at Sadler's Wells and within four months of dancing in the *corps de ballet* I got my big break and was given the chance to dance a part in a major production.

I stayed there for seven years and danced some amazing roles and, in the meantime, aged 21 had got married to a barrister. The crux came when I was chosen by the Russian choreographer Lionel Massey, who was one of the most famous in the world, for my first leading role. Madame de Valois overlooked his choice and named Margot Fonteyn, her star ballerina, as the lead instead. Madame had found out that I was married and I think she assumed it meant my heart wasn't 100% dedicated to dancing. I was heart-broken, I couldn't believe it, as someone who was intensely ambitious, I realised then that I wasn't ever going to get any further at Sadler's Wells so I left.

At the same time the London Palladium were looking to bring more dance into their variety shows and I was offered the chance to do this. It came at just the right moment and I knew I had to grab the opportunity. I was mad about dance, absolutely besotted, I wanted to know everything; I was totally alive in my outlook and thought me and my body could do anything. It was then that life really changed for me. John Redway, one of the most important Casting Directors at that time, was casting *The Master*

of Ballantrae, starring Errol Flynn. John came to the Palladium and saw me dance and I was invited to try out for the film. I was totally unsuitable for the part – they wanted a blonde with big bosoms – I was a skinny brunette but apparently I had that something they wanted. I went to Sicily for eight weeks and Errol Flynn taught me how to act. I had a wonderful time and came back knowing I needed to make some decisions.

When I think back, my husband and I should never have got married; we should have just been great friends. One of my decisions was to leave him and it was a very hard time, there was a huge rift between us, but we got over that and eventually became good friends again.

Life really moved on after that; being on my own I just threw myself into my work and success followed. The 60s, 70s and 80s were really the zenith of my career, which really properly kicked off when I was in my forties. In my first year as a choreographer I had one show on Broadway and had worked on three movies, one after the other. I went on to do eleven films eventually, one of which, *A Simple Man*, I won a BAFTA for, which was unheard of for a dance film so that was a lovely achievement.

As far as musicals go I created and starred in the first original dance show in England, *Collages,* which was a mix of jazz, music and words for which Dudley Moore wrote the score. It was a real turning point and probably led the way for shows like *Cats,* which is probably the one I'm most proud of. It was the first stage show that was choreographed from start to finish and got worldwide acclaim. As well as winning 'Olivier' and 'Molière' awards and the 'Viennese Artistic Art Merit Medal' for it over the years, which was just amazing, on another level it changed my life completely. It was the first time I'd ever made a serious amount of money and, considering I spent a large amount of my early career as a dancer living alone in a small room cooking tomato soup on an upturned gas fire every night, things could only have improved! Even when I had four shows on in the West End I still wasn't earning that much but *Cats* changed all that.

Things improved in other areas of my life just before the success of *Cats*, while I was working on Cameron Macintosh's production of *My Fair Lady* in the late 1970s. I was fifty two at the time and

had pretty much given up on any chance of finding happiness with another man but then I met a man called Peter Land who was in the show. At 25 he was twenty seven years younger than me. Initially I fought off my feelings for a long time but I knew it was something special. People said I shouldn't get involved and what was I thinking of; the only people who didn't at the time were Judi Dench and her now late husband Michael. I asked if I could bring Peter to dinner to meet them and they were just wonderful to him, Michael said after we'd gone that we were one in the same person and obviously belonged together. But it just proves you never know what will happen and, nearly thirty years later, we are great friends and truly love each other; we've been through thick and thin and are even closer now.

I was in my prime at 50 and had some of my greatest triumphs from then on. Life has been a big journey that still hasn't ended yet, I got a CBE in 1997 in recognition of my work which I'm immensely proud of and I don't want to give up yet. Though my body is starting to complain that it hasn't had a rest since it was 16 – I have two metal hips and a fused ankle now! But luckily I'm still strong and flexible for my age. My last performance as the lead in my own ballet was at the request of Princess Margaret in 1998, I was 72.

Even though I can't keep dancing forever, I can still be creative. I think everyone has to work on something whether it's creative or not; you have to have something to leap out of bed for in the morning. As you get older you can't slow down, you have to keep moving and drive yourself harder. Work hard – look after your body and face, feast your eyes on new things all the time to keep your adrenaline going and stay interesting and interested.

Doreen Lawrence

Who: Doreen Lawrence
When: 24th October 2002
What: Founder of the Stephen Lawrence Charitable Trust

'Turning fifty was a big thing for me, I couldn't even say the word; it was a big shock. I just couldn't believe I'd got to that age already.'

I came to London from Jamaica when I was nine. The first thing that struck me was that all the buildings were so close together and they all seemed to have smoke coming from the top of them. Children didn't run around and play in the house or outside, which was totally different to what I was used to in the Caribbean, where kids run around all over the place. So it took me a while to adapt and particularly to get used to the cold weather.

I never experienced any kind of racial intimidation then, either at school or in our neighbourhood in south east London, and even though mine was the only black face at junior school no one was ever horrible to me. At my senior school there was a stronger presence of black girls but again people were very friendly.

It was more when I started work that I noticed anything different; I worked for NatWest Bank, in the Clearing House in Moorgate, where lots of young teens started their working life. The line managers, who were all older than us, were in charge and we were all put to work on different floors. There were a few black people working there and it wasn't really anything obvious, but we either didn't get moved up in the department or, if we did, we didn't get paid as much as the white people there.

We'd moved to Greenwich by then and I suppose I did notice that, apart from our immediate neighbours, people weren't terribly friendly, but it was only after Stephen's death that I realised how ingrained it was in an area like that. The children would play in the street but they would play in certain groups and wouldn't really mix. Stephen had a couple of incidents at school with kids being racist and he got into a fight over it, but he also had friends who were white that stuck up for him.

On the night Stephen was stabbed on his way home I knew something was wrong, not that he'd died, but something, and once the reality of it hit I knew a part of me had gone that would never come back. At the time I questioned my own faith and asked myself why God wasn't looking after him. More so, I questioned my faith in humankind, how could people be so vicious and evil to have done that to my son.

The campaign happened, I think, within a week after Stephen's death when we realised the police weren't taking it seriously. They weren't doing anything with the information we were passing on to them and we became the ones being investigated – as a family, Stephen, his friends, the whole thing. We tried to find out exactly what was going on and got more people on board to look into and challenge everything we were told. We had to use every means necessary to bring to the public's attention how the police were treating the family, the criminal system and that rather than Stephen being treated as the victim we were seen as the perpetrators. The real perpetrators, a group of white boys, were being protected at all times. We were exposed, our car was attacked, we had people more or less watching the house, we came under siege. Nobody wanted to know what was going on. Stephen was not the only child who had been killed; he was one of a succession of young boys.

Every year non-stop for 12 years we've fought and are still fighting. There was the government, the justice system, the perception of the public out there, so many things to overcome as the years have passed, right up until the Inquiry was published in 1999. And still it goes on. In summer 2006 there was a documentary

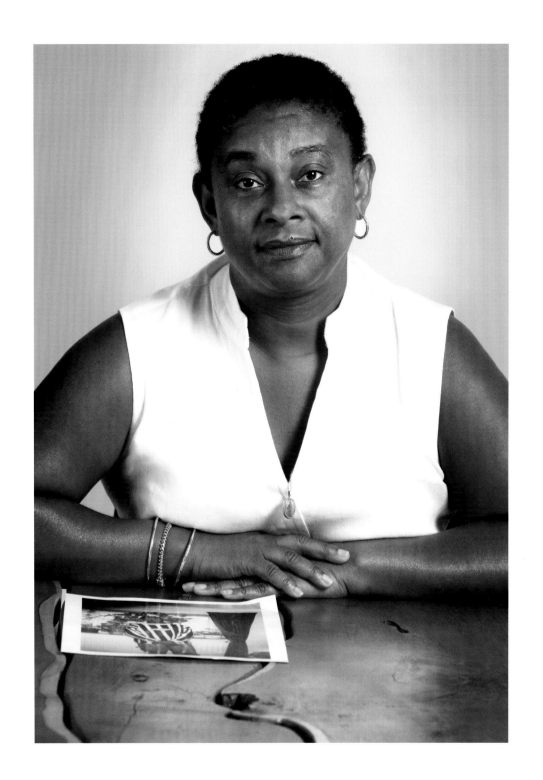

about Stephen and the case and the police said they would open the investigation again to see if any new evidence comes to light.

My dream one day would be to see the boys who killed him behind bars; it might help to change my outlook and perspective on how justice is seen to be done. I'm not as angry as I was, but then it depends what's happening; if their faces come up on TV or in the papers I want to see what they are doing. I can't be angry all the time or it would eat me up, but if something comes up about them I do think about it deeply. The fact that I know who they are and they are getting on with their lives, that Stephen is like a fading memory to them and I can't do anything about it is very frustrating. I think if I noticed any remorse on their part or even their parents' attitude towards what's happened, there could be a glimmer of hope – that they might change – but people like that don't.

As well as the campaign I wanted to do something else positive. Stephen always wanted to be an architect and when I saw that there were less than 3% black architects I wanted to do something. It's a very expensive course because it takes seven years to qualify. You have your first degree, your Masters and then a Diploma, so unless you have parents with money to support you it's very difficult to get through. So we set up the Stephen Lawrence Charitable Trust. We give out bursaries to people who have already got a place at university but can't afford to go – they have the ability but not the means. We want to motivate them and look to give them the practical support they need, whatever it is in order for them to achieve what they want in life. Stephen was denied his chance and opportunity, so it's good to try and help other young people achieve their goals and excel in what they want to do.

I'm proud to have set up the Trust and, in general, that the 'Justice for Stephen' Campaign has meant a change in race relations. This is included in all police training and the Home Office now works more with local communities rather than keeping their distance. The communities have more of a voice now. So things have changed as a result of his death, lots of people's eyes have been opened to the extent of racism and people are working to try and change things. But once it's ingrained it's hard to change people.

I still wake up every morning, hear the radio, get my bearings, see his picture and then it all comes back. I have to get up and get on with the day but it's a constant thing you have to live with – something I carry around all the time. You can't forget it or move away from it, something can happen at any point during the day that brings it all back. People stop me in the street and they know who I am, the connection is always there, which is good because it means people won't forget. The mere fact that Stephen's name is in people's minds, and they remember him, is a good thing. I think the last time I felt normal was before Stephen's death. Life is a rollercoaster at the moment and I just don't know when I'm going to get off and what normal is anyway! I go out with my family and friends and see kids playing and enjoying life – you know, mums with their kids – and I think I was like that once. I was like that, 3 children, not a care in the world and here I am now. I look at things so differently and I look at children differently. I look at my own children and my granddaughter – I spend a lot of time with her – and it's not just showing love, it's like I want to give that little bit more because you don't know what's round the corner. I think you have to make the most of what you have and give as much attention to the people you love as you can, don't take life for granted.

Turning fifty was a big thing for me, I couldn't even say the word; it was a big shock. I just couldn't believe I'd got to that age already. But you can't turn the clock back, you have to look at it positively. For women over 50 it's a time when you have something more to give, your experiences are so different. Even if you wanted to start a new career you would be able to do that. Society is so changed now that there isn't an age limit on people any more. There isn't that thing where when you reach 50 and you're looking to retire and settle down at home with your grandchildren; women don't do that now. I can't see myself waiting for my grandchildren to come and visit and being stuck indoors.

I'm planning on doing lots of things, like going off to Florida and travelling in general as much as I can and I don't think my age would stop me from doing it. I think just be yourself, grasp life as it is and aim as high as you can. Rather than sitting waiting for things to happen to you, go out and find them.

Mrs Shi Quiqin

Who: Mrs Shi Quiqin
When: 21st February 1995
What: Vice Chair, Shanghai Women's Federation

'Even when I was farming for 7 years during the Cultural Revolution I was looking forward to helping other people – it's what makes me happy, being able to help.'

I was born and grew up in Shanghai. My father was a carpenter, although he passed away when I was just fourteen. My mother worked in a textile factory and she is still very much alive at 94 years old. I was part of a big family and am the youngest of seven, with three brothers and three sisters, so our house was always very busy and full of life.

I was educated in the city but then came the Cultural Revolution in 1973 and we went away to work in the countryside. I had always liked helping people and even when I was farming for 7 years during this time in China I was looking forward to helping other people – it's what makes me happy, being able to help.

So when I returned to the city I went to work for a grass roots court, and then, in 1995 I moved to the Municipal Court as a judge, and was deputy director of the Intermediary Courts in Shanghai. I specialised in marital and family cases and I suppose I was seen as something of an expert in this field. I tried to treat every case individually and equally; I had, and still have, a real determination and duty to realise justice in society.

In 2002 I was invited to join The Women's Federation of China of which I am now Vice Chair. The Women's Federation started in 1950 with a mission to protect women's rights and interests, promote women in the workplace and in society in general. It was designed to help women not only to achieve their goals, but also, on a wider scale, to promote equality between men and women and create a harmonious society.

There is the main Women's Federation for China at a municipal level, and then each city, province, town and village has its own branch to help women locally. In Shanghai we have 3,000 women working for us. There are branches in businesses, factories, democratic parties and in the ethnic minorities. If women need help they can go to their nearest branch to talk, get advice and help with any problems they may have.

Our work in the community includes raising money to fund projects that are not Government funded; for example, we started a programme to prevent the spread of AIDS – involving the Government and community branches. We also run over 150 seminars and forums each year and are currently preparing for a forum to address various issues regarding children.

Probably the most meaningful part of our work is to unite women from all backgrounds and promote their own development. We split this into three levels to cater for the various different women who make up our society. There are the higher level women, those who themselves are in jobs that protect and improve other women's social status. The middle level is for women who are in any job, however menial, or for those who want to train to get a job. We can teach or improve their skills and help them gain cultural achievements so they can better themselves and improve their standard of life in general. Then there is the lower level, those that are suffering from illness or disaster and those who are poor. We try to integrate social resources in order to help them on all levels.

There is also a legal advice centre where women can walk in for advice and representation and we run a hotline which is manned by experts who can answer various questions. Or, if a woman just needs to talk, there are people on hand to advise and deal with

many difficulties they might suffer; marital stress, domestic violence or abuse or work problems. Many of the cases the legal people deal with involve either marital issues, domestic problems or city reconstruction and development disputes – this is where a person lives on a piece of land, or in a house, and a construction company want them to move but they don't want to. We can help in all these cases. The Federation also offers university students legal internships with them; so really we try to cover all possible areas where women of all ages might need help.

China is in a transitionary period. In the 90s people, particularly working in the textile industries, suffered redundancy and unemployment and for a lot of them it was a very difficult time. In those days many people had only ever worked in a factory their whole working lives and could not imagine or conceive of doing anything else. One of our great achievements at the moment is to lead women to change their concept of employment and change their minds about working and social development. To make them realise that they can do anything they want to do.

I am proud of many of the things the Federation and I have achieved and put in place, but in particular that they provide an arena for high level women to show their talents and develop further. Every two years there is a Women's Innovation Award presented to women working in scientific or technological fields. There is also the Women's Pace Setter Award which is given for a woman providing an excellent role model for others or those who have gained special achievements, whatever social level they may be. These awards are very well publicised throughout the country on TV & radio and in the press.

Throughout my working life I have never really thought or considered my age. When I reached 50 I was obviously physically different but in my heart I felt, and still feel, young and that nothing has changed. One of my big turning points in life was in 1999 when I suffered from breast cancer. It really made me appreciate my life and the friends around me. In a way having the disease strengthened the value of my life. I've been clear now for five years but I feel I am a better person for having been through this experience.

The majority of women over 50 in China have a stable, peaceful and happy life. Normally women retire at 55, certainly from factory work, and they may go back home to where their children have grown up and left. They have no big economic stress; they can enjoy social security facilities and enjoy life after retirement. Others may go and work for the Government and some come to work for the Women's Federation.

It is at this age that a woman's skills and experience can come to fruition and they still have lots of energy. Many companies need and desire this mix of experience, skills, wisdom and enthusiasm.

I am a very optimistic woman and my aim is to be happy every day. I love my life; it has been far more than I expected. I want to do everything well, to do my job well and if I suffer setbacks I want to be able to face them, deal with them and have a happy balance between my work and my family. As a woman it is not so important to achieve, but to have something there to support you mentally and help you push your life and work forward. That's enough for me.

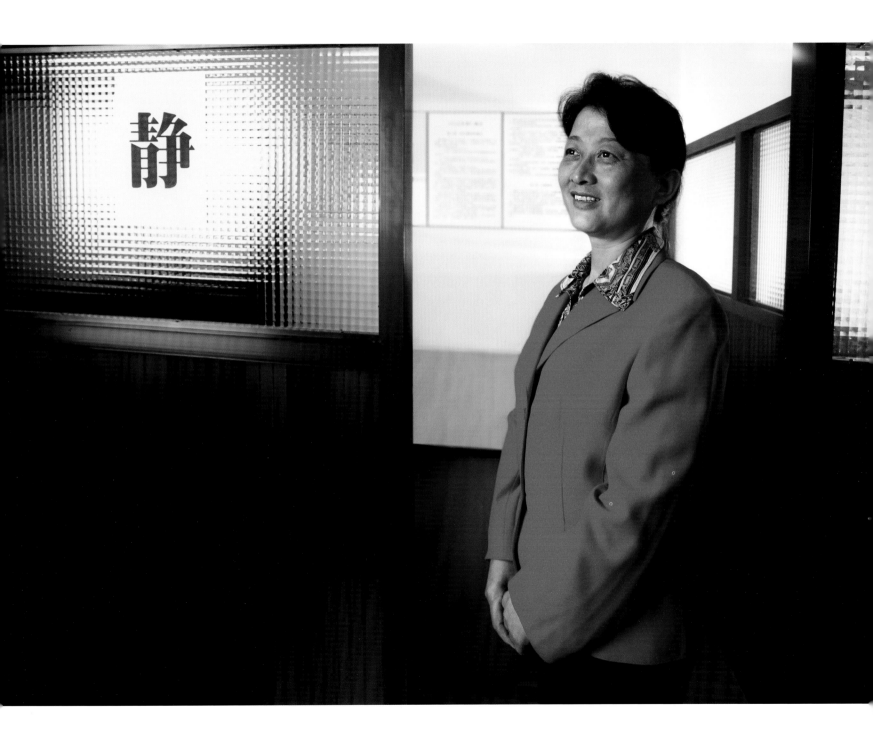

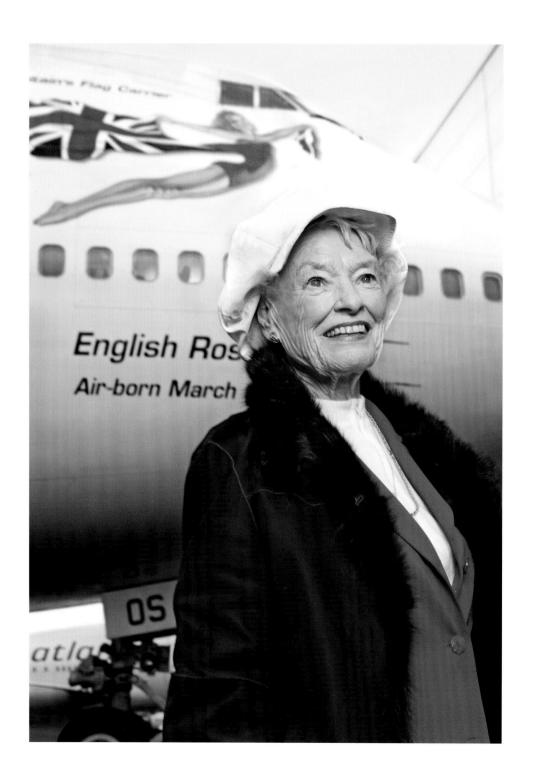

Eve Branson

Who: Eve Branson
When: 12th July 1974
What: Adventurer & Richard's Mum

'I could hardly turn down the chance to go into space. Of course, I'm a bit scared up to a point and the rest of the family think I'm mad.'

I'm dyslexic and the one thing I always wished for was to be more intelligent. I'm trying to learn French at the moment and having a terrible time! But I suppose you can't wish for what you're not born to have and instead, when I was a girl, I had dancing. Even though the teachers looked on me as a bit of a joke, I managed to be popular with the other girls because I could dance. When I left school I trained as a ballet dancer and danced in a few shows, but then war broke out and I was desperate to get involved. So I pretended to be a boy and learned to fly a glider so I could teach boys how to fly. That was my contribution to the war effort at the time and then I joined the WRENS.

My job was as a visual signaller at the end of Yarmouth Pier, flashing signals to all the boats. I was out in the open air either all day or all night and I loved it. I fell madly in love a few times when I saw a dishy sailor through my telescope, it was all terribly romantic.

Once the war was over I decided to carry on dancing and went to audition for the Rambert Ballet School. I did my audition in my WRENS uniform bell-bottomed trousers, much to the amusement of Madam Rambert who took me on more out of humour than anything else. But I didn't really want to be there, I wanted to be travelling so I lied about being able to speak several languages and got a job as an air stewardess. Back then though it was a lot different; the planes that were used were old war planes converted to take passengers. They were not pressurised so air sickness was par for the course. The other problem was the planes had a real habit of crashing, so it was a bit dicey. Aside from that it was very exciting; it would take weeks to get to America, for example, because we would go via so many other wonderful places.

It was then that I met my future husband, an ex-army major, at a party; I won his heart by offering him a plate of sausages. After a particularly bad month at work where I'd seen one plane crash behind my aircraft and one in front, he decided I had to stop doing that job before it was my turn. We settled down and while he studied to be a barrister I set up a studio in the garden and made sculptures and other *objets d'art* to earn some money.

Nine months after we got married we had a little boy, Richard, and later on, two daughters. Richard was very much like me, a bit of an adventurer and always up to something. One day on the way back home from Devon to where we were living in Shamley Green in Surrey he was very fidgety in the back so I said, 'Why don't you see if you can get the rest of the way home across country?' Of course, he jumped at the chance, he was only five. A few hours later we were quite worried until a local farmer called us and said, 'I have a little boy with white blond hair here, is he anything to do with you?'

When the children were growing up I had a variety of jobs. I was determined not to get stuck just doing one thing, I worked for the Red Cross and then was put forward to be a Justice of the Peace. It was only for one day a week but I came across such a mix of people; it was incredibly interesting.

In the meantime Richard was busy doing his own thing, and whereas his father saw what he was doing and let him get on with it, I wasn't always in agreement. When he took a job as

manager of punk band 'The Sex Pistols' though we were both horrified. But we had to make sure we didn't pull the reins too tight either way and give him the space to make his own mistakes, and there were times when he was almost as good as in prison; he was a very colourful teenager.

When Richard came up with the idea of starting an airline no-one ever believed it would get off the ground, and it was a huge challenge coming up against companies like British Airways. But I'll never forget the inaugural flight to New York on his first plane, with all the press and media on board. It was a wonderful atmosphere and very exciting. He had a free bar on board and, of course, the media chaps were queuing five deep at the bar and there was such a crowd that the pilot had to tell them all we were heading into some bad turbulence to make them all sit down. There were stories that the female insignia on the Virgin planes is supposed to be me. Let's just say I was a lot younger then, but no one really knows if that's true or not!

I am so proud of what he's achieved, I know he's done lots of things for publicity, but he also does many good things and is giving back so much.

One project of Richard's I am involved in is called Virgin Unite which started in Morocco. I go over there and teach the people to make things to sell, which can be arts and crafts or whatever, and all the money goes back into their villages. The eventual aim is for Virgin Unite to run all over the world which would be amazing.

Life has just got better and better since I've got older. I think of life as a piece of cake cut into four pieces; childhood, youth, middle age and then 60 onwards. That last bit of cake is the one you have to make the most of and work on enjoying every minute of it. I'm concentrating on writing my autobiography at the moment and, having just hit eighty, I'm also working on a book about the art of being over 70!

My next big adventure is to go up in Richard's first civilian space flight. My grandson Ned is running it and, though it won't happen for a couple of years, as the mothership of the family I could hardly turn down the chance to go into space. Of course, I'm a

bit scared up to a point and the rest of the family think I'm mad, but unless you do these things you never know; and it means I have something really exciting to aim for.

Jane Russell

Who: Jane Russell
When: 21st June 1971
What: Hollywood Movie Legend and Founder of WAIF/Operation Children

'Getting older does mean you can say and do what you want, but then I think I always did, that's the trouble; I was a bit feisty.'

I have thought back over my life and everything that happened to me I would call one of God's accidents, because I wasn't planning to do any of it. My mother had been an actress so I had already decided I didn't want to do that. I didn't want her telling me what to do – I was a very independent, nasty kid, you know! So mother looked at my school report card and said 'Well dear, it's art, music or drama, just don't worry about the maths and science.' If I'd been good at maths I wanted to be an architect, but it was not to be, so I decided I wanted to do designing; clothes, houses and whatever else.

I went to Los Angeles from where we lived in the San Fernando Valley armed with a cheque from my mother to go to design school, but I turned up ready to join mid-week and they told me to come back the following Monday. So I started on my way home and remembered that my best friend was due to start going to Maria Ouspenskaya's drama school, and I thought I'd drop by and see how she liked it. So I turned up and she wasn't there yet, and kids were walking by with their plays under their arms and talking and everything, and I just thought 'wouldn't it be funny if I was in class when she got there!' I knew my mother wouldn't mind so I went in there and gave them the cheque and joined the drama school just to surprise my friend – it was a bit nutty I know.

While I was there, one of my friends who was working in a coffee shop on Hollywood and Vine had met Tom Kelly, a really good photographer who asked her if she would like to come by his studio and try doing some modelling. She was a bit wary so asked if she could bring a friend. He agreed and, as I was the only friend

she had with a car, I was asked to go. Tom photographed us and we both ended up working with him, but he was very protective over us because he knew we were very young. So when an agent friend of his came by and saw our photo on the wall and asked who I was, Tom said, 'Now don't you worry about her, she's a nice little girl from the Valley, you silver fox, so forget it!' While Tom wasn't looking the agent went over, swiped the picture off the wall, put it in his briefcase and left.

He was scouting around the studios at the time and when he got to Howard Hughes' office, the casting director said 'Well she looks the type, because we're looking for a half Mexican and half Irish girl' and asked if he could bring me in for a test the next week. Well, of course, the agent had no idea even what my name was so he had to go back to Tom and ask him. That's how I ended up with the part in *The Outlaw* along with Jack Buetel who was one of the boys. My mum was delighted; she said she had picked my name because she thought it would look good in lights.

So we set off to make *The Outlaw,* but neither myself or Jack had ever made a picture and we really had no idea what we were doing. Howard Hawks was supposed to be the director – he was the one who did all the screen tests and casting – but when we went out on location every morning Howard Hughes would send Hawks a memo or call him on the phone and ask him to change something or do this or do that, and you just don't do that to Howard Hawks. He finally lost his patience and said 'Howard, why don't you direct the picture?', and promptly got in his plane and left. About a month later Howard Hughes decided that he would

direct the picture after all. He was a very polite, quiet, shy man, and while he was a genius about mechanical things, especially aeroplanes, he didn't know how to tell people what he wanted. So he would say, 'Well now Jack that was very nice but you raised your left eyebrow and so next time if you could just not do that…'. Well, pretty soon both of us were just like wooden dummies, we didn't dare do anything! It took nine months to make that picture but, of course, because I'd never done it before I didn't understand that movies could be made any quicker. When I got to do *Son of Paleface* with Bob Hope when I was nineteen, it only took eight weeks – I thought I'd died and gone to heaven.

Being in Hollywood at that time was very good. The head of the studio was the boss, whereas today the agents are. The studios were like your home away from home, you knew all the crew and publicity people and that you belonged to that studio. If you were loaned out, you just went to another studio which was their home away from home. For instance, I never worked at MGM so I never knew Lana Turner or Judy Garland or any of those kids, and I lived in the Valley so I wasn't partying with them or anything, so I never met them until much later when we were through working. You only knew the ones in your own studio, or who you actually made a picture with.

I think the best movie I ever got to do was *Gentlemen Prefer Blondes* because Howard Hawks was the director and Jack Cole was the choreographer. Cole was one of the first choreographers to do wonderful things in films and was a huge inspiration to others and, because neither Marilyn Monroe nor myself had ever danced before, he really had his work cut out. Marilyn had also never sung, I'd been singing for some time but she hadn't, so the piano guy, Hal Schaeffer, taught her to sing and even though she was learning to do all these things from scratch she was great in the film because she worked so hard at it.

Marilyn was a very nice, quiet, shy gal; she was also determined she was going to be a success and would work with her acting coach night and day to get better. But she was also very sensitive, and when Howard Hawks said that her coach wasn't allowed on set anymore, because every time she did a scene she would look at him for feedback instead of Hawks, the coach was sent off set and

Marilyn ran to her dressing room crying. On another occasion Tommy Newnan, the guy that was playing Daddy, had a kissing scene with Marilyn and one of the guys went up to him and said 'Well now you have just kissed Marilyn Monroe, what was it like?' and he said 'It was like, like – being swallowed alive!' Again, she ran to her dressing room crying. I would have said 'Buddy, you should be so lucky', you know, but she was just very shy and sensitive; probably too sensitive for the movie business really. I didn't have much contact with her after that as she went to work more in New York, but she was a lovely girl and made some wonderful pictures.

Turning fifty in Hollywood wasn't really a big deal. Of course, looks were a big thing there and I always tried to look as good as I could but it wasn't something I worried about; although I was still in shock at being that age. At that time though the studios were in chaos, everything was falling apart and the agents were taking over, so it was totally different from when I worked for them. I had also started off in another direction by then, towards Broadway.

I had singing dates in nightclubs and did some plays, and on my fiftieth birthday I was actually in New York doing *Company* which Elaine Stritch had done. She and half the company were going on tour with the show so the other half had to be replaced. The trouble was on that first night we'd only had three weeks rehearsal and all the actors who had made such a success of it were in the audience, so I was absolutely terrified. I wasn't sure I'd get through it but I ended up doing the show for six months. I was pretty pleased to have actually managed to pull it off.

The thing I'm most proud of in my life, though, was nothing to do with acting or showbusiness, it was setting up WAIF. My mother always used to say if the Lord wants you to go to work on something he'll rub your nose in it so that you know what's wrong and what to do about it. Before I was married I had an abortion and I nearly died. It was a horrible experience. They had to haul me into a hospital for a while and it was a close call so I couldn't have any children. For me, having grown up surrounded with such a big family, to be married and not have a family of my own was ridiculous, so I decided I was going to adopt.

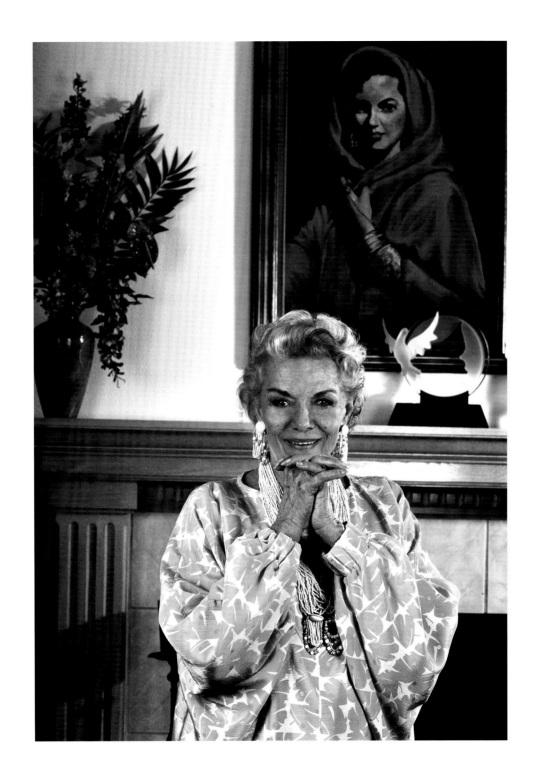

I got my daughter, Tracy, when she was six days old and she was born on my birthday so she was an amazing gift.

But I wanted her to have an older brother or sister, so I went to the adoption agency and they told me they only placed babies and I'd have to wait two or three years. I had no intention of waiting that long so I ended up going to Europe. I took my mother to France with me and we went to an orphanage and I saw what must have been about a hundred children sitting at tables. They were just playing quietly with their tin toys in front of them and the nuns walking around. The kids were so sad, you know there was no fun or laughter and I thought it was terrible. But you had to be French and a catholic to get a child from there so I went to Italy and found the same – every place I went I had a very strong feeling I was being led by the nose and shown all these things. I knew how many people in the States were trying to adopt children and couldn't and yet there were lots of older children there like I'd seen in Europe who were orphaned and without homes.

So I went home, thought about it and came up with the idea for WAIF and then set about raising money to get it started. I began bringing kids over from other countries and when the agency saw what we were doing, and realised there were older children all over the States who could be adopted in this way, they agreed to help. WAIF grew from strength to strength for forty years and from being just based in LA we then had chapters all over the United States; San Francisco, Hawaii, Chicago and New York. We've placed around 51,000 children since we started and although the name has changed to 'Operation Children', it's still going strong and they are still doing the very same thing.

Without a doubt my mother was my biggest influence, she was so calm, I'm not sure how she did it really. She never yelled at us, she just let us get on with it. Even when we were being horrible, shouting and playing up she'd just say, 'When you've thought about this you'll come round.' And she was always right, she was so wise. She used to say, 'There's a long haul in front of you and it's all doors. You go along and knock on each door, if the door opens you go in, if the door doesn't open that's not where the Lord wants you to go.' I think that's why I wouldn't give up trying

to adopt my second child, I knew if I knocked on enough doors one would eventually open.

My outlook now is just the same. Of course, I'm getting older and my ears and eyes aren't what they were, which is really annoying, but aside from that I feel just the same. Getting older does mean you can say and do what you want, but then I think I always did, that's the trouble; I was a bit feisty.

I think the most important thing in life is having good friends around. I have lots of friends and I'm not sure what I'd do without them. I still see people like Debbie Reynolds and Esther Williams. Of course, a lot of them I'm losing too, but I still feel like they're around. We had a lot of fun making pictures, we really did. It was about the people who were doing it – maybe the pictures stunk but we were having fun.

I had lots of wonderful friends, Carmen my stand-in, she was lovely and so many others like Robert Mitchum, Clark Gable and Vincent Price. Vincent, I called my big brother, we were both Gemini and were very similar in lots of ways. Of course, he did a lot of horror movies and he did have a serious side, but he was also one of the funniest guys I was ever around.

One of the things I've really enjoyed recently is that David Gest came up with the great idea to get all the older movie stars together and put us on a plane somewhere and have a big dinner. One night all of us have dinner together and then the next night there's a big charity event where each table pays for one of us to sit with them. It's really great fun and raises a lot of money, it also means we get to spend time all together, which we wouldn't normally do because we don't live near each other.

I'm still singing and touring now as much as possible, we just did a show down in Sureto and have others lined up. When we tour we play all the music from the 1940s and all the older people flock to see us because they love to hear that kind of music again, it's really wonderful.

Patricia Warren

Who: Patricia Warren
When: 14th September 1996
What: Founder of the Country Bureau Matchmaking Agency

'The most astounding thing is that I couldn't ever imagine writing a book any more than I could imagine climbing Mount Everest. But I did it.'

From when I was very little I knew I wanted to spend my life on a farm. My parents didn't own one but my grandparents did, so I spent my school holidays there and I adored it. My father had a small factory business specialising in hardening and tempering surgical needles, in Redditch, which was a really small industrial town where everyone knew everyone else. It was a nice place to grow up and good to have the two different environments but I clearly remember sitting in a field near my grandparents' farm thinking 'this will be my way of life'.

Like a lot of girls my age I didn't really know what I wanted to do when I left school, so I went into nursing. I wasn't ever a particularly dedicated nurse but looking back I think it was the best grounding a girl could have. It teaches you discipline, it makes you work hard, you have to get up early and most of all you have to get on with people – empathy is really important.

I'd never really seen myself as a career woman, I thought I was more suited to a domestic environment and when I was 21 I got married, but sadly it didn't last. It was a good marriage but I had always imagined that from early on I would be a mother and have a brood of kids running around. We tried and tried to have children but it just never happened and I suppose the reason we split up in the end was because of the stress that I could not become pregnant.

After seven or eight years the stress just got worse and ultimately my husband started to make a life for himself elsewhere and as happens in these situations he met someone else. He came to me one day and said he was having an affair and that the woman was pregnant. To find out your husband is having an affair is a

big enough blow but that she was expecting a baby, which I could not do, that was a double whammy; I was devastated.

It took me a long time to get over, but I used the fact I was alone to my advantage and went travelling around Europe and the Middle East. It was around the time when the Shah of Persia was being deposed, the revolution was starting and westerners over there were in the firing line, so I got out and came back to London as soon as I had the chance, but it was a good experience and the time away was just what I needed.

I was determined I still wanted to have a life in farming and wanted to become a farm secretary or something, so I applied to agricultural college. I had to wait a few months before the new term started so I went to do some temp work in Staffordshire. It was while I was there I happened to go to a farm show and met a man while I was sheltering from the rain. We got talking and he asked me out and after we'd been out three times he proposed! I said no to begin with but after a while he ground me down and we got married four months after we met.

He owned a farm and I settled down in my new role as a farmer's wife, it was just exactly what I wanted and was a real challenge keeping up the standards his mother had set. I tried to follow in her footsteps as much as possible. Farmer's wives in those days were very traditional, you were responsible for the upkeep and cleaning of the farmhouse, cooking food for the family and the farm workers, if it was a dairy farm you would have to clean all the implements and some would be expected to do manual labour; it was hard work and the day began by getting up at 4.30am every morning.

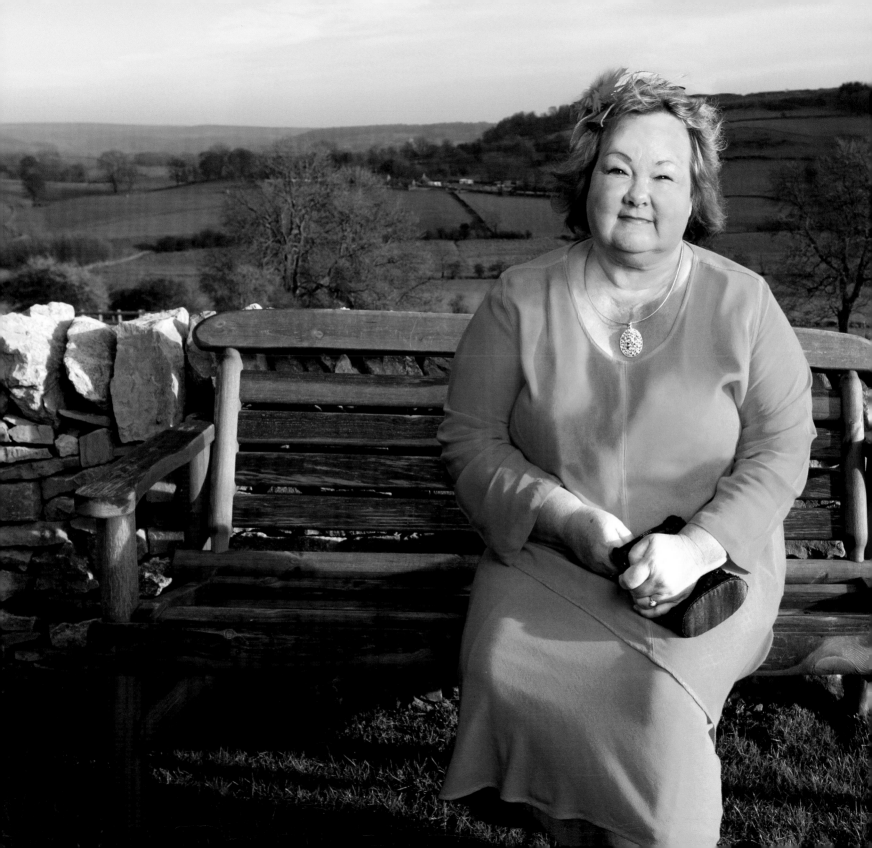

After the first year I was desperate to have a family, but once again nothing happened. I had to come to the conclusion it was down to me. I had told my husband John before we got married that there was a possibility I couldn't have children and immediately said we would adopt if that was the case. I had a fertility investigation and the doctor said I should go away and find something else to do that was interesting and would take my mind off conception.

When I was about 9 or 10 and was still playing with my dolls I had always been interested in matching them up with each other, I was a bit of a romantic, even at that age, and I thought why don't I do that with farming people? I hadn't seen anything like that anywhere else so I put a business plan together. My husband was a bit sceptical that farmers would actually respond to anything like that, but I thought I'd give it a go. I launched it around the beginning of 1982 very conservatively, advertising it in farming magazines as a nationwide introduction agency for the farming community. Amazingly people started phoning, so I filled in registration forms and did interviews with them and within a month it was up and running. After a year I had to set up an office within the farm and hired a secretary.

It was incredibly satisfying when the very first couple I successfully matched got back to me to say they were getting married. It was wonderful, they were both from East Anglia and sent me some photos of their wedding day. He arrived at the church on his horse and after the ceremony they both left and rode to the reception on horseback, the bride in her beautiful white dress draped over the back of the horse, which was decorated with white ribbons. I was totally spellbound by this image and knew I'd found my destiny. It gives me so much happiness back, to know that every bit of work you do is worth everything, because you're making people happy.

After 5 years I was employing 3 secretaries and there were marriages happening all the time and people were sending me pictures of their children. After 10 years we'd gone up to 5 staff and had a stand at the Royal Show. It was wonderful because I had this lovely stand where people could sit and have a chat and a drink, and all these people kept coming over to see me to say hello and thank

me for introducing them; it was probably the happiest week of my life.

There have been a few funny stories usually involving gruff Yorkshiremen who, quite often, never have contact with women. They are dour and introverted and very masculine. They just want a wife to provide a son and heir, so I have to explain that there's a bit more to it than that! But despite their harsh exterior I always find them to be so kind and gentle, they are lovely people.

Matching people on the Faulkland Islands was a real experience; it's just so remote, it's very difficult for them. One man stuttered an awful lot and was too nervous to phone the woman I'd matched him with, so I suggested writing to her but he couldn't write, so I said I'd write the letters for him, not really thinking it would work. They are now celebrating eight years of marriage.

A few years ago I was thinking about some of the lovely stories and decided to start writing them down – I didn't want to forget any of them. I said to my husband when I'm eighty I can go back and look through them all again. But he suggested they might make an interesting book – it was my turn to be sceptical! But I forwarded it to the farmers' publishers Potter and Stanton. They snapped it up and the book *Tales of a Country Matchmaker* came out and was really successful. Then I was given an advance and asked to write a second one, *More Tales from a Country Matchmaker – A Hard Day's Work*. It was just amazing; the most astounding thing is that I couldn't ever imagine writing a book any more than I could imagine climbing Mount Everest. But I did it.

Now the Country Bureau is in its 25th year and, though the criteria has changed slightly – it's not just exclusively for the farming community now, but for anyone who lives in the countryside – it's still thriving.

As for the family I always wanted, I never did end up being able to have children myself, so John and I adopted a child who then tragically died in an accident when he was five. It took us a long time to get over the loss and so when we were ready to go for adoption again we applied to the agency and they said that, because by this time I was 38, I was too old to have a baby and would have to adopt a child of around 10 or 12.

I was so sad, ever since I was 21 I had wanted a family. Then one Sunday afternoon I was sitting listening to the radio and I heard a feature about a lady who went to a third world country and adopted a baby. I looked into it and contacted an agency in Salvador, went over there and came back with a beautiful son we called Ben. Two years later I went back to the same place and adopted a little girl, Sarah. It was just lovely to have two healthy happy children in the house and the family I'd always dreamed of.

I suppose I started a bit late in life, I am probably more than ten years behind everyone else but it doesn't matter to me. With the business going well, a wonderful husband and young family, when I reached 50 I was just thrilled to have got there and been so happy. My husband arranged a fantastic 50th birthday surprise for me. He said he was taking me out to dinner with the children, drove me up to the top of our village hill and suddenly the church bells started ringing. He said, 'That's for you, Happy Birthday.' Then he took me to a huge surprise party with all our friends and relatives; it was just amazing for him to have organised all that.

I think now I'm having the busiest time of my life, 60 seems to be even more incredible than 50. There's so much I still want to do and experience. In many ways I feel like I'm starting to relive a life. My children are grown up and independent and I can lift my head up from my responsibilities and feel that the world is my oyster.

Janet Hearn

Who: Janet Hearn
When: March 13th 1989
What: Médicins Sans Frontières Nurse

'I want to carry on until I dement. I've told my managers in Cambridge that the day I come into the office naked they'll know it's time to send me to Occupational Health.'

When I was four I spent some time in hospital. I can remember at the time actually thinking, 'Yes, I'm going to be a nurse', then throughout my school days we were told a lot about Albert Schweitzer, a doctor who had devoted his life to helping the people of Gabon. I admired him greatly, so after that my aim was to work in Africa one day.

I had always planned to do it, but knew it would be after I'd had a career in nursing over here. I did my training and then worked at Addenbrookes Hospital in Cambridge, during which time MSF was founded and I knew it would be just perfect for me. Once my children were grown up I left Addenbrookes and joined MSF in 1999 when I was fifty nine. I had already spent a year away in a town in South Africa as a specialist nurse in HIV and AIDS and as a trained counsellor, so I had some preparation for what might lie ahead. The reason I chose MSF was because it was different from any other humanitarian organisation. It was founded in 1973 by French doctors who'd been initially working with the International Red Cross but they wanted to start an organisation that would have dual responsibility; saving lives and easing suffering to populations in distress wherever they are in the world – but also *téminage*, the French word, to bear witness and to speak up for people who are powerless and voiceless.

When the world doesn't want to hear, or when other governments don't want to know what's going on, we take press releases from people and, after very careful consideration, speak out. We did so with the genocide in Rwanda – although we were then asked to leave the country, everything came out in the open after that so it felt like we did something to help.

I've been on seven missions so far, and I couldn't pick out one that has been worse than the rest; one can be just as dangerous or heartbreaking as another. My first was in Northern Kenya, Bucea on the Ugandan border, where 35% of the people had HIV. Another was in Mandoa in Northern Kenya where Somali people kept being pushed over into Kenya fleeing for their lives – women and children – that was horrendous. In 2003 I went to Balay, Southern Ethiopia where the Ethiopian government relocated many people into unexplored bush and the children were dying with cold. There were no roads, no infrastructure, no medicine, no food; they had nothing. Then I went to Nigeria in 2004 and there was a massacre where Christian groups were attacking children. So really it's hard to say. You can't say one situation is worse than another – it might be twelve people in desperation or it might be 200,000.

Obviously there have been times I have been afraid. Probably the most scary mission was in 2005 when I went to Angola and came up against the Marberg fever outbreak. Marberg is similar to e-bola, it kills, it's a haemorrhagic fever, we don't know where it comes from, but when it does it's very sudden, like the old medieval plague. Because of how infectious it was we had to work very quickly with bodies in the street, and people were hiding their dead because they didn't want them to be thrown into the river. It really was quite an unbelievable thing because all you needed to do was touch someone who had Marberg and you'd be dead in three days. In Darfur recently we could hear shelling right near where we were and the Janjaweed came into town at night on camels, killing people. We could hear screams and shots, lots of shooting yet strangely I felt quite safe under my mosquito

net because it was all tucked in – it's crazy isn't it? And yet when I came back home somebody had a birthday celebration in the pub near where I live in Cambridge and at 11 o'clock at night I was asleep and they started setting off fireworks; I nearly leapt under my bed – I was right back in Darfur. So although you think you're not scared, it's all stored there, you know. Of course, I'll never get over my fear of cockroaches, I don't think I ever will!

I think the most satisfying thing about working for MSF is that you really do save lives and stop suffering where you possibly can. You could have a child who's unconscious and at death's door because of starvation, but gradually with very careful feeding and after maybe 12-16 weeks, that child is able to sit up, open its eyes and eventually walk again. It's wonderful to see that progress when you're working with starving children. Also while we were in Darfur we discovered that in many surrounding villages the children had had no vaccinations and were suffering from Polio, Measles and Whooping Cough. Just by notifying our mission in Brussels, within weeks we were able to start vaccinating the children; I'm incredibly proud to work for them.

There are times, of course, when the pressure gets to you, and you're often incensed by what you see. You can get very angry and horrified. In a way, it probably isn't very healthy, but my adrenaline keeps me going and I've learnt to swear in German, which is enormously satisfying. It's wonderful, you can do it in a dignified way, or like a fishwife, and nobody knows what you're saying! But you keep going because of the need. There's such a desperate need and you're there to do a job. When we come home we get lots of support – we're phoned by another returned volunteer and we can go and have counselling if we want to and therapy if necessary. We do have lots of support, but in the field, when you're there for maybe two months, you're there to do a job. You can't sit down and ponder how you feel. You might feel bloody awful and often you're sick and you cry, but you carry on because there's such a need.

There have also been some lovely memories. We found a little girl on the streets in Uganda near the border and her brothers and sisters had been captured by the resistance army. She was alive but she'd got AIDS and was very ill, she wouldn't respond to any-

one and was totally mute. After several weeks I was playing with her and I'd filled a condom with water and made some pin pricks in it with an injection needle. I kept squeezing water at her and then I made her squeeze water at me and I remember hearing this funny little noise and it was her laughing. We'd been working with her for about 8 weeks or more and it was the first sound she'd made; this funny little giggle.

There's no chance of me giving up now, I'm not far off being 70 and I want to carry on until I dement. I've told my managers in Cambridge that the day I come into the office naked they'll know it's time to send me to Occupational Health. I think as long as you're totally well-motivated and fit then certainly age is no barrier. It has many advantages. I often think people assume that you have to be fresh out of school or college, or from training as a doctor, to do this work, but actually older ones are better in many ways because you can support others in the field – younger people who are maybe finding it difficult. It's also interesting working in other countries as an older person; they certainly respect me in places like Africa for being older. I think anyone can go and do something like this. There are so many clapped out GPs, doctors and nurses all over the place who retire in their 50s and are an absolute wealth of information and knowledge. I think particularly GPs – they're so used to seeing a whole clinic full of different conditions every day – they're very adaptable, and many of them would be such a help to MSF.

I think deep down my family is proud of me, though my three daughters tell everyone they're not problem children – they have a problem mother! I've got four grandchildren between the ages of 7 and 13 and they just think that's what grandmothers do. When I told them I was going to North Darfur recently they said 'Yeah, okay, send us a card.' It was as if I was going down to Sainsbury's, they're just so used to it.

My daughters know I love doing it and want to continue, plus they couldn't bear me if I was stuck at home; I'd drive them mad. I'm sure they worry, but they say they'd have reason to worry more if I had to stop doing it. I couldn't bear to be a person who's just filling up a space. I wouldn't want to just take a ride through life; I want to do something with it and not waste it.

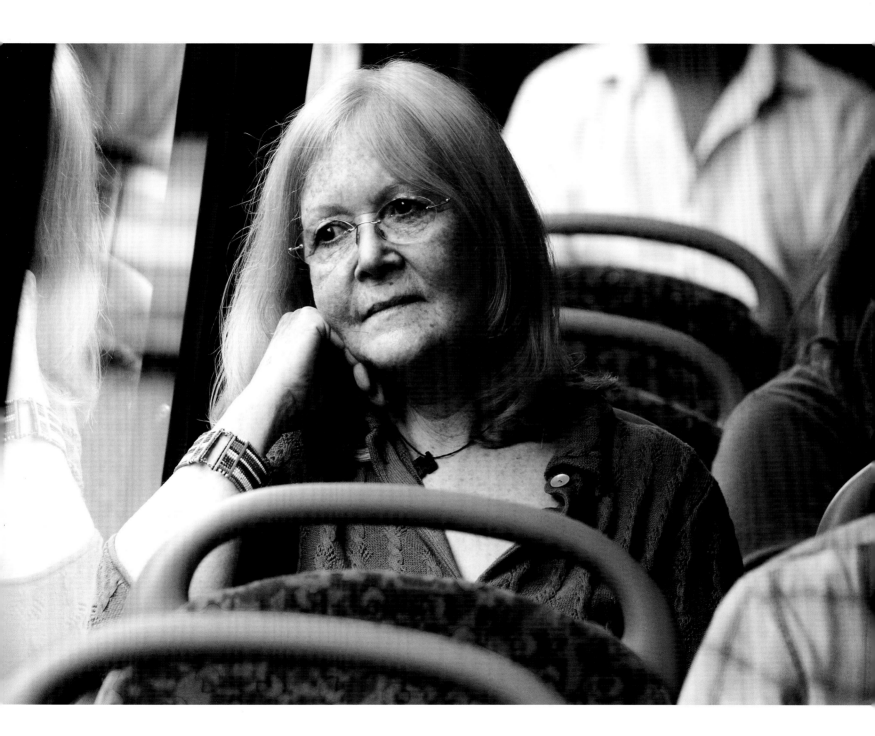

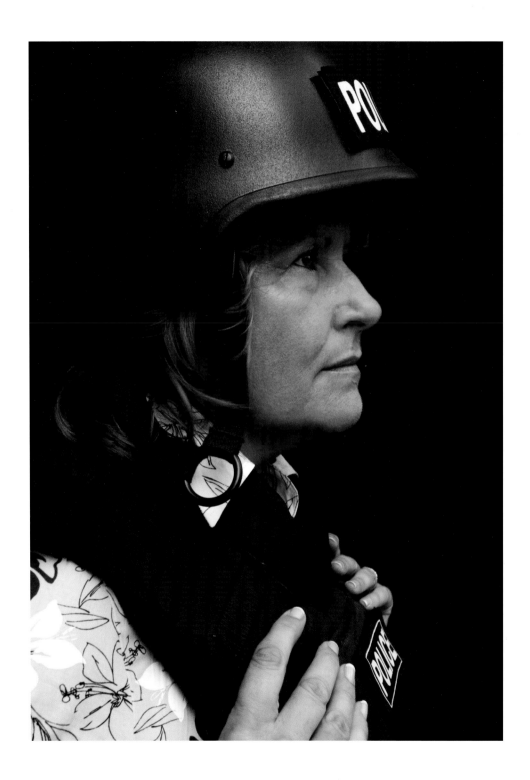

Detective Superintendent Sue Williams

Who: Sue Williams
When: 18th June 2005
What: Head of International Kidnap and Hostage Negotiation Unit, Scotland Yard

'I've never been in a situation where I've thought I'm not going to get out of this; I always look on the bright side – so far it's paid off.'

I had always wanted to be a police officer from when I was a little girl. My grandfather was in the police so I was brought up very much in that environment. He was a uniformed officer for his whole 30 years; I suppose he was what you would now call a Community Beat Officer. He was really inspirational to me, not for the type of police work I eventually ended up doing, but because of his commitment to making a difference and helping people.

When I left school, whilst waiting for the age limit – you had to be 19 to join the Police Force – I became involved in the rag trade. I actually really enjoyed it and ended up staying in that line of work until I was 21, it was well paid and quite glamorous and I suppose when you're 19 those things are quite important. But I still had an eye on working for the Police so as well as my full time job I was a volunteer officer with the Special Constabulary.

During that time, quite by accident I got involved in a murder investigation, purely by being in the right place at the right time. The criteria for such cases was that a woman had to be involved from a family support perspective and as I was the only female officer there at the time, I ended up being part of quite a high-profile murder inquiry. That was a big turning point in my life because it actually made me realise what I wanted to do and where I thought my future lay. So had that murder not have happened on a Thursday night which just happened to be Specials night then perhaps my path would have gone a completely different way, who knows.

So, I resigned from my job in fashion, joined the Metropolitan Police and took up wearing sensible shoes for a living in 1976. Like all police officers I had to do two years probation which I did

pounding the streets of Barnet, and then I went on to the Drug Squad at Scotland Yard for a few years which was something I really enjoyed. After that I went to West End Central and worked in the CID office; that was my first post as a Detective Constable. It was a really interesting place to work; Savile Row Police Station was a bit of a change from Barnet.

The people and the issues were totally different, as were the crimes. Because it was more of a business and retail orientated area there were a lot less domestic issues. In Barnet I'd been involved in marital disputes, family and childcare issues – West End Central was more street robberies, pick-pocketing, and shoplifting. It was also a much more diverse community than I was used to. Of course, there was Soho to deal with as well, the seedier side of things. Then I got promoted and spent a year back where I grew up, in Enfield, as a uniformed sergeant. It was quite interesting being there as a uniformed police officer, having been a child and teenager there, going back to my old school and things like that. After that year I went to Kentish Town, the Borough of Camden as it is now, and was a Detective Sergeant there for some years before going back to the Drug Squad. I got another promotion to Detective Inspector and went to Holborn, which I enjoyed, because again it was a really interesting and diverse cross-section of crime.

I would have been about 35 by then and I wouldn't say I was a real career highflyer, I'd had about 14 years service so that would have been about right. There were graduate entries and people that worked their way up the ranks pretty quickly. Some people peak a bit early, I think, but I'm glad to have done it the way I did

because I ended up with a much wider range of experience.

I suppose my first dip into a totally different area of policing was when I went to the Intelligence Unit to work in surveillance and covert operations. A move to the Kidnap Unit followed where, as well as working on domestic investigations, I was also involved in specialist case work. I dealt with lots of sensitive and confidential enquiries, food contamination, those sorts of things.

Looking back I've experienced quite a few different areas of police work, I even spent three years in the Royalty Protection Group to protect the Royal Family. It was in the days when if you got promoted you had to move departments or stations. So I did that as a uniformed Chief Inspector and had responsibility for external and internal security, though not personal security. It was building security really for Kensington Palace, St James Palace, Buckingham Palace, and when Court was sitting, at Holyrood and Balmoral. It was a big responsibility and I had a big team; you're not on your own. It was really interesting though to get such a different insight to life. The good thing about that job was I had quite a lot of time to study, so I was promoted again from there in 2001 and came to the central Kidnap Unit at Scotland Yard as Superintendent in Charge. This began with domestic kidnap – as in when the people of London unfortunately get kidnapped, which is quite a few, at one time we averaged 6 a month – then international kidnappings and hostage negotiation. I actually began as a negotiator 1991, while I was a DI at Holborn as it's something you actually do in addition to your day job. So if there was a particular call-out, you'd be on a rota and you would try and negotiate with people in crisis. The majority of those – 70% plus – are people who want to commit suicide, domestic barricades, things like that, and you try to talk them down. It was such a worthwhile thing to do and I really enjoyed it; I never fully appreciated that one day I'd be head of the department that sorted that out.

I first got into it because I'd heard other people were doing it and I thought it might be a very rewarding job. Also I thought I could do it because I have empathy, which you need, not so much sympathy but empathy, and I can listen. You don't talk somebody down or talk somebody out, you listen. The sort of mantra we have is that you've got two ears and one mouth for a reason.

My job now is divided into the international side which is on behalf of the Foreign Office, dealing with critical incidents, i.e. kidnaps that happen to British citizens overseas. Then from a domestic point of view, I'm also responsible for the 70 or so hostage negotiators that we have in the Met, their training and making sure we can respond to people in crisis in London.

Despite being the Head of Department I still do negotiations – a bit more now in a co-ordination role, but I still turn out to the crisis site and try to engage the negotiators. We usually deploy a team of three negotiators and try and brainstorm them to find the best solution. There are no heroes in negotiation, it's totally team work and about making that team gel and work together. You might not like the person; you sometimes haven't got much in common with them, for instance how do you befriend and empathise with a paedophile?

In many respects you can't. But a negotiator's job really is just to bring that person down, whoever they are, regardless of what they've done or who they are; you can't judge them. If they're going to enter the criminal justice system then that's somebody else's job, as it were, you've done your job. Every time my team rescues someone or returns a hostage to their loved ones – every single time – it's just fantastic. Like many detectives I've done murder enquiries and the thing about murder is the person's dead, and no matter how good you are, you're never going to bring them back. The best you can offer the next of kin or family is to bring somebody to justice as quickly as possible – giving them some closure if there is such a thing. When you're dealing with kidnaps when there are hostages, there is a chance that you can bring that person back – sometimes from the brink. I think that's the ultimate really in police work. It's also very demanding because decisions you make are against that backdrop – something you do, or say, or something you cause to happen could actually result in that person dying. It makes you focus your mind; it's incredibly challenging and sometimes absolutely exhausting.

I received the Queen's Personal Merit in June 2004 which was a really proud moment and a lovely surprise. You like to think you've got your ear to the ground and know what's happening but I was absolutely totally surprised and bowled over. I didn't know it was

coming at all. But generally we make a very silent contribution. You don't expect there to be accolades – you're only there for the people involved not for statistics or public opinion – you're there because you want to drag them away from this dreadful place.

But I would say my proudest moments are whenever you bring someone back, or out of a particular situation, because not only do their loved ones think they're going to die, but sometimes they themselves think they are. Lots of times when we do return hostages to their families, unless they're already aware or until they are told afterwards, they're very surprised by the amount of work that goes on in the background and the commitment to securing their release. The Foreign Office takes the responsibility for kidnaps of its citizens, and the support of their family, really seriously – they devote a lot of resources. It's really satisfying when somebody does come down or gives up a hostage – very, very rewarding.

I don't think people look at me differently in my job now I'm a bit older, well I hope they don't – it would be sad if they did. The Police Force is quite a young organisation really because we have a young retirement age, usually after 30 years service and most people are in their early 20s when they join. But I don't really think about it; saying that, I did hate it when my birthday cards arrived with the 50 on, I really didn't like that much! I don't think it's altered me very much apart from sometimes when I feel as though my knees are 50 and the rest of me isn't. So there's always a danger when you go to run up the escalator in the morning!

It's funny, before I reached 50 I thought by the time I got there I would know all the answers. But actually it's not the case at all, you never stop learning. I think I've appreciated that more and I'm still finding out so many things. I certainly don't feel more vulnerable in my job, not at all – I feel more experienced, more knowledgeable and confident. Perhaps now I suppose I might be more safety conscious personally on the streets of London than maybe I used to be and that would be age-related. Although it's ironic that I go to dangerous parts of the world and not think about it in the slightest.

I would say I do take calculated risks now, not necessary less risks, but they are more calculated mainly because of experience, but also because I'm far more conscious that whatever work we do will be under scrutiny. One of the strategies I have now is that in the past I didn't have a Plan B. I was perhaps so convinced that Plan A was going to work that I didn't need a Plan B – but I think now I'm better at that and I do both; I think that's come with age. I've never been in a situation where I've thought I'm not going to get out of this; I always look on the bright side – so far it's paid off.

My parents do worry – even now. They worry when you're 20 and that worry doesn't stop when you're 50. I'm very conscious of the pain I've put them through over the past three decades. But the good thing now is having text messaging and emails, so I am much better at keeping in touch and letting them know I'm ok these days. I also found that I lost touch with my old friends, not because I fell out with them but because I was busy working and didn't ever see them – but again I can email and text them so it's much better than it used to be.

Of course, I've made sacrifices and it probably has affected my relationships. But that's what you do isn't it. You have to accept that it's part of what I am. I wouldn't be the person I was if I didn't give it full time commitment and care. I am quite a caring person really, although in the Police Force you have to be more politically aware than care about it. It's not always beneficial if you care about it. I use humour, appropriate humour I hope. I've got an interesting sense of humour and you'd be surprised how sometimes you rely on it. But that's a type of mechanism, having a sense of humour and trying to see the funny side of it – I don't mean cruelly, but trying to find the funny side of a desperate situation.

It sounds a bit quaint, I suppose, but my philosophy is to do my best and try and make a difference. I've always been very conscious about that – I won't say that I wake up every day saying I'm going to make a difference today, I don't mean that – but in general. That's something really that was there 30 years ago when I joined the Specials, because I wanted to and felt that I should; that feeling is still there now. And I'm very fortunate because I'm conscious of being in a role within the Police that allows me to do that. If my career had gone off in a different pattern then perhaps I wouldn't, but I'm very fortunate that I can.

Susie Cornell

Who: Susie Cornell
When: 23rd April 2001
What: Devised the first Multiple Sclerosis exercise programme

'If someone comes into my office and I can turn their life around and they go home with a better quality of life as a result; that means everything to me.'

When I was 23 I was in my element. I had a fantastic job which meant lots of travelling, I was sharing a flat with one of my girlfriends in London, and I'd just met the man I knew I would marry; things couldn't have been better.

Then I started getting some tingling and numbness in my fingers. I spoke to my flatmate about it and she suggested it could be stress, and when I went to see my GP, she agreed. But I went back a month later and the tingling was still there and now I was tripping over the slightest thing, I just couldn't understand it. The doctor recognised that it might be something different and arranged for me to have some tests. I was sent to St Bart's Hospital, and as we had really only just met, I barely mentioned it to my boyfriend, Ian, because I didn't think it was worth talking about. When he did ask what it was about and I told him about the tingling and tripping over, he insisted that he would come and see me. I ended up in Barts for two weeks and while I was in there he proposed – I was completely shocked. We'd only known each other for three months so it was totally out of the blue, but of course I said yes; I knew from the minute I saw him he was the one.

When my mother turned up at the hospital and I told her Ian had proposed she seemed really pleased but then, when he arrived later that day, she whisked him away for a chat. I thought it was a little strange but just assumed they were getting to know each other. 'You've asked her to marry you but you need to know that she's got multiple sclerosis, and she doesn't know,' she told him. He was completely devastated but also sworn to secrecy as the doctors and my mother didn't want to tell me. They said that the stress of it could cause me to deteriorate. The possibilities were that either I would get well again and be fine or be confined to a wheelchair in three months time.

He didn't know what to do. He was completely gutted but had to keep up this pretence that everything was fine. In the meantime I left hospital with a certificate to go back to work which said I had polyneuritis, as they'd not given me a diagnosis of MS. My company were happy with that and I carried on my job. Certainly from my point of view it was even better because I had all these men fetching and carrying for me. When you are one of only six women in a 200 strong sales force the men love doing things for you so it was great.

But Ian was totally different, he became very distant and kept trying to make excuses not to see me or for us not to meet. He lived in Essex and I was still in London so the distance didn't help. In my mind I took it that he'd obviously got somebody else because marriage wasn't talked about and the wedding had been forgotten. So one night I decided to confront him and gave him an ultimatum. He couldn't hide it any longer. 'I've got something to tell you. You've got a serious illness; you've got multiple sclerosis and I don't know what to do.' The shock was just unbelievable; I was only 23.

With that we both went straight back to the hospital where I demanded to know what the situation was and what I could do about it. They didn't know. All they said was that I could be in a wheelchair but that it was hard to tell. I just assumed there would be a cure or some pill I could take for it, but I was told there was nothing they could give me and that I should go home and try and live a normal life. The two of us were left totally on our own.

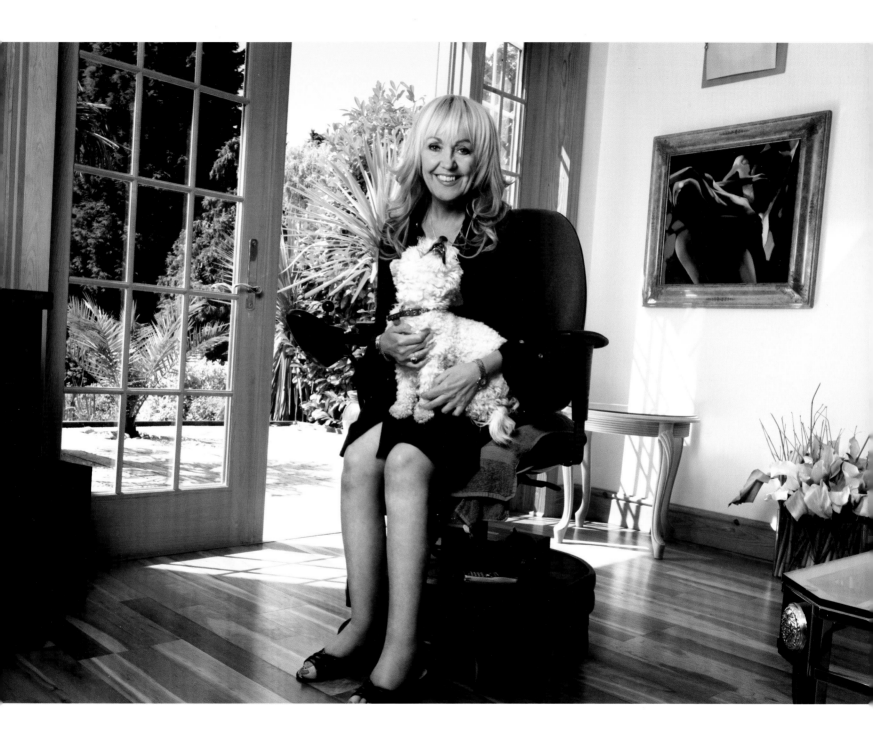

There was no help and no-one to talk us through it, we were just told to get on with it.

It was a huge trauma because with a diagnosis of MS the first thing you think of is a wheelchair, disability and total inadequacy. I went through a stage where I didn't want to live and wanted to end it all; I felt my life was totally worthless and certainly didn't want to get married and be a burden on anyone.

When Ian first told me I had MS I asked him to leave me alone and said I wouldn't marry him; that I could cope on my own. I was playing the real victim and martyr. But he just wouldn't go away, as far as he was concerned we were in it together. So we came to the conclusion we would get married, and for the first couple of years my condition seemed to improve and I didn't really have any problems. What happens with MS is you get your first attack and then it goes away for a few months and you think you're better but then it comes back. At the time it felt as if it was a cancer because then you didn't really talk about 'the C word'; it was as if it was a dirty word. I felt almost ashamed that I'd got this problem and tried to keep it secret from my friends and work colleagues. I suppose I was trying to protect them from knowing that I'd got this terrible condition because obviously they couldn't do anything about it, but I really felt like a leper. It got to the stage while I was still working that on a bad day I'd be limping around and my customers would say, 'Are you alright?' and I'd just say I'd twisted my ankle. I very quickly learned not to tell anyone I had MS because, on the couple of occasions I did, the look on their faces was just awful and far worse than just not telling them. For ten years I masked it totally. My very close friends knew but aside from them it just wasn't talked about.

The next big turning point was when my sister had a little boy who had cerebral palsy which was another big trauma in our family. But she was determined to seek out the best help for him and when he was three years old she got him a place at the Peto Institute in Hungary. The Institute specialises in conductive education and at the time was the only place in the world that looked after children with cerebral palsy.

My sister went to live in Hungary and while she was there she realised that there were people at the Institute like me with MS

but they were doing exercise programmes and seemed to be coping with it well. There was nothing like that in the UK and I had been categorically told not to do any kind of exercise as it would make it worse. As soon as we possibly could, Ian and I got a flight over there to visit the doctors and see if they could help. Ian had to come back to England to work but I ended up living with my sister in Hungary for three months and was accepted as the first British adult ever to go to the Peto Institute. Despite the language barrier – everything was done via sign language – they just were so caring and lovely. It was the first time since my diagnosis that I felt anyone cared about what I had and wanted to help, which was totally different to how I'd ever been treated before.

They encouraged me to realise that 10% of my problem was MS, 90% was lack of use. I just wasn't doing the right exercise; I wasn't doing anything about it. As I explained, I had no idea I could do anything, but they showed me. So I spent three months there; for the first two months as a patient and for the third I tried to learn everything I could about what I had and what they knew about it because I realised this was phenomenal.

It was a real breakthrough because for the first time in ten years someone was giving me hope. It also changed my whole line of thinking about disability and people with problems. I started looking at them in a totally different light after that. Because I thought, these people, although they might have a problem they've still got a soul, they've got a heart, they've got a mind and they need to be treated exactly the same as anybody else. I think by being there I learnt so much. I met so many wonderful people. It completely changed my whole attitude on life and people. I came back to the UK a different person. I not only felt physically stronger; my walking had improved and I was able to get up and down stairs, but I also had so much more inner strength.

Just by coincidence while I was out there TV AM were filming a feature on the Peto Institute and asked if I would go on the show and talk about what I'd experienced. I realised it would help more people like me if there was some publicity about it, so I agreed. When I got back to the UK I was on the programme and they ended up running two or three features on me charting my progress. Because of that the letters started flooding in. People

wanted to know about the exercise programme I'd followed to make the progress I'd made. I started writing to everyone individually detailing all the exercises and eventually my husband pointed out that I must be mad if I carried on like that. So I started an exercise class at the local hospital and there were so many people who came. I was inundated all the time; I just didn't realise so many people needed help.

After a while I wanted to work somewhere that catered more specifically for MS and joined a charity and therapy centre in Essex called 'CHARMS'. While I was there, along with contributing what I'd learned from the Peto Institute, I also met an Australian doctor who had been working on an exercise programme using pressure machines. We realised that the two programmes together, the one I had which was exercises done on a mat on the floor and his, using weights and machines, could really compliment each other. So I ended up training with him and being a patient of his for two years and in the meantime I put an exercise programme together, called *Under Pressure* and got it produced on video. It's still the only exercise video available in the world on MS.

The Peto Institute now have a base in Birmingham and the conductors who worked with me in Hungary now work there, so they recommend people to contact me and use my exercise video when they can't get to the Institute in person. I would think that every physio department in the country's got it because they carry out their rehabilitation exercises on the basis of my programme.

As I got busier and busier my husband offered a room in his offices to use as a base, but pretty soon I was inundated with people queuing up outside in wheelchairs and on walking sticks to see me. On the site of his engineering company was an empty factory unit so he said I could move into that, and I decided to open a small health and fitness club of my own. The club was for everyone, not just people with MS and it was a huge success. All of a sudden the whole of Chelmsford wanted to join the club, particularly those with disabilities because we had all the equipment they could use and get on and off of, we had all the amenities, disabled toilets, everything. So all of a sudden we became a very, very busy club.

I called the gym after the video, 'Under Pressure' because that's what the whole programme is about – all the exercise is done under pressure with air pressure machines. It was a wonderful place and it was such an amazing accolade when after ten years we were named 'Best Small Health and Fitness Club in the UK'. The year after that, I was awarded a Lifetime Achievement Award for being the first person to bring disability into the eye of the Health and Fitness world. It was the biggest achievement I've ever had in my work and was really mind-blowing; I just never expected that to happen.

Since then more and more gyms opened up in Chelmsford so we sold the club and I now have a clinic where I do assessments for people who come from all over the country, and the world in many cases, to see me. I specialise in putting individual exercise programmes together, and along with advice on general health, nutrition and lifestyle it's a complete programme for them. Because every single person – and I have to say this to everybody – no matter what you read, no matter what you see, no matter what exercise video you look at, you still need an individual programme because every case is different. They walk away from my clinic after three hours having had a complete assessment and they trust me because there's no-one else who does this. People come to me because I've had this condition for so long and am still surviving it, still dealing with it and still working on it.

In many ways I almost feel like my life has been mapped out, like I've been led along this path because every time I've tried to let it go it won't let me go. There's something really weird about the fact that if I've been on the low side and think, 'Why am I doing this? Do I have to carry on?' something happens to change it. Something comes into my life or somebody needs me; I've obviously got a direction to go in and my work isn't finished yet.

One of the things I'm most proud of is that my work has also been recognised on a higher level than I ever imagined. A little while ago I opened a letter saying I'd been appointed Deputy Lieutenant of Essex. It was signed by Lord Peter of Essex who had been given leave by Her Majesty the Queen to make the appointment. I just couldn't believe it, I was so thrilled; to be recognised

and given a lifetime position in the community for what I've done was just unbelievable.

Of course there are times I feel I've been cheated in life – I can't go skiing with my friends, or drop everything and just disappear with them. But I feel that my life is fulfilled because I'm just so happy doing what I do. I love what I do. If someone comes into my office and I can turn their life around and they go home with a better quality of life as a result; that means everything to me.

For me, age has always been something I've thought about, mainly because from such a young age I've never been 100% well and have had to work hard to have some semblance of a normal life. But, because I look after my health, what I eat and drink and I do the right exercise, I've remained relatively healthy. I always give myself 5 or 10 minutes every day to look my best. To me that is vital. I have to do that with my work because I feel that people want to see me looking good and I owe it to them really to make the effort to do that. I can't walk very well but I've got everything else that works so I make the most of it. It's so important for anyone whoever they are, whatever their abilities or disabilities to make the most of everything they've got.

Thope Lekau

Who: Thope Lekau
When: 26th April 2002
What: Runs a B&B in the Kaleisha Township in South Africa

'We mustn't make any excuses about coming from the history of apartheid – now we are becoming entrepreneurs, we must deliver.'

I was born in an area called Steenberg in the South Peninsula. Even today I go to spend time on the beach where I grew up. I love that beach; our school was really close to it so we went there all the time. This was before the oppression and segregation laws were becoming serious. Then, because of the Group Areas Act, they forcefully removed our family to the Guguleto township – where my sisters still live now. We were brought there to live with other blacks rather than remain living with other racial groups, whites and coloureds. We were still very young. I think we came to Guguleto in 1960, so I was only 8. It was not nice because I still had memories of my life in Steenberg. What is also painful, especially now when I often go over to that side, is that I would have been able to buy a beautiful house there many years ago and would have finished paying for it by now if it had not been for apartheid. But we were brought to these townships and today I could never afford a home there. Whenever I drive past I think I would love to live where I was born, near that wonderful beach, and yet I am so far from there now in every aspect. So when I think of those things, I can never forget apartheid.

My family was very poor and uneducated. My mother was a domestic worker, my father was a labourer. When I was young – I was the second eldest out of seven – I had a lot of responsibility. My mother was at home bringing the children up. She also used to sell homemade ginger beer from there, and I would go to school and sell sweets to try and help my mother. She would also buy milk from this wholesale company and my brother and I made a cart out of a box and some bicycle wheels and used to sell milk in the streets of Guguleto to earn money for the family. We didn't even think it was something we should be ashamed

of in those days – my main objective then was for my brother not to spill the milk.

I never had a straight education. I got to high school and then had to drop out and go to work to help my family. I did a few odd jobs where blacks were allowed to work but, because of what was going on around me in the townships, I really wanted to do something for the community.

So in 1977 I started community training then started work as a literacy co-ordinator. This meant getting involved in self-help projects; going to places that were called bachelor quarters, where migrant labourers were living. We would go there in the evenings and run our literacy co-ordination classes. In those days, the migrant labourers were unable to communicate directly with their families or write letters to them because they couldn't read and write. They had to ask someone to write letters for them – there was no privacy. Part of our work was to go there and teach them to do it themselves. Then in the early 1980s I decided to go to study, so I went to university but in the same year we had the national education boycott. So I got another job but it wasn't what I really wanted to do. I resigned and joined the Legal Education Action Project which was based at the Institute of Criminology.

Doing this type of work during apartheid was very frightening. Many, many of my close friends died during that time and we took a lot of risks in our way. Just by working for LEAP we were like enemies of the state because we were going out to different communities to give them legal information and advice. In those days the government and police system were committing all kind

of atrocities; people were being detained, killed and many just disappeared. So we were always being stopped and interrogated. One day, I'll never forget, we were supposed to run a workshop outside of Cape Town. We used to travel around the country to visit each town and run workshops for paralegals covering basic human rights. So if a person is detained under Section 26, part 8 of the Security Act or whatever it might be, we could tell people what it meant and what their rights were.

On this particular day we got to this town at about 8pm, still deciding with the comrades in this area whether we were going to start the workshop the following day, when suddenly the house we were staying at was surrounded by all kinds of police cars. There were police vans and private cars all around us, and they came inside to order us to leave immediately. It wasn't long after the murder of four political activist teachers who were killed by the police. They were coming from a meeting in Port Elizabeth and the police stopped them somewhere, tortured them and burned them to death in their car. So when they demanded that we leave, we were very frightened that the same thing would happen to us. We asked if we could call our people in Cape Town to tell them we were being ordered to leave so that if we didn't arrive they would know to go and find out what had happened.

They allowed us to do that and afterwards they escorted us to leave. They were following us like some kind of army convoy. We were praying, we were so nervous; we thought we were going to be killed on that night. So it was a very high risk job, when you look back you think, 'What were we doing?' but in those days we were so committed, we were driven to do it. We made our choices and it was for the right cause so I have no regrets. The type of things we and many others did brought about change in this country today. I will always be very proud to have played a role in that change.

Apartheid was really there to demoralise us, to kill us mentally and physically. Even now some people are unable to do anything for themselves; that is why we must prove that if we lived through apartheid, we can make something of ourselves.

When we voted for our first democratic government in 1994 we all had a huge opportunity to seize. The whole world knew about

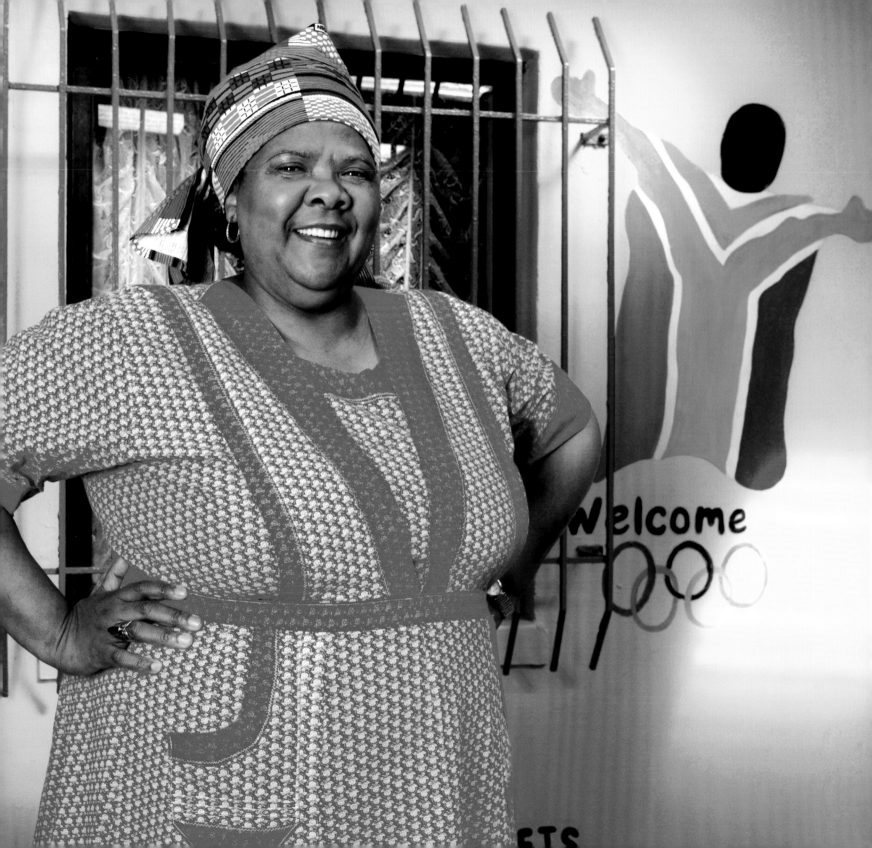

South Africa, the whole world wanted to come and meet Nelson Mandela. So that was my challenge, to start thinking like an entrepreneur. A couple of years before that I'd left my job at LEAP and joined another NGO, the Social Change Assistant Trust. SCAT was serving as a conduit, receiving funds from foreign donors for us to channel to community-based organisations, like advice centres started by the paralegals we trained when I was with LEAP.

But by 1997 I was really burnt out and needed a change. One day at work it was announced at our staff meeting that people could apply for something called the J.H.Heinz Company Foundation Fellowship. Every year they would select two candidates from developing countries to spend a year in the US gaining new skills and experience. I didn't wait to find out any more, I just took an application form and filled it in. I explained about my community work background, and that I wanted to move beyond that to go and learn about small-scale entrepreneurialism so I could come back and pass it on to the communities.

Myself and a guy from Brazil won the two places and I spent a term at each of the relevant schools and universities studying things like Public and International Affairs and Business Studies. Then I got the chance to work at the Women's Business Development Centre in Chicago as an intern, where they train women who want to start their own businesses, give them technical support and counselling etc. Part of my job was to update their database which was a very enriching experience because I had to track all of the women who were trained by them, find out where they managed to start their businesses and how they were getting on now. I got to know all of them and learnt so much, particularly about the pitfalls of starting your own business. I went back to Pittsburgh to submit my report and came back to South Africa armed and ready to start my own business.

At the beginning of 1999 I started to convert my home to a B&B and registered to become a tourist guide. Many people thought I was crazy, you know, to think that I could bring people from different parts of the world to the township. Obviously the Segregation Act, which brought about the creation of the townships, isn't in force anymore; but it's hard for people to get out now because of social and economical circumstances, so many

people have just stayed. Despite what has happened in our country the divide between the haves and the have-nots is still vast. Most townships have a lot of unemployment and poverty, so there is still a long way to go.

Aside from my community development background, what inspired me to convert my house into a B&B was seeing how many tourists were clearly interested in seeing the townships. Tour operators would come into the township with lots of visitors from different parts of the world, but they were in buses that just drove around without stopping anywhere. They would drive around our community, taking photographs of people but they never got out to interact with them. Our townships are not zoos. People here were finding it offensive having photos taken of them with no discussion or interaction, like they were some kind of side show. So I started to approach the tour operators, to ask if they wanted to stop over at my place with their visitors. Then they could get an experience of being in a home in the township and find out more about it, instead of just looking out from a bus.

It was funny really when I first started and these white people were coming into my house, many of my neighbours thought I was in trouble. They would ask me, 'Have you done something wrong? We saw white men coming to your home.' I had to explain that I had converted my house into a B&B.

People in our communities have really welcomed seeing visitors come here from all over the place, driving in their cars, coming in and out and chatting to the neighbours; it has brought them back some dignity. Because of apartheid, the morale in the townships was very low and everyone knew that white people couldn't come here. But now when they see these people there is that sense of pride. I get some really nice feedback from those in the neighbourhood, even the youths, the ones who are seen as the potential criminals because they have no work. They say, 'We are so proud of you – everyone needs to change in this neighbourhood because you have now made it known to the whole world by bringing so many people here from all walks of life.'

The great thing also was that when they heard what I was doing, all sorts of people came to offer their services. One man had been a cook and a waiter in the past so he offered to help with cater-

ing. I also asked women I knew for help when large groups came over for lunch. So from thinking that I was just crazy to begin with, more and more people got involved which was a very positive thing for the township.

I'm glad to say I've inspired lots of friends to do the same. I started training them, because many people ended up helping me full-time with visitors, cooking, or running tours, and now some of them have opened their own B&Bs. Others went to cookery schools or to learn about business. So now when we have large groups coming, if we don't have enough room I will send them to one of the other places nearby. You cannot think of yourself alone, you think of the next-door neighbour and the entire community. I want to do something for others because it's so fulfilling; I'm passionate about what I do.

Metaphorically I look at it like a cake. I have a cake, in my B&B, I cut my own slice when I have visitors staying with me, but then the village hawker in my neighbourhood will also have a slice, as will the crafters at our craft market because the tourists go there and buy gifts. Then the youngsters will get their slice when they take the visitors for a walking tour of the neighbourhood and tell them the history of the township, and the one who does the transfers to and from the airport does too. So just about everyone gets a slice, which is how it should be.

I was in my late forties when I opened my B&B I think, but the more you grow old, the more you forget your age! The thing is, because of our background in this country, there were no opportunities such as starting a bed and breakfast or any business, because we were coming from an apartheid system; none of us were educated to become entrepreneurs in the past. The opportunities are now coming for people later in life. Since I started my B&B I have been asked to go and do motivational talks to other women who are starting their own businesses. I often say to them, we mustn't make an excuse of coming from the history of apartheid – now we are becoming entrepreneurs, we must deliver. We must render a professional service; we must be prepared to learn so that we can do things perfectly. We must work hard to prove a point that, given an opportunity in this country years ago, we might have been owners of big hotels in town by now.

Sometimes I do forget that I'm 50, I have so much energy and I don't think like a person who's over 50 because I'm still ready to do so many things. Women of my age here are now trying to be more independent, but it's tricky. So many find themselves in relationships they are not happy in, both young and old, and they have to rely on their husbands or partners to give them money. When I do my talks with them I say they must be prepared to learn and that it's never too late. They need to educate in order to liberate.

The same applies to younger women; they should not be dependent on a partner but should educate themselves. Education gives you the power and independence to make your own decisions in life; people must be prepared to seize opportunities so that they can stand up for their rights.

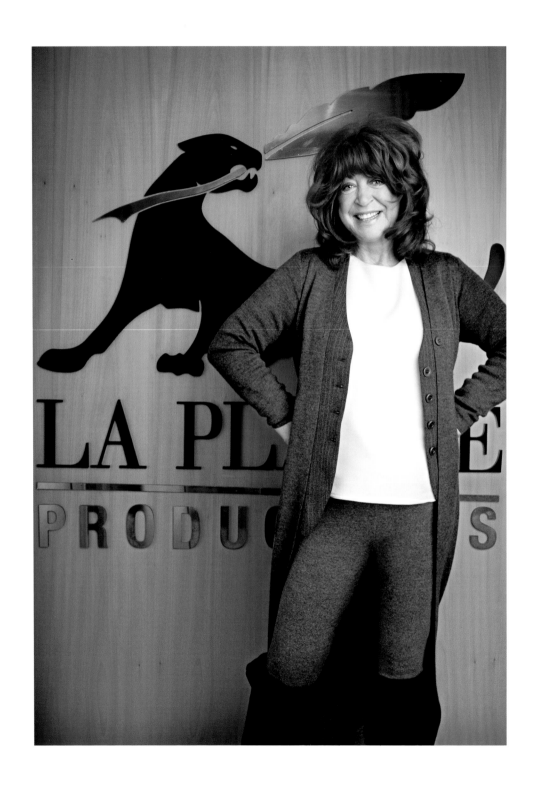

Lynda La Plante

Who: Lynda La Plante
When: 15th March 1996
What: Author & Screenwriter

'Enjoy as much of life as you can, have a ball, ride a horse, or as I do now; take my son to see Santa Claus when he's three and a half and I'm 60!'

When I was a little girl I was always very dramatic and loved dressing up. I remember my granny lived with us and she had this beautiful black lace evening gown hanging in her wardrobe, and every so often I'd go in there and cut bits out of it to make something for myself. One evening when she was getting ready to go to a ball I got called upstairs and my mum asked me what on earth had happened to granny's dress, 'Moths?' I replied.

I was constantly getting into trouble for being a bit scissor-happy. The mother of Jane Maxwell Brown, one of the girls at school, used to do all the costumes for the local amateur dramatics club and kept them all in this big trailer. So I got all our friends together on our bikes, like something out of *ET*, and we rode over there and took some of the costumes for their forthcoming production of *Camelot*. A bit later on my mother got a call from Jane's mum asking if she knew where the costumes might be for their dress rehearsal that night. Mum opened up our garage door and there we were, like little midgets dressed in the costumes which we'd chopped up to make them fit us. I was up all that night sewing them back together!

I really enjoyed school despite the fact they thought I was simple because of my dyslexia, but I loved literature and to be honest I had more trouble with numbers than words. To this day I can never remember my own phone number or the alarm code for my office. I loved drama and poetry and also fancied myself as a ballet dancer. When I left school at 15, I applied and got into RADA. I knew I was too young, so I told them I was 19. My parents hadn't a clue what I was up to but they just let me get on with it.

Looking back I wasn't old enough to be in London on my own at that age and I didn't really enjoy drama school; my inexperience and naivety didn't help. At the end of my time there, the principal said to me, 'You're very small and plain looking and I can't see that you will come into your own as an actress until your 40s.' He was probably right. But I left there and got quite a few stage roles and after one particular performance was nominated for an award and got into the Royal Shakespeare Company. I had also started doing a few TV roles by then but I was always pigeon-holed because of my looks. I was small, red-haired and came from Liverpool, so nine times out of ten I was cast as a prostitute. I remember when Melvyn Bragg did a special on me for the *South Bank Show* and showed some of my TV appearances – almost every one was as a prostitute!

As a working actress I was earning a good income because I was constantly working either in television, theatre or rep but there is a stage you get to as an actress around the age of 28 or 30 where, if you aren't a household name by then, you might be lucky to get a break, but then you'll be playing older ladies for the rest of your career.

While I was working on *The Gentle Touch* with Gill Gascoigne I thought I'd ask if I could have a go at writing a story line for it. I came up with some ideas and they all came back rejected, but one of them had scribbled on the top 'this is brilliant!' – that was the idea for *Widows*.

That gave me the confidence to send it to a TV producer called Verity Lambert who I had worked with before, but she knew me just as an actress so I sent it to her using my maiden name. It was

great timing because they were looking for a new series that was female dominated at the time and so she asked me to come in and meet her. When I walked in she was really shocked, 'Oh my goodness, it's you!' she said. She then explained that she thought it was a great story but wasn't sure I would be able to write it. But she was willing to give me a chance and said I could write the first episode. If it was any good they would commission the rest, if not they would buy the idea from me and get another writer. I obviously had to give it a try and so began the process of writing that I've stuck with ever since. As I didn't know anything about the type of people I was going to be writing about I decided to go and find them – I got in touch with everyone I could think of and they got in touch with the people they knew and gradually I found them – criminals, their wives, girlfriends, the police. I had to find out from the people who knew best how they behaved, their personalities and what the professional procedures would be, otherwise it wouldn't be accurate or believable.

I had a brilliant advisor who helped me in this process and, when I said I wanted to meet a murderer, he took me to a pub in the East End of London and introduced me to this man who, after killing his victims, fed their bodies to pigs. It was quite an experience and the main thing was trying to be indifferent and not reveal any of the shock I felt that I was actually talking to a man who'd done this. It was so worth it though, one of my advisors in the police, Detective Resnick, was so happy to find someone who wanted to find out what really went on and get it across properly.

Even now, I still run a very tight ship and make sure I have policemen, forensics, pathologists, weapons experts etc, whatever is relevant to the particular scene, all to guarantee authenticity. I do it totally out of respect, if I have a question on a script I can call anyone and they will tell me straight away. If it's wrong I will rewrite it, no questions asked. One of the things I'm really proud of is the respect I have from those people as a result.

It's also a massive pull for actors to know that it's an accurate script and what they are playing out is correct and something they can believe in that they aren't going to get pulled up on in the future.

I got huge enjoyment out of writing the first screenplay for *Widows* although I struggled a bit with my dyslexia. I managed to send them a first draft which was a bit overlong but Verity Lambert was pleasantly surprised and told me I could definitely write, no problem. Verity was a total genius, as an editor she was my mentor and probably one of the biggest influences in my life. I had been initially writing a part in the series for myself but as the writing evolved, the character I had originally thought of for me became more Italian, dark and fiery. When it was done Verity asked me what part I wanted to play and couldn't conceal her relief when I said I didn't think I was right for any of them! I was far more interested in casting people who were right for the parts, people like the ones I had based these characters on, and bringing them to life. I knew how they dressed, how they walked, how they spoke, how they wore their hair, their make-up; everything had to be right. When it all came together I never expected the power or emotion I felt when I saw a scene playing out, it was amazing.

The turning point really after that was *Prime Suspect*. She was obviously based on a real Police Officer, Jackie Malton, who was one of the most witty, funny women I've ever met. But she was a boss in the Police Force at a time when you didn't have a laugh or joke with your colleagues, especially as a woman; you were the boss. When Helen Mirren started playing the role I used to have to tell her, 'Hold back, don't smile – you're the boss and they hate you.' Gradually Helen got it and she was wonderful.

The success of *Prime Suspect* was totally amazing and life changing. Among other things it won the Edgar Alan Poe Writer's Award, six BAFTAs and an EMMY and was successful not just in the UK but really made my name in the US. It was just extraordinary that a small British detective show did that. It broke barriers because it was the first time people had seen a real police woman. After that it seemed a tremendous amount of *Prime Suspect* seeped into lots of shows, both in the UK and US, in that they became quite gritty and more bloody than they ever used to be. My boyfriend used to say, 'I can't believe all those ideas come out of your little head'; but all you have to do is pick up the newspaper and it's there.

The thing was, as with *Widows,* I didn't own *Prime Suspect*. Even though they were my ideas I was just a writer for hire. So when it came to the third series I was finding it difficult being told what to write so I walked away and set up my own company, 'La Plante Productions'. As a result lots of other things came about, like *The Governor*, *The Commander*, *Comics* and then another huge success in *Trial and Retribution,* so I have no regrets about any of it. I just want to carry on doing what I've always done which is do something I love and work really hard at it. I love going back to writing which is what I'm doing at the moment. I'm currently working on a book dealing with current problems like how helpless the police can be, issues with illegal immigrants, victims who are treated appallingly and a system that seems to favour the criminals. My intent is to show the pain of crime, how it really affects people and that there is a retribution; a finality about it. I also have some ideas for some movies I'd love to make, but it's a long process and there's no guarantee it will happen but it's something I'm working on.

I don't think as I've got older my outlook has changed, perhaps I am writing more about issues that worry me, but my pace of writing has definitely got faster. I have more experience and knowledge so I can cut a few corners in research. In myself I don't feel any different, although I did adopt a son when I was in my mid 50s so that changed a lot of things.

I had wanted a child for so many years and had been through lots of miscarriages, IVF and divorce and then I put myself on adoption lists in the UK and the US. But after a long wait I made a decision it was over, it was never going to happen. So I bought myself this mad lunatic Great Dane instead, but while I was staying in the US I got a call to say I was top of the list for adopting a baby boy when he was born; I was there in a flash! Typically for this country, I legally adopted a baby in the US and it took me 18 months to get him home to England. But after all that time I really wasn't prepared for how I felt, a frightening unconditional love I've never understood before. I catch myself looking at him and my eyes well up with tears every time.

From my point of view I think everything in my life I've had to work hard and fight for and I think the main lesson I've learnt is that rejection doesn't always mean no; just don't take it to heart. Everybody has a view, someone can say they hate something, others will think it's brilliant, you just have to have the confidence to keep trying. Most of all, enjoy as much of life as you can, have a ball, ride a horse, or as I do now, take my son to see Santa Claus when he's three and a half and I'm 60!

There's such an obsession with age in this country and in general, but really age is nothing, it's about what's inside. Wonderful things can happen as you get past 50, new careers, new loves and, as happened to me with my son, even a new life.

Eva Fraser

Who: Eva Fraser
When: 20th December 1978
What: Founder of Facial Fitness

'Even if you're 60 you've still got 40 years to go if you live to 100, so what are you going to do with those 40 years?'

I had a strange childhood really. My parents spent a lot of their time travelling so it was safer to put me and my sister in a boarding school. I was four and my sister was five. Although they didn't usually take children till they were eight they made an exception. That was in 1932 when schools were very strict, so there wasn't any question of treating us any differently because we were young. We were treated just the same as if we had been older.

Because of my parents' lifestyles we rarely got to go home and I think I only saw my mother about three times until I was 17 when she came to visit us. Our whole lives were spent at school. By the time I was 11, and went to a different school, I was quite used to it and had the attitude that nothing really mattered. Whatever was put in front of me I just accepted. There were some girls at the school who tried to bully me but I didn't take any notice of them, for some reason I could cope. It made me very independent, though, because I always had to deal with things myself. It was different for my sister Maud. Despite there being only a year between us she was terribly grown up and was absolutely devastated that we had been left to fend for ourselves at school; whereas I just accepted it, she couldn't cope. At our school we were only allowed to talk at certain times but she was always whispering to me that she was going to take me home. One day one of the girls fell and broke her arm and was immediately sent home. So Maud came to me and said, 'I know how I can take you home.' She used to look on me as her child really in a way. She went into the gym, climbed up the wall bars and threw herself off, but instead of breaking an arm as she had hoped she broke her spine. She was taken off to hospital and spent eight years in a spinal unit. It was just tragic because she was such a lively young girl, but for seven years after that she never moved at all.

I first went home when I was 17. My mother had a gorgeous house in Highgate – just so amazing; like going to paradise. She was so glamorous and always had lots of parties and people coming to visit, it was such a tremendous life I thought if I had come here for school holidays why on earth would I have ever returned to school?!

As my mother had worked in Paris a lot I decided, once I'd been at home for a little while, I would like to go there and find a job or do something. I just assumed my mother would be happy to let me go. Usually if we wanted to do something or needed money for something mother would say yes, but she refused and told me I didn't need to go there anyway. We got right to the point of her taking me to the station and me getting on the train and telling her I had no money to go but she still wouldn't give in. So I went anyway and just had to fend for myself. I think it was because when we did eventually come home from boarding school she didn't want to let us go again. My mother died of cancer quite young, when she was only 49, and I never did get a chance to ask her why she didn't come to see us more often; perhaps it was too painful for her to have to leave us again. I think there was a lot we didn't know about my mother and her life, but then, as she once said to me, the problem in those days was that people didn't talk about anything personal, it was all quite formal.

I think my way of survival was just to look after myself and be totally self sufficient, I didn't want to have to rely on anyone else. When I was very young I got married, I was totally in love with this guy, he was very, very handsome. Every year he used to rent a

villa in Lake Como or somewhere like that. One summer we were just going out of the house and for no reason I suddenly said, 'I can't come with you now, I just have to stay here.' Obviously he couldn't understand what on earth was wrong, but he let me stay with the promise I would join him in a couple of days. Well, I just knew I had to leave him so I walked out. I left everything he'd ever given me, jewelry, clothes, everything and left with one suitcase. I think it was because he was trying to look after me too much – not in an overbearing way, but I just wasn't used to being with someone who wanted to do everything for me. I enjoyed the attention and love but I felt the only way to get back my independence was to leave; he was totally distraught.

But it was obviously meant to be, because three days later a friend of mine invited me to the opening of a club in London and it was there that I met Gordon. He came over and asked me to dance and I said no. He asked me three more times and eventually I agreed. At the end of the evening I told him my name but wouldn't give him my number because I was still married and had to sort things out with my husband in Italy. A few nights later the phone went and it was him. He'd rung everybody in the phone book with my name. The next day, because my address was in the phone book, he came to the house and said, 'I just can't let you go.' From that day on we were together for over 40 years.

Before I got involved in Facial Fitness I had all manner of jobs, I was the sort of person who would do something, stick with it for a couple of years until I was really good at it and then move on and do something else. One of my jobs was working as a tapestry conservationist; I used to buy and sell tapestries at auction and employed 15 girls to work on them. I used to go abroad quite a lot at that time and once when I was in Germany at an event I got chatting to a woman called Eva Hoffman. When she told me her age in the course of our conversation I couldn't believe it – she looked around mid 50s but she was actually 76; I was shocked.

She told me she'd been a ballet dancer and had noticed that although they tended to keep their beautiful bodies for many years, by the time they were 40 their faces didn't match their bodies at all. She thought there must be a way of keeping your face in shape as well as your body. One of her gentleman friends was a doctor and between them they designed a method of doing facial exercises. I was 50 at the time I met her and was very relieved because I had no intention of having any surgery and asked if she would teach me how to do it. But she was adamant she had retired in her early seventies and would never give another lesson.

As it turned out she hadn't ever officially trained anyone else. But I kept bumping into her at various parties while I was over there and just kept on at her until she got so bored with me she eventually agreed to give me a lesson. I went to see her the next day and at the end of the lesson she decided I would make a very good teacher and agreed to come to London and train me properly. I had no real intentions of doing it for a living or anything but I thought at least I can learn how to do it. So she came and stayed. Fortunately we had quite a big place because she ended up staying a whole year. After six months she said, 'Oh let's take someone else on.' So we did, and at the end of another six months, she said, 'Well I'm off now and I'll leave it with you; just work when you want and charge a fortune because otherwise you'll wear yourself out!'.

By this time I had developed my own programme and I looked so much better as a result. I was working from 10 in the morning until 10 at night and I thought I really would like to make a go of this, you know, to get people not to resort to surgery and all that stuff, but to realise how unique we all are. It's just a case of learning how to look after yourself. So I started it up as a business and it was quite easy. I got regular write-ups and TV coverage and it became really top stuff. The *Facial Workout* book even reached number 2 on the bookcharts; it was wonderful.

True to form though, once I had made a success of it I decided to start thinking about what to do next. I thought 'I've done the book, I've done the television show, so what next?' I met up with an astrologer friend and was talking about what I should do. She said she had never known anyone have so much success with something and then walk away from it. She was convinced I should continue with it because it was quite important.

But then life changed for me dramatically. My sister, although she

had fully recovered from her broken back and was a wonderful woman full of life, the years of being in hospital flat on her back had damaged her kidneys and she had to have a kidney transplant. Her second husband called one day to say they had found a kidney for her; he was terribly excited about it. Then at seven in the morning, the next morning, he said she'd gone. Apparently the kidney was damaged, and she just bled to death after the operation. I don't think I've ever stopped screaming. She was a gorgeous girl, really gorgeous and she had this amazing manner. It was a terrible shock to me. Then Gordon, the person I'd been with for forty years, died six months later, which was very sudden. I suppose they were the first two shocks that made me change, very much, it really affected me massively.

I suppose before then lots of people would come to me with their problems and worries. I've always been one of those who solved things; I'd say, 'Now listen, all you've got to do…'. But when Maud and Gordon died I thought, 'My God, I can't get through this, I don't know what to do.' So I suppose after that I was much softer, and I realised that not everything can be solved and sometimes there isn't anything you can do. So I thought about what my astrologer friend had said and decided I would carry on with Facial Fitness, and today I'm still doing it. In a way, this is my mission in life, to get people to look after themselves. As people do the course, they always say it isn't so much making faces and looking better, it's getting to *feel* better about yourself – it's really that. People say they just feel they can do so much more now.

I enjoy the work hugely, I really do. Every client I get, I just feel totally engrossed with them. I just love it. I hadn't done any teaching in any job I had before but teaching people how to look after themselves is just wonderful and so rewarding. People are so frightened of ageing, this is the problem and there's this thing of dreading birthdays. You know, it's a birthday; it's supposed to be something you look forward to. It's just about trying to get people to have a very different idea of age and to realise how young we all are. Even people in their 40s have said to me that because they've got to that age they think they aren't young any more and start getting scared to do anything. Loads of people still do, even men will say 'Oh gosh I'm 42, it's awful being 42.' People don't realise men think that way as well, I certainly had no idea.

Even if you're 60 you've still got 40 years to go if you live to 100, so what are you going to do with those 40 years? You can do anything you want, anything – you can start a new job, you can travel the world – you can do anything you want to do. It's just getting your mind around the fact that perhaps at 80 you may have 20 years to go, so if you want to sit and knit you can, but you could also start a new business or something. It's nothing to do with age. Once you get to know that, I think you can change your whole mindset to look at your life differently. I've still got 22 years to be 100, so I can't even think of being old. Our work is about getting people to be much happier about themselves, which is nice, that people are so cheerfully ageing.

I feel totally different as I've got older. I do resemble the person I used to be in many ways but I'm glad I'm hopefully more approachable, and that I think is better, especially in this work. I wasn't when I started it, I was still quite indifferent. But now I have great friendships with people, whereas before they were just clients, I liked them but I didn't have the closeness I have now. I think as you get older you just appreciate people more. I didn't really value my friends so much when I was younger, not until I was 60 I suppose. People were always doing things for me and when I think back, I didn't always say thank you, I just accepted what they did. But I've learnt to always appreciate what people do; I feel very differently about people now.

I think younger people need to realise how incredibly young they are, to appreciate things and really go for it and enjoy their lives. Not getting stuck in your life is vital. If you're not happy, don't think your life is some sort of sacrifice and think 'well, I've made my bed' as it were. You get up and remake it. One isn't meant to be miserable in this life. I don't mean you've always got to be laughing and enjoying yourself, but there are so many things to do and I think if you're not happy you need to have the courage to say 'This isn't right' and move on. Obviously if you can avoid hurting people in the process that is better, but to know how young you are is the main thing, and to know how many things there are to do in life, and to go and do them. Probably one of the most important things is to have love in your life; to give love and hopefully to be able to accept it. Those things are really the most important I think.

Noerine Kaleeba

Who: Noerine Kaleeba
When: 2003
What: Chairwoman, Action Aid

'Until you are dead you are living. I always say to people with AIDS, and of course they smile, dying is not a prospect. Living is.'

I think my family and where I was born has been one of the land-marks that has defined what I have turned out to be. I come from a little village called Betanazigo in Uganda and had a large family. My father had four wives and in total I had 28 siblings. As I was growing up, although I loved and enjoyed my mothers I always wondered how these women were able to share this one man I called my father, who was a lovely, wonderful human being. I think the majority of families around us at the time were polyga-mous, so maybe it's female instinct, I just always felt that those women were not happy. Despite the fact that we had food, we were always clothed and they were content doing their chores, I felt there was something missing. As I became a teenager and my hormones began to tell all sorts of stories, I said to myself that when I get a man I'll have him all to myself!

I also decided that perhaps one feature tying these women and many more like them into that situation was that none of them had gone to school, none of them had what you'd call a good education and none of them had a job. So that was my prompt, I wanted to get a good education and a good job, but more importantly I wanted to find a man who would love me, who I could call my man and who would listen when I told him I don't want another woman in my house.

So I worked hard and got myself into one of the best high schools in Uganda, Mount St Mary's Secondary School. It was run by Catholic Irish missionaries who were a special bunch of women! They were very tough and discipline was unquestionable; there was no reasoning with them. If they said 'stand' you stood, 'sit' you sat. And of course, although we were girls growing up, there was

no talk of sex, you were not even meant to have any such feelings without a huge amount of guilt attached. But again, I see the missionaries as mixed blessings because I can attribute a lot of my determination to change situations around me, especially when situations get tough, to the teachings of those women. They were very determined to change all of us into very good and very accomplished women.

After high school, I trained as a physiotherapist, initially in Uganda but then I went to the UK where I graduated as an Orthopaedic Physiotherapist. But before I went away, I found the man of my life in Uganda. Christopher and I found each other when he had just graduated as a radiographer and I was second-year physio-therapy student. By the time I graduated we had already had our first daughter Elizabeth and, before we got married in December 1976 our second child Fiona was on the way; so you could say I didn't exactly pick up everything I learned from the nuns! Eventually we had four children and were very happy; we led a very good life until June 1986 when Christopher was diagnosed with AIDS.

In 1985 he'd got a scholarship to go to Britain to study for his Masters degree in politics and social anthropology. It was a won-derful opportunity for him to go to England with the prospect that when he returned he would have a better job and could earn much more money. After he'd been there a year and had finished his Masters studies he called me and told me he had got a schol-arship to do his PHD which was fantastic news. But just before he had started his PHD work he collapsed and was taken to hospital and diagnosed with meningitis.

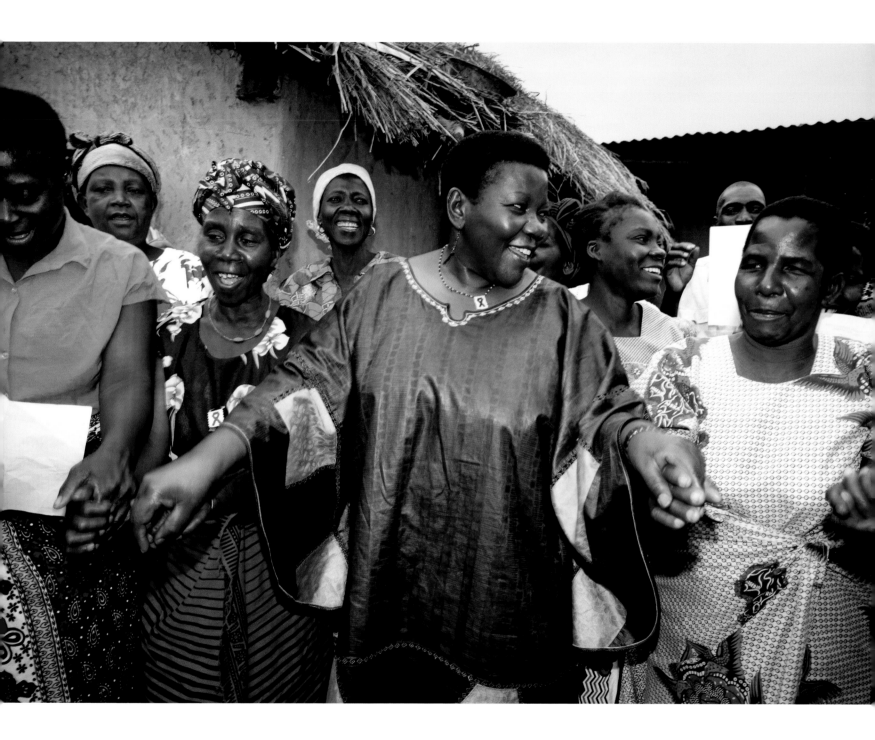

When they did diagnostic tests they established that the type of meningitis he had was very, very specific to HIV infection – called Cryptococcal Meningitis. Once they realised he had this type of meningitis they did the HIV test and found that he was positive. There was panic and pandemonium, especially in the hospital where he was, because he was the first heterosexual case of HIV they'd ever had in 1986.

In the UK, AIDS was being looked at as a predominantly gay man's disease and in that hospital, Castle Hill, where he was taken, they were puzzled because when they looked at his history they realised he had a wife and four children. I obviously thought the hospital had made a mistake; how in the world could they have thought he had this disease. What we found out later was that Christopher was infected in 1983 so he had it long before he went. He contracted HIV through a blood transfusion he had following a road traffic accident, but from that time until he collapsed he was perfectly healthy.

As soon as I got the news the British Council organised for me to go to hospital and be with him. But he wasn't getting any better and he wasn't getting any worse, so we decided I should go back home and be with the children, because they were going through some very big stress. But as soon as I had gone, he also decided he wanted to go home, because he reasoned, and I can totally understand, that he really wasn't living. So he came home at the beginning of December and died on the 23rd January 1987.

The period between the diagnosis and him dying was the worst experience my family went through, in terms of suffering. Knowing that he was going to die, because at that time there was no treatment therapy, but more importantly what he suffered most was the stigma. Because of my doubts that he really had HIV, before I went to England I told everyone – his mother, my mother, my friends at work – that it was obviously a big mistake. But then of course when we realised it wasn't, it was a bit late to retract what I'd said. While I was away seeing him the girls couldn't go to school, because the other children were tormenting them so much.

Once AIDS comes to your house – especially at that time although things have changed since then – nobody invites you to a wed-

ding, or their child's party, your mother can't walk down the street with her head held high because she has AIDS in her family. I remember one time I went to church and took Christopher with me before he died and we sat on one of the church benches, and suddenly everybody stood up and left. It is a disease that robs you of both your health and your dignity, and robs not only the person who is HIV positive but all your family.

After Christopher came home I also realised how different the attitude was where he was in hospital in England to the place he went to and eventually died in Uganda. At Castle Hill we were treated with such compassion and love. In fact, today I look back and think if HIV had turned out to be contagious and you could catch it by touching someone, by combing their hair or by hugging them, then all those nurses in that English hospital would have been wiped out. So then when I returned to my own country and received the total opposite in terms of care and support for my husband, it made me very angry.

In Uganda there's a tradition that your family stay with you in hospital for as long as you need them, and to many people, if you are taken into hospital, left there and people just come to visit, it's seen as abandonment. I have never seen a disease for which people in Uganda brought loved ones into hospital and just abandoned them, until I saw AIDS. So when my husband came back home just before he died, we were in the Mulago hospital, where both Christopher and I had been working, and the nurses wouldn't touch him. He was in hospital from December until he died in January but he wasn't touched once by anybody.

Everything that needed to be done for him, I did along with my mother-in-law, my mother and another woman, Mary who was a friend and key pillar of my support system. We nursed him, cleaned him and even in the last 48 hours of his life when his vessels collapsed and what is known in medical terms as a crack-down was necessary – where they cut your skin and find the vein in a desperate attempt to revive him – I had to do it.

I felt so angry and cheated. Not only did I feel let down by God, but then when the healthcare workers in my home town also turned their backs on us, I was even more angry. But then my anger progressed into a kind of energy to do something and to

prove to God first and foremost that I wasn't a bad person, but also to prove to the healthcare workers that there was something that could be done to improve things.

After I saw the way my husband was being treated in the Mulago hospital, I started looking at other people there who had AIDS and found that their treatment was even more appalling because, unfortunately, not all of them had access to a person like me who had health training and could care for them. So I invited those people I met in the hospital to Christopher's room for us to talk about the issues that were affecting us, and that was the beginning of TASO (The Aids Support Organisation).

Today it is the largest organisation in Africa that works with families and communities affected by HIV and AIDS. So the energy that was loaned to me by anger was turned into something positive. I can't claim that it was anything academic or structured or planned very eloquently – it wasn't. It was really initially a space for us to meet, share, cry and pray.

It was while we were meeting like that that the company director of Action Aid Uganda heard about these crazy, positive people, who were meeting and talking about living with AIDS and he came one day to see us. He sat in a corner and listened to our talking and crying. I think, by then, I was regarded as the group leader, so he called me and said he thought what we were talking about was very important and invited me to his office to discuss it further. He said he would like to work out a way for Action Aid to help us be a more organised group. So he arranged funding, counselling, training and development skills and really was the first organisation to actually believe in us.

After I had been running TASO for eight years and with some very concise guidance and support, it grew from this very small group to being a globally recognized organization. Then I was invited to head up a joint venture between the UN and the World Health Organisation called UNAIDS in Geneva.

I always say to people if you start something good, one of the best gifts you can give it is to leave. Because it's only when you leave that you can prove it had good foundations and can survive. Also at that time after running TASO for eight years, I had got to

a stage where I was emotionally burnt out because I had lost so many people. After my husband died, my sister Rose and her husband passed away; over a period of eight years I lost nine immediate family members to AIDS. I began to worry a little bit about my state of emotion and my ability to continue providing leadership to people. It was also then that I had another test to see if I had contracted HIV; I naturally assumed I had and lived with that assumption despite the fact that an immediate test after Christopher's diagnosis proved negative. I knew the gestation period was quite long so I just left it. But somehow my test eight years on was still negative; by a miracle I was clear.

I took my four biological children to live in Geneva; I couldn't take the 16 foster children I had at the time with me, but it was good in many ways as I realised my own kids really needed the space. It was quite a milestone in all of our lives. I remember my youngest, Christine, had never slept in a bed by herself until we went to Geneva; she always had someone share her bed. I remember her creeping in my bedroom after we'd been there a few days and saying 'Mummy mummy, I have my own bed, I'm the only one breathing in my bedroom.'

After ten years in Geneva and when they had all grown up, I came back to Uganda, because I realised that my role as chair of Action Aid needed me to be a bit more on the ground, be able to have time within the country to be able to accomplish certain processes especially for causes to do with women, women's empowerment and education. So, as well as being a trustee of Action Aid, which is on a voluntary basis, I also work for a foundation called the Children's Investment Fund Foundation. I cover four countries in total, Uganda, Kenya, Ethiopia and Malawi and we work with families and communities, using the entry point of HIV and AIDS and the issues facing affected families.

I have also retained a role to work on the global coalition on women and AIDS and this is realising the position of the African continent; that the numbers of women infected by HIV has already overshot that of men, especially among young women in the 15-25 age group. In many countries there are twice as many women infected as men, for which the issues and reasons why are well known. It is because young girls are having sexual relations

with older men, young children are being married off because families are poor. Kids of fourteen can't abstain and neither can women who are raped or coerced to have sex, they have no choice. There are also more married women who are infected because despite them being faithful, their husbands are not. The point is that many women have no power, little or no education, no income and ultimately no voice. So they are really falling through the cracks. But we are at a stage, especially in Africa, where Action Aid has eloquently come up with no apologies and said 'We are going to work for women.'

I think everything that I have achieved I can say has been a blessing from God. I couldn't say that anything I have done I have deliberately gone out of my way to learn to do and had skills for, but it has been a kind of in-built ability to respond to a situation. One thing I have done is proved that people in a very sad, devastating situation can rise from that situation, given strategic support and given encouragement – the notion of living positively with AIDS is my proudest achievement.

My life motto is never say die – you're not dead until you're dead. I always say to people with AIDS, and of course they smile, dying is not a prospect. Living is. So you can say 'I'm dying' – because you say that, you could be dying for ten years, twenty years. Until you are dead you are living. You are living with a condition – you are living with cancer, you are living with AIDS.

Turning 50 can be different depending on where you are in the world and your context. If you live in a country like Malawi where the average life expectancy for a woman is around 44 or 46, no more than that, you would have very good reason to celebrate because you would simply be living.

I think for any woman it's also a time to start a new journey in your life, it's a new phase; your own space to do with whatever you like. One element for me was that until I turned 50 I never thought about love and relationships again and nearly three years ago I met a man. One might think you can't meet a new man who sweeps you off your feet when you're fifty. I did, I met Stephen – and since then my life has not been the same, especially in terms of looking at myself and feeling as a woman. I always go back to the mirror and do a bit more make-up when I go out

now! Stephen has brought a new lease to my life and I would encourage women turning 50 to reflect, especially when they don't have a spouse for whatever reason, to look at love, relationships, the way you look at your career, your family, the way you look towards enjoying your grandchildren if you have them, and the way you look at life as a whole.

I have a network of friends around the world who call themselves 'FONK' – Friends of Noerine Kaleeba. So when I turned 50, they threw a humungous party for me. We are not exactly advocates of vegetarianism – so many, many cows died! There was a massive feast and a barbecue for two days – cows and goats were brought from all corners of Uganda. I saw it as a celebration of a new era in my life, an era of putting the icing on the work I started because it was at that time I decided I was going to leave UNAIDS and come back to the frontline. So today, I'm in my mid 50s and I feel like I'm 42. I feel a very, very focused energy that I want to use to make a difference on the issues I feel strongly about. For me, 50 plus is a very exciting decade.

Linda de Cossart

Who: Linda de Cossart
When: 9th November 1997
What: Consultant Vascular and General Surgeon, Chester Countess Hospital

'I think the whole God complex thing comes from having to perpetuate an image of always being in control and of course, you have to be in control.'

I decided when I was about 8 years old I wanted to do medicine; I watched *Doctor Kildare* and *Emergency Ward 10* and it seemed like a good thing to do. When I was an undergraduate 30 years ago we had quite a long exposure to surgery, almost 6 months of the year was spent doing surgically related procedures. I enjoyed the style of practice and operating and being in theatre; surgery is different from any other aspect of medicine in that we have strict deadlines and there's a momentum and pace to the whole thing.

Everybody thinks about the fact that a person's life is in your hands and that surgeons are great showpeople who never seem to be bothered and are terribly macho and larger than life. But behind closed doors the majority I know will actually reflect quite carefully on the problems they've had and worry about them. I think people would be surprised how many go home and angst about the decisions they made that day or what went on in theatre. Part of being a good professional is considering your job carefully. If you don't, you don't develop from where you were. We have always worried about our patients but currently it's highlighted – more so by being endlessly pursued by complaint and litigation. I don't think litigation has driven us to worry about what we do, but there is an element nowadays of it because of the risk of getting criticised.

When you're going to operate on patients you have to recognise you're going to be the lead person for caring for that patient when they're in theatre. And although we can have pre-planned what we are going to do, you still find things you don't expect. Their arteries can be much worse than they looked on x-ray, and as a consequence you need strategies in place to deal with the situation you find. You have to be very brave to change your mind, sometimes you have to be brave to stop a procedure and admit you

can't do anything more. Sometimes one of the bravest things is to tell a patient they shouldn't have an operation at all, which can be much harder. It's much easier to say I'm going to do an operation that will make you better; telling them you aren't can be very difficult. I think people have a particular impression of surgeons – the whole God complex thing comes from having to perpetuate an image of always being in control and of course, you have to be in control.

I think one thing I am set on doing in the next few years is to make sure that young doctors and surgeons particularly can argue their case. They are so controlled by guidelines and protocols that sometimes they give up and follow protocol rather than argue the case. Arguing their case is something we aren't teaching them to do enough. We work in a system where sometimes the most logical decisions are not always made and you have to be prepared to fight your corner. In equal parts, it's a very exciting, motivating job that can also be incredibly tiring and frustrating. It's frustrating in that there's always more work to be done than there is time to do it and that new technology and new equipment is being developed faster than we can afford it. There's always an anxiety that you'd like to do more, you'd like to get better equipment, certainly more recently the procedures on controls and availability to get new equipment are greater and greater, which makes things difficult.

The most depressing thing for me at the moment is that the NHS is being broken and disintegrated and is irrevocable in a way. The Health Service in the future is going to be much more expensive for the individual patient and for society. We will get to the stage that if you can afford it, you can have it. There is lots we can do to improve it but we had a system that was probably the best in the

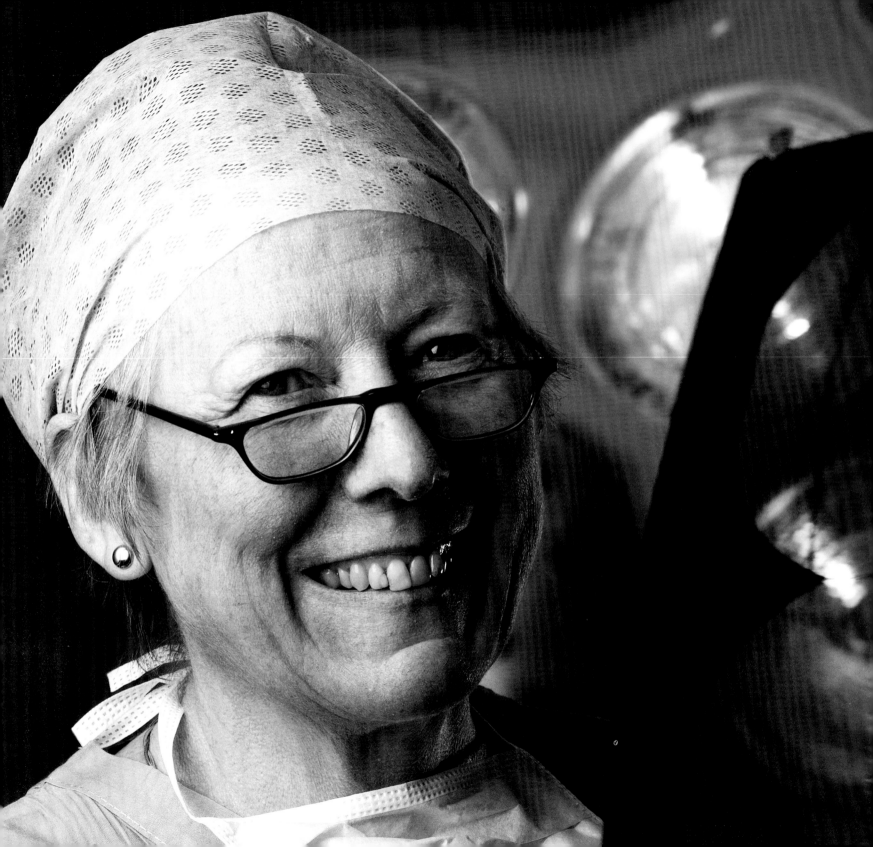

world. Yes, we were untidy, yes we were messy, but we were extremely efficient because we spent relatively little money. We had to improve the timeliness within which patients were seen and we've done well on that. The independent treatment sectors and the way healthcare is changing may be good for a modern affluent society, but I'm not sure that it won't bring with it a more underprivileged society than we've seen before. It scares me to think what will face young people I know and care about in the future, it also concerns me as an individual, who hopefully is going to live for another 30 years, as to whether the service is going to be there at all.

I've been lucky in my career; I've held quite important appointments as a consultant and been heavily involved in training and education. I was very instrumental in setting up the vascular service here in Chester and we have a very good and wide-ranging surgical team of which I'm very proud. We are constantly evolving what we do and developing it. As a consequence we've attracted young surgeons to work with us. We've got a research base and I think that's a really important aspect of what I've achieved. On wider issues, I'm very proud to be able to take part in both the regional and national development of surgery; I've been elected to the council of the Royal College of Surgeons where again, the emphasis is on education and training, and, in particular, women and their roles in surgical practice. I'm pleased to say we are getting more women through, certainly in the training grades, and I'm hoping that in the next 5 to 10 years they will appear as consultants.

As I get older I think more and more of the need to leave some kind of legacy, however small. One thing I've managed is to introduce a proper on-call rota system for our hospital that is now used across the districts. It used to be very ad hoc. Many surgeons used to say they had no objections to being on call and didn't see what the problem was, until you called them and they'd be on holiday in India or something! As a woman I wasn't prepared to be on call on such a random basis so I thought I had to put something else in place. My system was a real success and the first one in the country that worked. It was a huge leap in my feeling of relief at going away at the weekend, being able to hand over to someone capable. It is nice to think these systems will be in place and continue to work long after I've gone but it is a very shifting field. The main

principle I hope I have instilled is that things should be done well.

People often think that working in this profession automatically means you look after yourself better, but it doesn't. The thing I'm not good at is expecting my 50 year-old body to still do the things my 30 year-old body could. Physically you can't be up all night working, then work the next day. Mentally I'm probably better equipped now to do that, but physically it does take its toll. I don't think you become more emotional as you get older in this job, though you can have more empathy if you've had more personal experiences with death and disease and that does affect how you look at things. You become more considerate and reflective about what you do to patients. You don't expect to make them perfect after you've operated on them and that communication is an important aspect of talking about what they can expect from you. Since I'm often dealing with patients who are older, I can empathise with them because they are often the same age as me.

Turning 50 should definitely not be a trauma, you have to look at it in terms of having an awful lot of experience behind you; the only sad thing about being 50 is that you wish you'd known what you know now when you were 17! Plus I still think I am 17 sometimes and suddenly have to draw myself up and realise I'm not. You have to recognise you're older and look at it as a new adventure where you can explore more mature aspects of life and influence people in a different way. Even to the point of slowing down and taking a more measured look at what you do professionally and personally, and making a more sensible balance of what you do in life and work. Though I suspect that any of my friends and family reading this will say, 'Yes… good words, but will you actually do it?!'

Of course, I have made sacrifices, personally and financially. There have been certain things I've missed out on, special birthdays, children's christenings when you're godmother. I made a decision around the age of 50 that I would always make it to funerals because they only happen once. But I certainly wouldn't have done anything differently if I had the chance. The main thing for me has always been to be principled in the things I do and to be fair, honest and give my best, in whatever I'm doing. Never be put off by things that are seemingly put in your way, don't take no for an answer and above all, make things happen.

Sylvia Strange &
Jean Grange

Who: Sylvia Strange & Jean Grange
When: Sylvia, 13th October 1991: Jean, 24th September 1991
What: Queen Victoria and Lady Ponsonby Enactment Actresses

'I've got a friend who's a lot older than me and she says when you get older you're seen as a shadow, nobody takes any notice of you. And I said, "Well, that's certainly not going to happen with me."'

JEAN: It started when we were in the Leicester Antique Market where we both have a stall and there was a Victorian Open Day. Because Sylvia was termed 'dumpy' she was asked to be Queen Victoria and I was just a Victorian lady.

The next week Sylvia heard a radio programme asking for people to come for auditions for Queen Victoria so she rang me up and asked if I would go with her as she didn't want to go on her own. So we decided to go and got a friend, a very pedantic little man, to drive us. We were sitting in the back of his car with a bottle of Irish Mist, two glasses and two sausage rolls. He was very worried about us making a mess and kept saying, 'Please don't make any crumbs in the back of my car or spill the Irish Mist.' I assured him there was no chance of us spilling the Irish Mist but we would be careful about the crumbs. So we had two or three glasses on the way up and decided what we were going to do for this audition. When we got there, there were eight other entrants. It was most peculiar because one of them was a man doing it in drag and another woman was auditioning using vegetables!'

SYLVIA: Even though we hadn't really planned what we were doing and were quite inebriated by the time we got there, we did a little act of Lady Ponsonby fussing with my dresses and cane and generally had a bit of a laugh. To our surprise they wrote back and said they'd love us to do the job. When the local paper asked

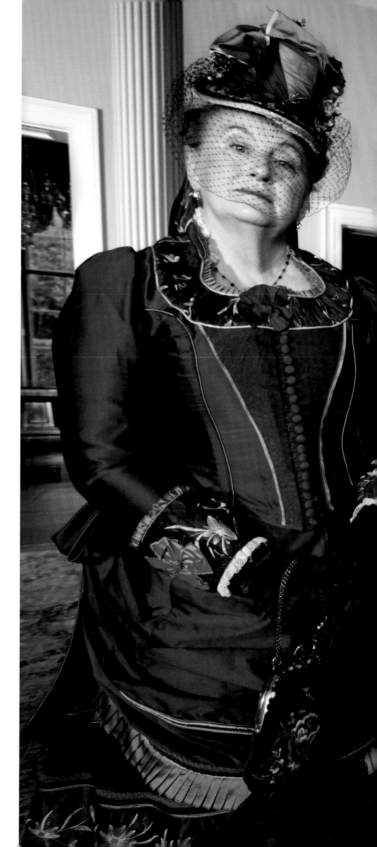

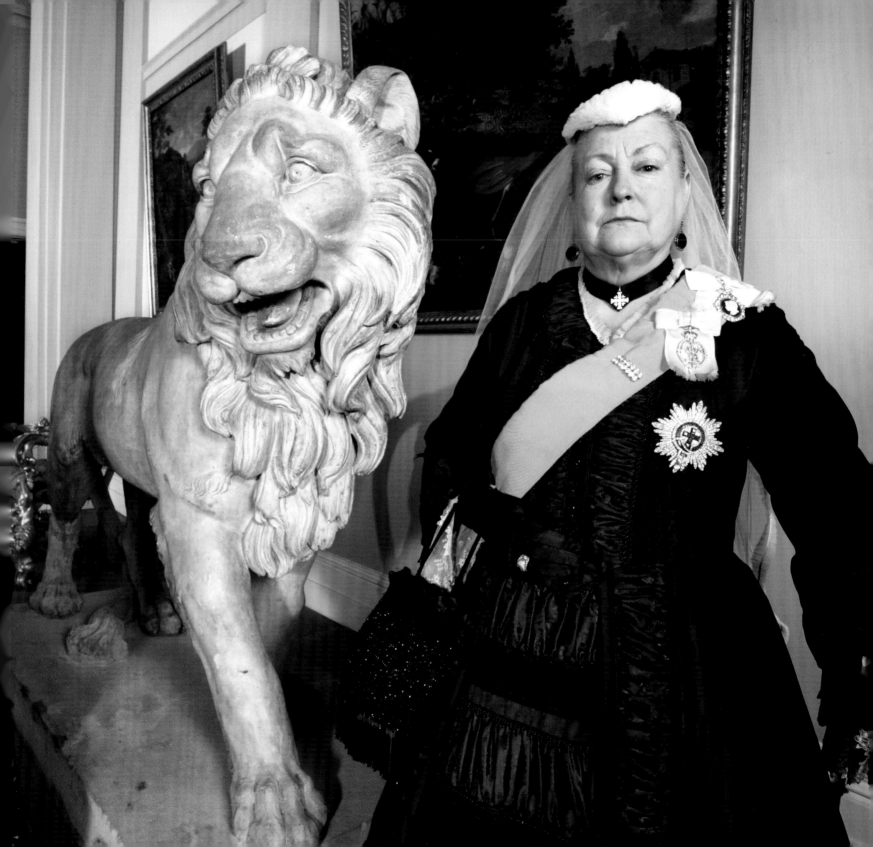

us if the competition had been stiff, we said, 'Oh terribly – we were up against some really good people' – naturally we didn't mention Mrs Vegetable and the fella in drag.

JEAN: We work probably once a fortnight and are professionally booked. We would say we are professional now because through the years we've done our research and we've also got these fantastic costumes. They were made for us by a lady in London who works for the film companies. Because we're enactment actresses people come up close to us; you'd be surprised how many people do actually look at the costumes in real detail so they have to be really well made and accurate.

SYLVIA: When we first started having our dresses made, we had people who made costumes for the theatre. In theatre you can get away with a lot of things – like rough stitching and sewing and cheap jewellery. But we couldn't get away with that now. We started working regularly during the year of the Silver Jubilee when English Heritage got hold of us. That was a lucky break, it really was for us, because then we went all round the country which was lovely.

The reaction we get from people differs really, but it's very interesting to see how people play the part. They will come and say, 'Oh your Majesty I saw your house at Osborne last week,' and then you get talking to them and they tell you about their lives. The one that comes to my mind was a lady in a wheelchair who was just so pleased when we were out meeting and greeting everybody and the 'Queen' came to speak to her. I think the biggest surprise has been that the children like us. We didn't realise that she is on the National Curriculum so they know something about Victoria. They always recognise Victoria.

For me the most moving thing was when the American Civil War Society were having a re-enactment and there were these huge battles going on on horseback and on foot and there was gun powder going off and everything. They asked us to take part and I explained that they were going back to 1860, whereas I was from 1880. They didn't seem to mind and asked us to take the salute of the Confederates coming through. So they came over the brow of this hill, marching down, rather ragged soldiers, but they really lived their characters, their knowledge was

phenomenal. There were tears in my eyes as these men came past and they all said hurrah for the Queen; it was very moving.

JEAN: One of the things I remember was when we had to go and meet these die-hards, a unit of Victorian soldiers who are really serious about it. We were asked to give out some medals to some of the long-serving soldiers and they were just so thrilled to have Queen Victoria there, absolutely! So that was quite moving too.

SYLVIA: What we've really enjoyed is meeting people. People who are completely different from those we've met before, and we're doing things that are different from what we've done before.

The funny thing was we'd been in the market together for ages but we didn't know each other as friends before. We just hit it off at that Open Day, something sparked between us and it really works incredibly well. I wouldn't like to do it on my own – a) because it wouldn't be half as much fun and b) you can't develop the Victoria character without Jean. She allows me to be cross and people love that because Jean makes mistakes and I scold her. If I make mistakes I blame things on her. We have a wonderful friendship. Though I probably get on Jean's wick – I'm sure I do because I'm pedantic and nit-picking and a perfectionist. And we are just like an old married couple; we have our ups and downs, usually when we're in the car, trying to get to places and getting lost. Then we get terribly polite because I think it's her fault, she thinks it's my fault!

JEAN: Yes, I've just purchased a Navman so we're going to try it out and see if it helps us because we are actually notorious for getting lost. I think the problem is we're always chatting too much; we don't concentrate enough and end up going off on a tangent.

SYLVIA: I think doing this has given us a lot of confidence. I wasn't even interested in Queen Victoria particularly and didn't know anything very much about her, only that I loved Victorian artefacts, clothes and so on. But it's definitely given us a new lease of life, and a chance to do something really interesting that we can grow into; after all, Queen Victoria did live until she was 81.

JEAN: It has and having the confidence to do this means you have the confidence to try other things as well. Also, as people, we

have more self assurance because it probably makes us more interesting. When people ask us what we do and we say we are re-enactment actresses they think, 'Oh that's a bit different'. And our families are both very supportive, they're very interested in what we do. For women our age, I think we can take quite a bit of satisfaction in knowing that we can do something well at this stage of our lives.

SYLVIA: The great thing about being older is that you're not incompetent any longer. I think that's terrific freedom. But I suppose I can say that because I know we're good at what we're doing. It has created a completely new dimension. Because when you do get to over 60, which we both are now, we're still as keen to do things as ever; I can't ever imagine not working. We've both done antiques for a long time, Jean's done a lot of different things before antiques and so have I, but I think this has made us think that there are other things out there.

JEAN: My advice to anyone over 50, 60, or whatever their age would be to go and try something new, something you haven't done before. People are living longer now and I think if you've got an interest, an absorbing interest, it keeps you young, it keeps you going. It keeps you looking forward. I think you have to look forward all the time; you can't sit back and think about what you have done. I feel that this is just the next stage of our lives, we've both had lots of different experiences, lots of adventures and this is just another thing. Like when Sylvia worked with Mother Teresa.

SYLVIA: I just went out to Calcutta to see if I could help. I'd seen all these news stories on the television about her and I thought 'that looks interesting; I'd like to go out and do that'. I'd just been turned down for a job in blind welfare and was so miffed I thought 'Sod it, I'll go and help Mother Teresa. Somebody will recognise my talents.' But of course I didn't choose to go to London, it had to be somewhere oriental and dramatic and you know, I was just fulfilling a personal thing but it was very interesting. In truth I really couldn't do anything there to help and, being a very astute woman, she said to me when we were out in the street one day, 'What would you do for that blind man over there?' I said, 'Well I could teach him to be independently mobile,' and she said, 'But he begs for a living and people give to him because he's immobile. Are you going to take his living away?' In the end I thought, 'I am a very small cog and not particularly useful!' I was a bit of an embarrassment to them really.

Saying that, it was a wonderful experience, absolutely terrific, but anybody who does that kind of work must never think they are holier than thou – they're not. People do it for their own satisfaction really, as Mother Teresa did. It was for her own satisfaction that she went to an open order where she could do what she wanted to do. Jean's done things as well, we've done lots of different things but I think this allows you to show off a bit.

JEAN: Personally I've had a hell of a life really, I've enjoyed it so far and I always want to do other things, more things. I'd like to have another lifetime really to do all the things I want to. My mother died when I was five and I remember thinking I was going to have as many experiences in life as I could because I might die young, so I have.

SYLVIA: When you experience death or the prospect of it, it does give you a reality check. I had breast cancer when my children were very young, just as the second one was born. It was very frightening because I found myself looking around thinking 'How's this husband going to manage if I die and there's nobody to look after these young children?' I ended up having a mastectomy, there was no other choice really but I came through it and, although it was a difficult time, I consider myself very lucky.

JEAN: Yes, we're still alive and kicking. I've always enjoyed adventure and doing different things. I used to work at a climbing club and I've done all sorts of things like dropping out of aeroplanes and flying Microlites and all that and, in many ways, this is another kind of adrenaline pull. I've got a friend who's a lot older than me and she says when you get older you're seen as a shadow, nobody takes any notice of you. And I said, 'Well, that's certainly not going to happen with me.'

SYLVIA: That's right. My philosophy has always been give anything a try; to have as many different experiences in life as you can. Doing this job means we can carry on for as long as we possibly can. After all, what better job are you going to get when you're over 60?!

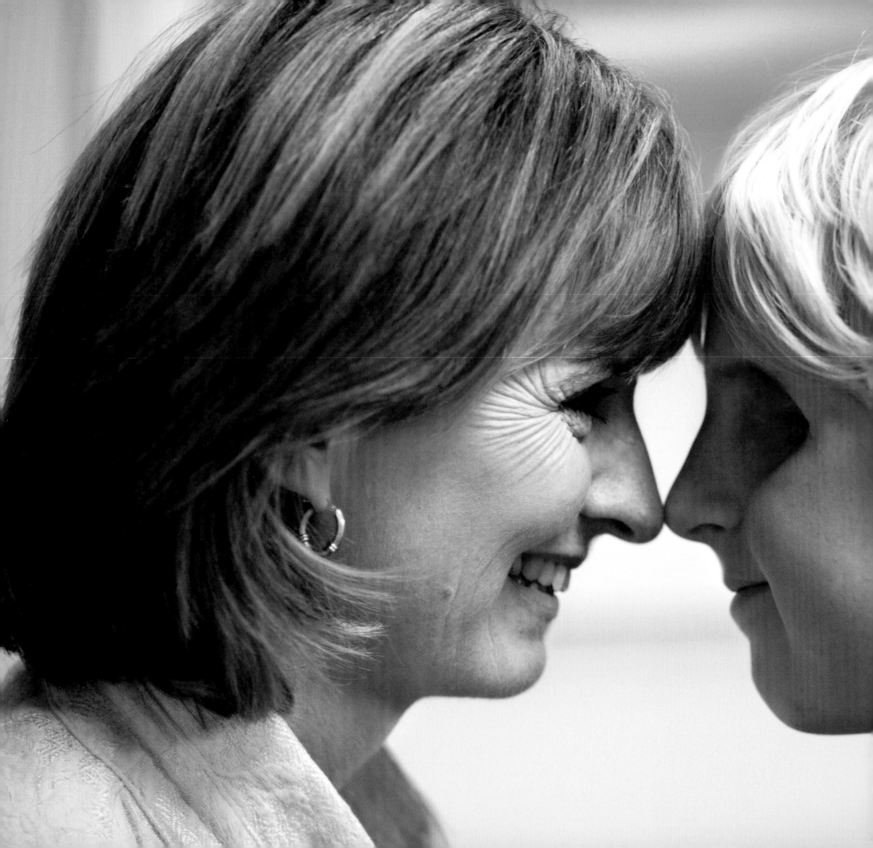

Adi Roche

Who: Adi Roche
When: 11th July 2005
What: The Angel of Chernobyl, Founder of The Chernobyl Children's Operation

'To be offered the unique privilege to intervene in the life of another human being; that to me is the meaning of true love.'

I come from a place in Tipperary called Clan Miel which means 'meadow of honey'. It was a very fertile land and very wealthy in terms of the environment so I have always been interested in this subject. As well as their day to day work; my mother as a house-wife and dad as a technical engineer, my parents would do a lot of volunteer work and very much had a social conscience. There was a big travelling community where we lived, so we were used to sitting round camp fires and experiencing different ways of living from a very young age. We saw in our community that people were hungry, cold and poor and very subtly and slowly learnt that all things in life were certainly not equal.

We were also a big debating family reared on discussion and, from the age of around 3 or 4, I remember mum and dad would make sure we knew what was happening not just in Ireland but around the world, like in Africa and other distant lands.

I was a very bold girl in school and very interested in social activity, anything that would keep me away from book work really. When I was 8 or 9, I initiated a collection for the starving Biafrans during the war in the late 60s. We'd have bazaars and dress up to raise money and send it out to Africa.

One of my biggest influences was definitely my grandmother, she was around when colonialism was at its peak and Ireland was being stripped of its culture, language and spirit. She would tell us how the population was halved in the mid 1800s because of induced starvation, despite Ireland going through one of the biggest export periods of its history. Ships were queuing up at the

ports to take goods away from us and yet half the country was starving. A story she told really inspired me. All the way over in America an Indian tribe called the Choctaw's, who themselves had experienced the same fate during what was known as the 'Trail of Tears', heard about what was happening on a little island near Europe and decided to help. They put a collection together and sent over bags and bags of grain and corn to Dublin and Cork to help us.

That sort of thing reverberates in our psyche as a nation. We have an affinity with the oppressed and those who have suffered injustice. Ultimately it taught me compassion and respect and also that kind, generous words are all very well but action is what really saves people.

After I left school I wanted to be all sorts of things, a ballet dancer, an architect, an astronaut; I'd still like to do all those things! Instead I became an air stewardess for Aer Lingus and I loved it because I just loved people so much. But it was around 1977 or 78 that I saw the film *The China Syndrome* and found out that Ireland was going to build not one nuclear power station but four. A couple of years before that I'd been to my first anti nuclear rally and had just been in awe of the speakers. One particular lady Petra Kelly, a Member of the European Parliament who was eventually murdered because of what she believed in, had me enraptured and really awakened something in my soul. Another lady who spoke was a radical Native American Indian called Wynona La Duke; she was from the Black Hills of Dakota where the nuclear chain began. Most of the reservation died because of uranium mining, which killed not just the people but the land too. My jaw just dropped listening to them speak; they were incredibly important early role models and mentors for me.

So I went to work for the Campaign for Nuclear Disarmament (CND) and it was in our offices there on 26th April 1986 that I saw the first bulletin on the BBC about a nuclear incident in the Soviet Union. I remember thinking at the time, 'Oh my God, everything we've talked about has just happened.'

The Chernobyl nuclear power plant was located 80 miles north of Kiev and had 4 reactors. Scientists there had decided to carry out some experiments on Reactor Number 4 but had disregarded

advice and numerous safety procedures. These were also carried out without a proper exchange of information between the team in charge of the tests and the personnel responsible for the operation of the reactor. At 1:23am the chain reaction in the reactor was such that the balance of power couldn't be controlled and, despite the foreman's attempts to shut it down, it was too late. The reactor overheated creating explosions and a fireball which blew off its 1,000 ton steel and concrete lid, spewing 190 tons of radioactive materials 7km into the atmosphere.

More than 30 people were killed instantly and, as a result of the high radiation levels in the surrounding 20 mile radius, 135,000 people had to be evacuated.

All of us had to quickly move from theory to reality and we immediately set up an emergency hotline for people to call if they wanted advice or had any questions. We followed regulations from Germany that advised pregnant women and children not to go out, that people not eat green vegetables and that kids should not play in areas like sandpits or anything. I am very proud that we did this despite our governments of England and Ireland having been convinced by propaganda from the Soviet government who said all was well and that the incident and the radiation had been contained. But due to a lack of information and ignorance we were all exposed to radiation in 1986, 68% of the UK and Ireland's land mass was contaminated due to heavy rainfall. Even now there are some farms that are still not allowed to sell livestock and produce because they were contaminated; this information has only recently been released. But new figures show there were 15% more cancer deaths in that year than have been previously suggested. Part of our work has not just been about helping people but unmasking the cover-up that surrounded the disaster. Chernobyl was a huge turning point for me; my life really began when that happened.

In the same year the scientists responsible decided to tell the truth at the International Atomic Energy Agency Conference. Having previously said that an accident like this couldn't happen, they wanted to admit they were wrong and they tried to let people know. One of the men, Valery Legasov, could not live with the lie or the deception of what his own scientific colleagues had helped

to create and he committed suicide two years to the day of the accident. His note found after his death said, 'Today no task is more pressing and noble, not only for a scientist, but also for any sober-minded individual, than to prevent nuclear insanity.'

What many people don't know is how many unsung heroes there were who saved so many lives by burrowing under the ground to extinguish the fire just in time to stop the radiation spreading further and reaching critical mass where it would have destroyed much of Europe. 25,000 firefighters and miners died and a further 70,000 who were contaminated have or will die since it happened. Twenty years on is nothing really, it's like a gestation period; we need to think four or five decades ahead to when the real impact will be. We're dealing with an invisible enemy that paralyses everything in human life, genetically. The life cycles of the earth are delicately balanced as is the link between man and nature. We have to recognise how precious life is in the hands of man.

After years of being prevented from going to Belarus and seeing what was going on for ourselves – the KGB ruled the roost then – it wasn't till the end of 1990, beginning of 1991 we could actually go there and do any hands-on work. We went to the heart of the contamination zone to a hospital in Gomel and everywhere we went children would follow us around hoping for a little treat of some kind. But on one particular occasion a little boy shouted out louder than all the others. I asked the translator what he had said and she replied, 'Please take me to your country; I will die if you leave me here.' He was only 8 years old and had a condition called 'Chernobyl Heart' which was like a time bomb, they had no medicine there to treat it and, as he said, he would certainly have died.

So I got a businessman from Iceland and another from England to help me; one lent me his jet and we took four children out of there, we had no authorisation to speak of, or a runway come to think of it, we just took them away when it was dark and flew them to Ireland. Three of the children survived but the fourth, a 7 year old little girl, didn't. We got her back and she fought so hard to live, she wanted her life so badly but she died in my arms of a massive heart attack. I was heartbroken; she was an amazing little girl. It was in her name that we set up the operation, The Chernobyl Children's Project. The truth had to be told; in Belarus every day parents were being told all they could do was take their children home to die.

Since then we have tried to make life better for thousands of children, whether it be getting them out of their environment during the most dangerous time of the year, the summer, and bringing them to Ireland for a holiday, or giving them life-saving medical treatment where we can. But there are still children dying all the time that we can't help which is devastating.

The long term aim after 20 years and looking to the future is that we are offering hope to live, and moving things on from tragedy to recovery. The work we do in the next 20 years will transfer from being an emergency service if you like, to a long term sustainable relief and development agency, to continue the journey.

One of our aims also has been to get the message to as many people as possible about the lasting effects of radiation. One of the greatest moments for me professionally was winning an 'Oscar' for a short film, *Chernobyl Heart*, in 2004. Myself and a camera woman, Mary Ann Deleo, produced it between us to let the world know the effect the disaster had and is still having on the children there. As a result, I got invited to show the film and speak at the United Nations Assembly. It was absolutely amazing; powerful, awesome and frightening at the same time. I remember standing there seconds before I spoke just realising the weight of what I was doing and that I was about to give the most important speech of my life.

More importantly, we have to keep the communication going and start with young children; kids at 1st or 2nd grade are a powerful wealth of openness. They aren't born prejudiced or to hate or be violent, so we have to change societal patterns and nurture them into recognizing their responsibilities to the earth they live on and the people they live among. It's also about challenging ourselves not be too overwhelmed by the enormity of the issues and to realise that no amount of effort to change things is too small.

The work we do in schools is such that we teach children of the amazing gift of life the earth is. That we have to look after this

amazing thumping, living organism; our inheritance as it were. We are the caretakers of the earth. I will never forget the words one of the American elders who said to me, 'Mother Earth is only one being and we the children of all nations must learn to protect her and all living things and help to hold the world in balance.'

As I get older I think about what we've created over the years with the organisation and the importance of leaving a legacy behind. Turning 50 was a big turning point for me, a real defining year; I lost my mother and began to realise I'm not invincible and would have to start thinking about the future. If my life's work dies with me it will all have been for nothing so I want to prepare that pathway, which sounds a bit spooky I suppose. I also find I am more philosophical than I was before and I have more hope than I did 30 years ago. I evaluate things differently now and assess how I use my time.

I also found that having been an activist for 30 years and always being the youngest, I suddenly realised I am now the oldest! But aside from a few interesting changes in my body I don't think of myself as being a particular age, I still see myself as a human dynamo bursting with life and full of ideas and inside I'm still the wild woman I always was.

A very proud moment for me was being named 'Tatler Woman of the Year 2006'. It was just incredible at the award ceremony that this room was full of 1,500 of these awesome women who were my heroines and mentors. It was an extraordinary moment for me and a great gesture of solidarity and support for all the volunteers we've worked with and the hundreds of people who have died over the years who will never be forgotten. I was proud to receive it in their name.

The award itself was absolutely beautiful; it was made by a female glass blower and was a model of half the earth with a crystal star in the middle. It was made from Waterford Crystal and was a complete one-off. Everyone was looking at it and one woman came up and asked if she could have a look. All of a sudden I had this feeling that I knew she was going to drop it, but I didn't feel I could say no. She picked it up and it fell right out of her hands and smashed into a million pieces on the floor.

I thought she was going to have a heart attack. It was strange really because the day before the awards I had come back from a trip to Chernobyl and six children there had died while we were there, so in the great scheme of things it really didn't matter. The good thing was, as a very influential businesswoman she's now going to organise a big fundraiser for us, so to be honest I'd drop an award every day if it meant raising more to help those kids.

On a personal level one of the loveliest moments for me was when a little boy called Alexi came into my life on Christmas day in 1995. He was four months old, dying of a tumour and flitting between life and death. He had been abandoned and my sister and her husband had offered to adopt him. He was put into my arms with no clothes on, it was -25° and he was just the most extraordinary gift. He had numerous life-saving operations and was at one time declared brain dead, yet now he's a fit and healthy little boy who is the light of our whole family. To be offered the unique privilege to intervene in the life of another human being; that to me is the meaning of true love.

Maneka Gandhi

Who: Maneka Gandhi
When: 26th August 2006
What: Member of Parliament, India, and Animal Rights Activist

'All of us have been afraid and if I can make that fear a little less for someone and make them believe someone is there, then my life is not truly wasted.'

I was born in Delhi and my father was a Colonel in the army, so like all army families, we moved every three years to somewhere else in India. We were taught to do everything on our own so I was a very independent child. We didn't make a lot of friends because of moving about so much and circumstances dictated that my brother, sister and I all loved reading and nature; quite solitary pastimes. Reading because my mother was very very strict about it and we were always encouraged to go to the library. We grew up with nature because the army bases tended to be set in the countryside. I think I had my first anti-rabies shots when I was 8 because I was always feeding stray dogs. Growing up with animals and nature is what shaped what I am now and the way I have lived my life.

Finally we were put into boarding school, The Lawrence School in Sanawar which was extremely disciplined. In Kipling's book, they sent him there to make a man of him; that's what happened to me. Though technically it wasn't an army school, it felt as if it was. When I came out of school I went to college, and in my first year of college I got engaged. I was married as soon as I turned 18.

I met Sanjay at a cousin's wedding. I had just turned 17. I went with my sister who was 14 and my brother who was 13, so we were very much part of the childrens brigade there. I was standing in one of the rooms having just gone to the buffet and got food. Somebody walked up to me and said, 'There's this huge queue for food and I don't think I'm going to make it so can I take something off your plate?'. I thought it was one of those people who gatecrash weddings just to eat the food! After I'd left he asked my cousin who I was because he'd like to know me.

My cousin told him to stop being stupid, that I was only 17. Sanjay was 10 years older and he was due to get engaged the next day. He cancelled the engagement to somebody he'd been seeing for a long time, and said, 'I'm sorry about this but I've met somebody I'd like to marry.' We were married six months later.

It was just as if I'd found my other half. I can't say it was a hugely exciting love but it was like I was incomplete and I'd come home. He knew immediately, it was as if he'd known me forever and I'd known him forever too. I just knew from the minute I saw him. There was no courting though, when we did go out I had to be back home by 8pm. Then one day we went to his house and he said he thought it was time I met his mother. I suddenly realised who he was; Indira Gandhi's son. I burst into tears and told him I wanted to go home. I cried all the way home; when I got there my mother said, 'Well he's not going to introduce you now.'

When I finally met Indira she was nice, although I can't remember much about it except my own terror. I think she was a bit taken aback because she thought I was a bit young. Everybody in that house was much much older; I went in like a little girl at 17, and came out a woman. They were a nice family; really reserved. I just met them at meals until I was married, and then everybody was enormously busy all the time. After the wedding I was ordered to go back to college. I tested them a bit by saying I'd got married to save myself from college; I had no desire for more education. But it was made quite clear that everybody there went to college.

It was a very busy life, we were travelling all the time. It was particularly stressful at that time during the mid 70s because an Emergency had been declared and politically it was a time of great

upheaval. I didn't really have a clue though as to what was going on, I went to college each day and came back to be with my husband. It's amazing how little I can remember. All I remember was him. I'm a very focussed person in the sense that I very rarely see the whole picture, back then it was always Sanjay. If he entered a room that was it, nobody else was there. So I can only remember things in relation to him and that was over 25 years ago. I didn't finish my degree at college because the elections came along and I had to either sit for my exam or go and campaign for my husband. I went to campaign and was quite relieved I have to say, no more studying. But then the elections were lost so it was very traumatic after that because everybody was in and out of jail all the time. This used to happen in India, if you lost you went to jail and everyone was really pulverised; it was the first time the communist party had lost. After three traumatic years they came back into power and won the election again. By then I was expecting our son.

When our son Varun was only 100 days old Sanjay was killed in a plane crash. While I was pregnant I started getting bad feelings that Sanjay was going to die. I used to lie awake at night and couldn't stop crying. By the time our son was born I was in tears constantly. Everyone said it was post natal depression but I knew differently. I already had my pilot's licence. Sanjay had taught me to fly and he had just taken delivery of a new plane. He took me down to see it and I sat in the cockpit; I was beside myself, crying hysterically and begging him not to fly it. He was all set to take it out the next morning. Later that day I went to see Indira. 'I have never asked you for anything in my life but I want you to forbid him to fly that plane; I don't care which other plane, but not that one.' She spoke to him but he said he would just go up the once, and she jollied me along and said that maybe the plane was meant for men not women. The next morning the maid came in with big tears in her eyes and said that my mother-in-law wanted to see me. I rushed to the hospital still in my pyjamas. As I got there I saw his body being brought in; it was as if someone had just kicked me in the stomach and I just doubled over. I asked Indira if he was dead and she said no, which of course he already was, she said that he was alive and they were going to operate on him. With that she locked me into a little room. Three hours passed. It was the longest and worst three hours of my life

because I still had hope, and where there is hope there is pain. That time was so traumatic that nothing else about that time has stayed with me apart from that. By the end of it when she finally told me he was dead she asked if I would like to kiss him goodbye; I couldn't, I had to get out of there.

God knows why she did that, it would have been much better to tell me he was dead straight away. I knew it in my heart anyway. The truth was that on the same night I had the feeling he was going to die, so did she. Obviously you don't go to your mother-in-law and tell her that her son is going to die and she says, yes I know. So instead she began to have a fast each Tuesday to keep him alive, because that day belongs to the 'air', and yet she let him up in that plane? I only found out she did that because he died on a Monday and on Tuesday she didn't keep the fast. For 2 years I don't remember anything after that, I don't remember who I met, who I talked to; obviously I was there living and breathing but I almost lost two years after that. It makes me sad that I had so little time with him and I think of him all the time. Though I don't think he'd even recognise me if he came back, apart from the fact that I'm about 500 kilos fatter, but I've sort of changed so much as a person also.

Sanjay had a huge influence on my life. One of the best pieces of advice he ever gave me which I have applied to every aspect of my life since, was that to change something I must first change myself. About 2 months after we married, he said, 'You know I can't bear this, you always go on the whole day saying you're saving this and you're saving that, and then you come home and eat meat. I would suggest that if you're going to change the world you should change yourself first.' That was really the strongest lesson in my life. I stopped eating meat the same day – I didn't really realise that I was eating what I wanted to save. After he died I started the first animal shelter in India, and named it after him, the Sanjay Gandhi Shelter. I was working with animals and had started getting involved in politics. Though it wasn't common knowledge as I didn't know whether anyone would appreciate it or not.

Obviously having the family name made a huge difference. But of course if there wasn't enough learning or enough truth behind what I said it would be of no value – it would get me the initial

crowd. It's like a movie with film stars in it – if the movie itself is not worth anything then nobody can pull it through any further than the first few days. So I had to study and learn a great deal. For a long time my opponents would try to say that I only cared about animals and not people, but they can't say that anymore because I usually win my elections by the largest majority in India. But I remember one election, my 44th I think, my opponent was telling everyone not to vote for me because I only loved animals. When this lady had finished speaking, she got off the stage and into her car, and a troop of monkeys suddenly appeared from nowhere and tore up most of her posters. The headlines in the newspapers said 'Monkey's enraged!'; it was very funny.

In the last elections my opponent said I had released 50,000 monkeys and another said that 500 tigers had come into the area because of me. I think it's just that they have nothing else to say about me. They can't say I've stolen money, that I come from one caste or another or that I've done awful things so they come up with some quite bizarre stories. I have no idea what to say about it really apart from 'well don't forget I also released a billion mosquito's into the area too!'. The good thing is that people get fed up with it after a while and I just tell them to get on with it.

After I lost my first election I started travelling around a lot of India, to find out what we could do, what was going well and what needed attention. Eventually after some years of working actively on environmental issues and writing various articles on the subject, I won my first election in 1989 and served as Minister of the Environment in VP Singh's cabinet. In 1996 and 1998, I was re-elected to the Lok Sabha as an independent member and served in the BJP led governments as Minister of State for Social Justice and Empowerment, and Minister for Culture. One of the things I'm most satisfied with was the creation of the Department for Animal Welfare for which I was also the Minister.

Through all my work I am most proud of the fact I can be happy with small things; that's my single achievement. For instance, recently we saved two camels that had been bought for cutting, and I just felt on top of the world for half an hour, and that's the best one can hope for from life. On another occasion I met the chief minister and told him it was about time we stopped dissec-

tion in schools in a particular state, because I'd stopped it all over India except for this one. He stopped it the next week. I just felt so happy, that I was who I was, you know, and had the ability to change things.

My philosophy is live and help live. Live and *let* live is about the weakest damn thing I've ever come across. Where as live and help live is everybody's responsibility, from the little ant that runs when it sees you coming, to the leaf that quivers when a hand comes towards it, to the person who's completely dispossessed, or the woman who's battling a thousand things. All of us have been afraid. If I can make that fear a little less for someone and make them believe someone is there, then my life is not truly wasted.

After Sanjay I have never been in love with another man; yet I fall in love about nine times a day. As in, I can be sitting there and see a really good looking lizard, and automatically my heart is drawn. If love means all those little things that make your heart flutter and go wonky, like a cuckoo calling, a lotus flower coming out, or the smell of first rain then I am perpetually in love. I love the state of love with all its highs and lows, with all the screaming and shouting and feeling elated or miserable. All of it can happen without having a person as the subject, you know.

I remember when I was approaching 30 it was traumatic – I was crying my head off when I was 29 and said I was never going to be older than this. And I think I was saying I was 50 for the last ten years, just to get into the hell of it before it actually happened. In a way I wish I wasn't 50 for no other reason except that I have a great deal to do, and when you're in India the older you get the less seriously they take you; although I'm not sure if that's as a woman or a politician. So you're taken hugely seriously between 40 and 50 and then it's 'oh, here comes the old bag.' I don't want to reach old bag status just yet.

But really, it's just like any other age, and actually 50 is a very elegant age because you know what you are doing and you're not going to be any different to what you are now. So there's a certain amount of coming home to yourself which is nice. In myself I still feel I am 16 and still waiting to grow up and be something. I was so enchanted with little bits and pieces of the world and still am; there's still enormously wondrous things to see.

Anne Abernathy: 'Grandma Luge'

Who: Anne Abernathy
When: 12th April 2003
What: Veteran Luger 'Grandma Luge', competed in six Olympics

'I remember walking out and thinking, I'm living every woman's dream, to walk out at the opening ceremony of the Olympics and have the television cameras all facing you and the lights turn on as you walk through the tunnel… and then they announce to the 70,000 people in the stands and 3 billion people around the world how old you are!'

I didn't actually get to take part in sport competitively until I was over 30. My mom was from the south in America and to her it was not considered ladylike to participate in any sports at all. The only thing she allowed me to do when I was growing up was either swim or play tennis. I think the only reason she allowed me to play tennis was because we wore short white shorts or dresses and they used the word love a lot in the scoring.

I tried out for the swim team before I even started school and I think I was in maybe two competitions, but there was a girl who was three years younger than me who kept beating me. When you're a pre-schooler and you're being beaten all the time by somebody that much younger it's really emotionally scarring; so I quit after three swim meets! I felt a bit better though because the girl, Melissa Bloat, went on to win three Olympic gold medals, so perhaps she was just extraordinarily good rather than me being that bad.

I was born in Eglin Air Force Base in Florida but we were stationed in the Caribbean and I consider the US Virgin Islands my home and my love. As far back as I can remember my parents have been busy; mother used to teach business studies at college and university, and after my dad retired as a test pilot he worked for the Department of Transportation.

Despite my mother's opinion of sport, the reason I took up the Luge was because of her. When I was in my twenties she had decided that I'd been single long enough, so one Christmas she and my dad gave me membership to the Washington Ski Club, which included a trip to the Winter Carnival in New York to go skiing. My mother was so focused on doing the right thing for me at the time, she hadn't really thought about the fact that I was living in the US Virgin Islands. So I had to fly to Washington to join the trip, which began with an 11 hour bus journey from there to Lake Placid, New York.

This was during the early 1980s, right after they'd had the Winter Olympics there. When we eventually arrived and got to go skiing it was a terrible morning and really, really cold. The ski slope was just ice, and after going down just a couple of runs which wasn't a great deal of fun, someone down at the bottom suggested we all go and watch the bobsled. Twenty people immediately shouted 'Yes!'. So we went over to the run where I saw my first bobsled come down and initially I thought they seemed a bit nuts.

They were slamming the wall back and forth and they'd get out at the bottom, yelling and screaming at each other and not a single smile, they were not having any fun at all. Someone said it might have just been that particular sled team who were grumpy, but the next one came down and it was just the same. They'd get out of the sled, these grown men with big huge shoulder pads and great big helmets on and be crying. No, I thought; they're all just crazy.

So as we were all standing there we saw this other sign pointing the way for 'Luge'. None of us had any idea what that was, let alone how to pronounce it, so off we went to find out. We walked over and I saw my first Luge sled go down. After seeing

the bobsled which was about as graceful as a dumper truck, it was like watching a Porsche. You almost didn't hear it and you didn't see the sled because the athlete covers the sled, so it just looks like they are floating down – very fast of course, but floating. I was totally mesmerised.

There was a man standing on the track above us, who turned out to be one of the US coaches. He looked down and said, 'Anybody who wants to try it, take a step forward.' From the 20 of us immediately 18 people took a step back, and there I was standing there having not moved an inch with another guy who was a fireman from Maryland. We just looked at each other and said, 'Why not?' As it turned out there weren't any camps we could participate in that week so he went up the next year, had a go and broke both of his legs. I thought, 'I can do better than that', but because of work commitments I had to wait another year before I could go.

Ever since I first saw the Luge I fell in love with it, so when I finally got to try it it was kind of like waiting in line for two years to go down a rollercoaster; the anticipation was just so electric. All I had thought about for the whole time was going down that run; I couldn't get it out of my head.

So after all this build-up I had my first run and it was even better than I expected. I was at a training camp for a week and at the end of that time I was doing the competitive run from the ladies start. So I was invited to come up and stay for the rest of the season at the Olympic training centre. I couldn't believe it; how often do you get invited to stay in an Olympic training centre and train in a sport with all these other athletes, I couldn't possibly not do it. I hadn't even given any thought to my age; I was 30 which is probably nearer the age most athletes retire.

From then on all I wanted to do was go to the Olympics. Three years later my dream was realised and I was selected to compete in Calgary in 1988. By then though there were other issues afoot and just getting selected had been a huge challenge. Two years before the games I had a major setback when I was diagnosed with lymphatic carcinoma. I couldn't let anyone know because at that time, this is before the days of Lance Armstrong – if anyone

knew that you had cancer or any other sort of disease, the Olympic committee couldn't send you – it was like sending damaged goods. Plus you would lose any sponsorship because there was a stigma attached to anybody having an illness. So I couldn't let anyone know I was ill. It wasn't until I got to the Olympic village, checked in and had my Olympic credentials that I was able to tell the president of my Olympic committee and, more importantly, my parents.

My mother had never seen the sport before. My dad had helped me in Lake Placid and other places – he would come to video and help me train, but mom had never seen it. You can tell somebody that your daughter is going to be going down a track at 60, 70, 80 miles an hour but until you really see it, you don't realise that 60, 70, 80 miles an hour is somebody literally flying past in a blur three inches above the ground.

My mom stood at the track and watched me zoom by four times and after my final run I went to see her. It was such a big deal for me to make the Olympics because I had overcome cancer, but also, I was representing the Virgin Islands for the first time in the Winter Games and there was just so much emotion attached to it. So I gave my mom a great big hug and I said, 'Mom, I did it,' and she said, 'Yes, and you don't ever have to do it again.' I tried to explain that in the World Championships the next year I was expected to take a medal but she just turned round and walked away. My dad looked at me and said, 'Young lady, we'll talk about this when you get home.' It wasn't until my third Olympics in 1998 that Luge was allowed to be spoken of in my parents' house. They figured I'd been in one Olympics and that was enough, I didn't need to do any more.

It was in that first Olympics that my coach actually realised how old I was. It was the last training day before the competition and I took my first run down. The announcers were practising in German, French and English what they were going to say as the athletes went down. I took my next to last run and ran back up to the start house. When I walked in, my coach Gunther, from Austria, was there with a German athlete, George Happell. Gunther looked at me and they both started laughing, I asked

what was so funny and he said, 'Well they just announced as you were going down that you are drei und dreizig years old, which is 33 in German.' So I said 'yes', and he said, 'But Anne you're only drei und zwanzig, 23.' I said, 'No, actually I'm drei und dreizig.' He said, 'No Anne, your German's not so good; you're drei und zwanzig, 23.' I said, 'No, your English is not so good, I'm drei und dreizig, 33.'

Meanwhile George is on the floor, rolling around laughing until he manages to stand up, look me straight in the eye and say, 'Anne. You're too old for Luge.' 'George,' I said, 'I wasn't five minutes ago.' Fast forward 14 years to 2002, and it's mine and George Happell's fifth Olympics, so they put the two big powerhouses together in the same building – the German team and….The Virgin Islands! George came running over and said, 'Anne, I owe you a beer.' I said, 'George, the entire German women's team owes me a keg!' George had just won his fifth Olympic medal and the German women had just swept the medals 1, 2 and 3 and they were all older than I was in my first Olympics in 1988. I had broken the age barrier. If I hadn't done that they never would have been there. So I suppose, although I didn't win a medal, somebody's got to crash the gate; I guess I'm a gatecrasher.

The best way to describe going down a Luge is like maybe being on two skateboards going 60, 70, 80 miles an hour. There's no support for your head or legs and you go straight down incredibly fast and then hit curves. It's extremely tough on the body physically; that's one of the unusual things about me having had such a long career. I've never really felt nervous before a run but there's a certain amount of anticipation and adrenaline that's running in your system and really builds it up – more so at the Olympics because of the enormity of the event. But you need that because it helps you keep focused and you cannot do my sport unless you're 100% focused. But it's such a blast! There's just nothing to equate it to; I can't imagine doing anything else for 23 years.

I was nicknamed Grandma Luge during the World Championships in 1993 when one of the girls in the team came up and said, 'Anne, you've got to give Gabi Kolish a hard time, it's her birth-day.' I asked how old she was and she said Gabi was 30 and that they called her Mother Luge. So I said, 'Well I'm 40 years old, what do you call me?' She said, 'Oh, you're Old Ma Luge.' I laughed and asked her not to tell anybody, so, of course she immediately told the press and everybody else and it stuck. At first I wasn't too pleased to be called Grandma Luge, and then, as more and more people started calling me it, I realised it was meant as an endearment. In Turin in 2006 I was called Nona Sleeta, and then, after the opening ceremony on Italian TV, I was known as Nona Olympia; that was very special.

To be honest I didn't really need to compete in 2006, I'd already broken the record for the oldest female Olympian in 2002. It's also a difficult thing to go to the Olympics, not just physically but financially, it's huge. It takes up such a large part of your life, and because of my age I have to train longer and rest longer so it's a whole different ballgame. Then I heard about this group called the Red Hat Society which is for women over 50, and was invited by the founder Sue Ellen Cooper to come and speak at their convention in Dallas. I had no idea what I was going to talk about firstly because I wasn't even 50, I was still only 48 and I also hadn't made up my mind if I was going to go to the next Olympics or not.

Anyway, I got up to speak and before I'd even said a word I had a standing ovation. I thought 'Wow!' I wasn't expecting that at all. Then when I started talking and told them I had the record for the oldest woman to ever compete in the Olympic Games, they applauded. Then I said, 'Well if I go to the next Olympics, probably the most important thing, aside from breaking the record and being the first 6 time female Winter Olympian, would be that I'm the first woman over 50 to ever compete in the Winter Olympic Games.' They jumped out of their seats and they were applauding madly, then I pulled out one of my old Luge helmets that I'd spray-painted red in anticipation and said, 'Well, if I do go, I can't wear a red hat so maybe I could wear this!' The ladies all jumped up cheering and clapping and I realised just how much it meant to these women and just how big that 50 year mark is. I also wondered how long it would be before anyone else would be in a position to break the 50 year old record. I had broken the 30 year old barrier when I first started

and only recently I'd had emails from the German women who said they were continuing in the sport because they want to be the first ones in their 40s to win Olympic medals. I realised nobody ever broke that 50 year old age barrier and I needed to do it.

When I carried the flag of my country in the opening ceremony in Turin in 2006 it was one of the most important moments of my life, and of the Red Hat Society and all women over 50. They were my nation and that's who I represented. That was the reason I went. The funny thing was that I remember walking out and thinking, 'I'm living every woman's dream, to walk out at the opening ceremony of the Olympics and have the television cameras all facing you and the lights turn on as you walk through the tunnel… and then they announce to the 70,000 people in the stands and 3 billion people around the world how old you are!'

What happened to me at that Olympics was important as well, because it's not an easy journey to get to 50 and 50 plus, and it's not always what you dream it to be. For me, I crashed 24 hours before the competition, broke a bone in my back and couldn't take part, and I thought 'Did I do the wrong thing? Am I sending the wrong message?'. But afterwards I received hundreds of letters and emails of support from women around the world.

Baron de Coubertin, the founder of the modern games, said, 'The important thing in the Olympic games is not the winning, but the taking part. The essential thing in life is not the triumph, but the struggle. The important thing is not to have conquered but to have fought well.' I fought well and I did as much as I could and these women over 50, women around the world, have all shared the struggle of life with me. I think more people and more women watched the Olympics this year because I was in it.

Now I've finally retired I'm primarily doing motivational speaking and am in the process of writing several books. I'm also hoping to do a speaking tour across the US called *Grandma Luge: Ageless Dreams*. I met a man recently who said, 'I'm too old to dream,' and I hate the thought that other people feel the same. I'd also love to get involved with winter sports again, maybe commentating or something, I'd hate to step away from it completely.

Looking back I've had so many proud moments, but I think probably one of the best was in the last Olympics in Turin in 2006. At every Olympics there is, of course, the opening and closing ceremonies that are broadcast live, but there is also a special ceremony that takes place at the beginning of every Olympics. It takes place in the Olympic village and it's the welcoming of each nation, each country's delegation into the village. It's private and just for the athletes, their coaches and the Mayor. In Turin, I became the first female to be in six winter Olympics and all the other athletes kept saying how cool it would be if a five time Olympian passed the torch on to the only six time Olympian. I didn't realise what they meant at the time but the Mayoress, Manuela Di Centa, was also a five time Olympian and in her official capacity would be the one who passed the Olympic torch to me. So we had our welcoming ceremony and I was invited up to the stage where Manuela presented me with the Olympic torch and said, 'What you've done is open the door for so many people to follow.' And I stood there holding the Olympic torch, my flag was raised and they played my anthem. It was one of the most special moments in my life. To realise the Olympics is so much more than just winning a medal – it's opening the doors for other people to be there, not just from other countries, or other walks of life, but that dreams have no age barrier and anyone can dream to do anything.

I think there's a lot of pressure on kids today to know what they want to do and that they've got to have this dream. It's true, some people have their dreams from an early age and they know what they want to do, but others don't, and that's okay. What you have to do is keep your eyes open for opportunities as they present themselves. Don't be afraid to say, 'Why not?', but more important than that, when you get that opportunity make sure you don't take a step back. You don't always have to jump forward, but if you just stand there and say, 'Why not?', it may open doors that you never dreamed could be open before.

Dame Betty Asafu-Adjaye

Who: Dame Betty Asafu-Adjaye
When: 4th February 1998
What: Formed the 'Mission Dining Club'

'Whatever comes from your mouth, let it be rich; rich in content that doesn't harm other people.'

I was born in Ashanti, Ghana, but my dad died when I was born so my uncle, Sir Edward Asafu-Adjaye, who was the first High Commissioner that the Queen instated in the UK, brought us up and we came to England in the late 1960s. I was privileged and went to a girl's primary and secondary school back home and so continued my education at Kilburn Poly in Camden doing Home Economics when I arrived here.

I'd always loved cooking so after passing my exams I got a job with a catering company. It was during that time, when I was having my second child that I went to my GP for a check up, and a West Indian lady in the doctors asked if I could go and see her for a cup of tea.

I didn't really understand first of all what she meant, so I went back and asked her if she had children and she said they had all gone. I took the address and said I would come to see her not realising at first she lived on the other side of town.

I had just had my son, so it took me a few weeks to go and visit. When I got there I found out she had died. She'd been dead for two weeks and not a soul had found her because nobody ever visited. I cried and I wept, because I asked myself the question; would I have saved that woman if I'd gone the following day or the same day? So straight away I wrote to Brent Council to ask if they could help me to set up something so people in the community weren't on their own. I called it the 'Mission Dining Club'.

To begin with it was at my house, I cooked food for everyone and through word of mouth lots of people started coming. After 10 years we managed to get our own premises thanks to the National Lottery, a very kind contractor, and IKEA who decked it

out for us. So all sorts of people of all nationalities and colours: white, lemon, purple, black, golden, any colour; they come here to be with each other, talk, eat and socialise. And they are happy.

Around 1996, when we were still using other places for the Dining Club, a man came to see me and asked me why I had done this. He had a cup of tea and we talked and then a few weeks later he came back with another man to ask me some more questions. A while after that I got a letter saying: 'Due to the job you have done in the country and what you are doing with your charity work we are now honouring you with the exemplary honour to become a Dame of the Order of St John of Jerusalem.'

I didn't even know what it was to be honest. The next day I asked Tim, one of the men who come to the club, and he laughed and said, 'If you knew what it really was, you would be jumping up and down!' He told me to sit down and said, 'In the Royal Family, only the Queen Mother can do this, so you must be doing a good job.'

So the two men who came to see me made me a Dame, and after that everyone who knew me or heard about my dame-ship was so proud of me; that really, really gave me the best reward in all the world.

Since then I have worked with Age Concern, and I've spoken about the work I've done at the European Parliament, in Austria, and in Japan. I've also worked with the Church of Scientology who sponsored me to go to America to work on a study about respect and communication in communities. It's been an amazing experience.

I think that my biggest inspiration has been my mum, she was so beautiful and had so much humility. People can say that a mother does nothing really in the world, but then she might bear a child who is a doctor, a lawyer or a teacher; every mother should be rated as a star.

When I turned 50 I didn't even really know it had happened because I'm always on the go. Also my mum trained me that every day is a birthday so I don't really talk about age, not because I want to hide it but I think every day you grow up. The way I live my life is that every day is my living, and whatever comes from your mouth, let it be rich; rich in content that doesn't harm other people. If you make other people happy, you yourself are happy.

I believe every human has to leave a legacy in the world, something that generation after generation can follow – like humility, sharing and being each other's keeper. All we need to have is affinity, reality and communication; when you have this in your life you know where you are coming from and where you are going to; so you will always sow seeds.

Virginia McKenna

Who: Virginia McKenna
When: 7th June 1981
What: Star of *Born Free*, Founder of ZooCheck and The Born Free Foundation

'You never ever forget they are wild; you have to respect their nature. You must never forget they could finish you off in one fell swoop.'

I was born in London where I lived until I was 4, when my parents parted and I went to live with my father in Sussex. When the war broke out my father asked my mother if she would take me away to South Africa because we were in the air raid shelter every night at my boarding school and he would get very anxious. Mother was a wonderful jazz pianist and had her own trio, but she gave it all up, to take me to South Africa, which was rather amazing really. In some respects I've always felt quite guilty about escaping the war; my childhood was really lovely considering what the other children in England had to go through. Another reason I felt so awful was because on the day we left from Liverpool we were in a convoy of ships and we were the last to go. As we were leaving the four in front of us were torpedoed and we had to go past all the bodies and wreckage floating in the sea. There are so many reasons to feel that some kind star was looking down on us, I felt very privileged and very very lucky to have lived.

When the war ended we came home and I went back to school as a boarder. When I was younger I had found boarding school quite tough, but when I got back I really loved it because I was 14 and perhaps more ready for it. I made some great friends and it was there I first got involved in acting. The school did wonderful productions of Shakespeare in the gardens under the copper beech tree every summer; they were quite famous for that. I graduated from playing the Duke of Athens in *A Midsummer Nights Dream* up to Paulina in *A Winters Tale* and Aerial in *The Tempest*. As well as performing I found I really enjoyed the challenge of the production process with the other actors, for me the learning side of it was the most interesting and exciting part.

After I'd finished school I had intended on going to university to read English but I didn't have the right qualifications so I ended up going to drama school instead. My parents were really supportive as I think they felt that I had a real chance of doing something in the theatre on a professional level. I got into the Central School of Speech and Drama at the Royal Albert Hall which was amazing because we were allowed to go in to listen to rehearsals when we weren't doing classes. Looking back I had a really happy and fulfilled student life living at home with my mother in London. Once I'd finally left college I started working as an actress.

I met my late husband Bill when we were doing a play in London, *Capture the Castle* by Dodie Smith. We were both in other relationships so were just great friends to begin with. Finally, when we were free to be together, we got married in 1957 and remained happily so until he died 12 years ago. We had been married around 5 years when we got involved with *Born Free*. When Bill was in Stratford in 1962 he was approached by some Americans about the possibility of making a film of a book called *Born Free*. We'd gone on holiday after a play he'd been in had folded. He was quite shattered by the whole thing. When we got back to England they contacted him and said they wanted to meet us both about the project. We met up with a producer and the original director, Tom McGowan, for tea at The Mayfair and they asked if we would like to do it. I hadn't read the book or anything but it sounded like an amazing opportunity so we said yes. Of course from that moment our whole life was dominated by lions; reading about them, trying to find out what kind of creatures they were and what relationship people had had with them. We read the book from cover to cover millions of times.

Then we sailed with our three children to Kenya and worked for the next 10 and a half months making *Born Free*.

I felt very comfortable making the film, working with Bill. He was always there, we were in it together. But there was one day when we were asked to do a scene lying in the shade by a big tree by the water. I was meant to be lying on the ground with a lioness called Girl. Even though he wasn't in that particular shot I asked Bill if he'd come with me; I just felt apprehensive, that something wasn't right. I lay on the ground and started stroking her and suddenly she flipped over and pinned me to the ground with her teeth. I knew I mustn't move at all, her nails were in my thigh. Luckily a few minutes went by and they managed to call her away. It was obvious then that all the conditions were wrong for that scene. She just didn't want to be lying there.

When I was under her paws all I could think was, 'Just don't forget what you've been told.' You're thinking about practical things. It's happening to you but you have to remember what you have to do… which is absolutely nothing! You have a belief that the lion you know is behaving in a way that isn't anything to do with the relationship you have with her, it's the conditions that have caused her to do that. But you never ever forget they are wild, you have to respect their nature and never impose anything on them. You must never forget they could finish you off in one fell swoop.

Making the film was quite a life changing experience. It was lucky we could both be involved; if it had only happened to one of us it could have been problematic later because our lives were totally different from that moment. It was absolutely incredible though and we went on a path together which was very special and very important to us both. It was also quite tough because we got a huge amount of criticism for a long time. I suppose because really we were ignorant of animal behaviour and all the things you're meant to know if you're going into the animal field in that way. We never confessed to being experts on anything but once we realised and really started to look into the problems of wild animals in captivity we had the absolute determination and passion to do something about it. That, of course, remains our work to this day. Of course, we do lots of other things as well but that was the initial focus.

For us the realisation hit home when we went back to Kenya in 1968 to make one of Bill's films that he produced and wrote with his good friend James Hill, who directed *Born Free*. When we got there we knew we needed a little elephant for the film and we were going to work in Solvet with Daphne and David Sheldrake who had orphaned elephants which they eventually introduced back to the wild. They didn't have a little one but then we were told there was a 2 year old in the trapper's yard in Nairobi who'd been caught from the wild – wrenched from her family as a gift to London Zoo from the then president of Kenya. We went to see her and she was in this compound in an awful state, demented really, banging herself on the side and thrashing about, so we thought we'd never be able to use her. But David, who was fantastic with elephants, suggested that he take her for 2 or 3 days and reassure her and calm her down so that we might use her, and that's what he did; we called her Pole Pole. After the film we asked if we could buy her and give her to the Sheldrake's to look after, and we were told we could but that they'd have to take another one from the wild as it had been promised as a gift. We couldn't have another one taken from its family so she was sent to London Zoo.

Bill went to see her, I was not brave enough, and, of course, she recognised him. He decided he shouldn't go back again because she needed to get used to her new environment. Twelve years later we had a letter from Daphne saying she'd heard that Pole Pole was going to be destroyed and asking if we would find out why, because she was then only fourteen. We started to ask some questions and were told she'd become too difficult, her companions had either died or been moved, and she was in very bad condition. So we started to make a bit of a noise and in the end, although I did find a reserve in South Africa who wanted to take her, the zoo wasn't prepared to discuss this. But they did say they would move her to Whipsnade where there was a group of elephants, which was better than staying alone. But that move never happened – she collapsed in her crate because she'd been kept in there for so long and then they put her down because she'd damaged her leg when she fell. So that was it; that was our catalyst. For so many years we'd been saying about zoos and how they treated their animals to no avail, but we had so much support

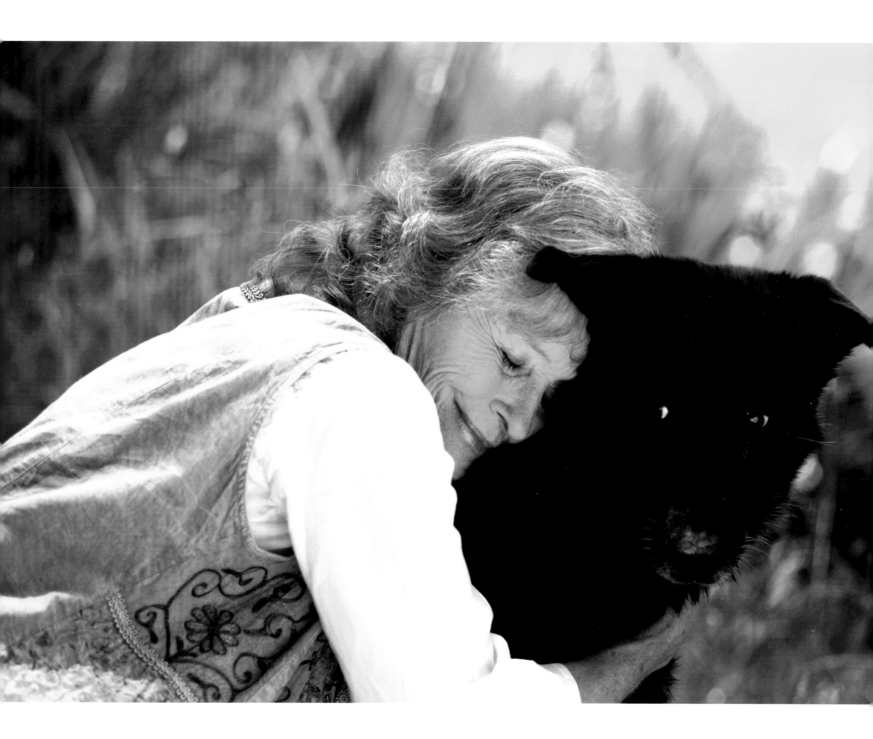

from the public following the press about Pole Pole we knew we had to do something. She was just one of thousands having problems in captivity and that's why we started ZooCheck with 100 people supporting us.

At the moment The Born Free Foundation works in Sri Lanka, South Africa, Zambia, Ethiopia, Tanzania, Nairobi and America. We are also part of a European network for captive animal welfare, so individual groups working throughout Europe can communicate and work together to help animals all over the continent.

As far as what I would like to achieve, in an ideal world we would like to see the phasing out of zoos altogether. We don't think any zoo can provide adequate environments for all the animals they keep, by any means. We aim to conserve wildlife in its natural environment, to educate the public on the problem wild animals face both in captivity and in the wild. To promote more compassion and understanding for what animals are experiencing when they are put into conditions that are totally unsuitable for them. There are still a number of wild animals like lions and tigers in circuses, and we would definitely like to see this stopped straight away.

Nature is true to itself, however harsh or gentle or compassionate it is; that is what's natural and what the world started as. Of course there is the killing of one animal for the survival of another but that's nature. Nature has an order and we destroy that order; we destroy that pattern of behaviour. Whether it's animals or the environment, whatever we do we are interrupting nature. I believe in the order of nature and I trust it because you can rely on it, like the changing of the seasons. Whatever happens somehow these things will carry on whatever we do. I think it's about how you look on life, I look on it in a sensitive way and whether you're an animal or a person you still have feelings. Lots of people don't think that animals have feelings and of course they do.

I've changed since I was 50, I suppose because I'm not an actress anymore. I'm not dressing up and appearing as a character and talking about pretend things. When I get up and do a talk I talk about issues and not myself, so I have more courage, I'm not talking about what I do or what I feel, it's about things that I really care about. I'm a mouthpiece, so I'm actually very lucky to have the chance to do that and that people ask me to do that. When

we started the Born Free Foundation and ZooCheck 21 years ago we were very much scorned and laughed at. Nobody considered zoos an issue; it was somewhere people went on a Sunday afternoon. I think we were one of the first groups to highlight that zoos were a problem.

Other things change too obviously as you get older. When Bill died of a heart problem in 1994 it was a big shock, mainly because he'd only been for a check-up the day before and everything was fine. But I don't feel cheated because his time had come and I am a great believer in what happens, happens when it has to. His was a health thing. I know he would have been deeply unhappy if he'd been a long term invalid so, for that reason, I'm relieved that it happened quickly. We had 37 fascinating, exciting and challenging years together, doing all sorts of unusual things. We've got our lovely children and I'm very lucky actually to have had all that.

Life is always changing whether you are under or over 50. You have to accept the ageing process, no-one is going to look young forever so you have to be philosophical about it. The main thing is health, because you want to stay active and keep doing the things that are important, that you enjoy. I believe in enjoying life, live every day to the full, you'll never have yesterday again. So don't waste it by complaining. Of course I'm very lucky to have a lovely home and be surrounded by nature and all the things I love, except my husband, but I just don't think you should waste a minute of your life.

Never give up. I mean as long as you want to go on, whether it's working or a hobby or if you have an interest you're passionate about. Whatever it is, don't feel like you're 50 or 60, or whatever, so you have to stop, absolutely not, don't waste the most fascinating years that are to come. I didn't feel very old when I was 50, I'm a bit older now but apart from slowing down a bit physically, I'm still interested, curious and longing to learn more. As long as you have a fascination and curiosity about life why give up? There are endless things to explore and learn about and I think you should just go on until you drop; that's what I want to do, absolutely!

Karen Black

Who: Karen Black
When: 31st October 2005
What: Lifeboat crew for Royal National Lifeboat Institution

'You have to have an understanding, almost an affiliation with the sea. My mum says it's in my blood.'

Being involved in the RNLI doesn't run in my family at all; though my grandfather was a Sea Captain and my husband's father was lost at sea. I have just always loved the sea, my grandfather used to take me out fishing and I've always lived by it; I felt I wanted to give something back for all the enjoyment I've got out of it.

Larne lifeboat service was only set up in 1994. For years people fought for it here because it's a port. People from all walks of life put their name down to apply and I got in. You don't have to have any formal qualifications, you just need to be aged seventeen or over, be reasonably fit and have good eyesight. But you can't be colour blind and obviously it helps if you don't suffer from seasickness!

Training is quite sophisticated, you go down to the college in Poole in Dorset where the Navy and SBS train and you go through all aspects of sea rescue and survival. From radar, navigation, boat handling, rigging, safety, first aid, and sea survival – that was completely exhausting. Generally you rarely have to go in the water, but at the end of the day if you had to get someone out you'd have to go in. There are two boats that serve Larne, a larger boat and a dinghy. Every boat crew has to consist of one mechanic, a navigator, a first aider and one other member. Unless it's an absolute emergency and lives are at stake the boat can't leave without a full complement. Apart from the mechanics everyone pretty much does everything.

The achievements I'm most pleased about are, of course, being able to save a life, and things like passing my exams are fantastic, but also it can be about dealing with a situation, such as where someone has died, and how you handle that.

Since I've been there we've had two fatalities. They happened within a month of each other, which was awful. One was a sixteen year old boy who was walking along the path by the sea. Because the pathway stopped he decided to scale the 100ft climb, but he fell into the sea. The fall killed him. It was really sad because it just needn't have happened. The other I was more angry about; two guys went fishing and as they got nearer the shore, one decided he would swim the rest of the way, but he got into trouble. When we got out to there, we just saw this t-shirt floating and I felt sick to my stomach. It was the first time it had happened to me but my training kicked in, we got to him and pulled him out, but he was already dead. What happened to that poor fella still annoys me, if he'd only been wearing a life jacket he would still be alive.

It's obviously a terrible thing and it did get to me, but it was the member of our crew who pulled him into the boat who was really cut up and I almost found myself mothering him. It hit me more when I got home, but you have to try not to think about it.

Another incident involving a younger child had a happier ending. A little six year old boy had gone out on his lilo in the sea and the current had dragged him out. We got to him and he was safe, but he was really reluctant to get in the boat because he was so scared. When we got back to the beach it was hard not to give the parents a real ticking off for letting him go in the sea on his own. We spoke to the coastguard and I think he definitely had a few harsh words with them; it's hard not to get personally involved with incidents like that.

The RNLI does run sea safety talks in schools so the message is

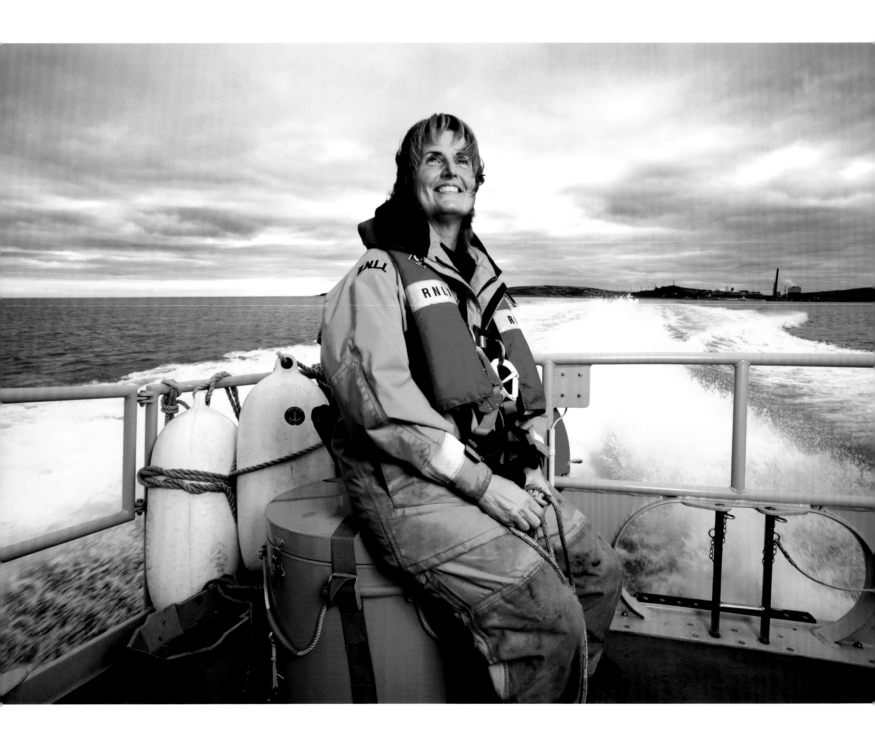

starting to get through to people. The sea can be wonderful and calm one minute and raging the next, that's what I love about it but it is totally unpredictable.

The main thing about doing this is that you have to have an understanding and almost an affiliation with the sea. My mum says it's in my blood. I live right on the coast and sometimes you can't see out of the windows because of the salt. The smell is amazing and in really rough weather I can just watch it for hours. Just being able to hear it all the time calms me, it's beautiful.

I've never really feared for my life out on the boats. There have been some hairy experiences, one in particular when we were guiding a boat to safety. We were in our big boat which has a huge aerial. The sea was so rough the aerial on the top of the boat was nearly touching the sea. It was very scary, but we know the boats' capabilities – even if it had capsized it can right itself in fifteen seconds. There are times too when it's so rough you have to strap yourselves in because if it does go over you'd be thrown around like a rag doll.

My mum is very proud of me, she has to be because of my grandfather, but she also worries about me. But there's nothing she can do, I just make sure I don't tell her any details. I also have three grown up children who are all really chuffed about what I do and my husband, of course. I know he worries when I get called out at two or three in the morning and the seas are rough but he knows the conditions and is confident about the crew with me.

There's a great camaraderie among the crew. We train together every other Sunday and on a Thursday evening we go out to exercise, then down the pub for a few drinks. We work together as a team so team work is very important.

The RNLI is a superb organisation. Because it's voluntary, apart from the mechanics that are full time, there's great spirit and commitment from everyone, which I think would be spoiled if people got paid for what they do.

As it's voluntary I also have a day job as a teacher with dysfunctional or ill children who I teach at their homes. It's a brilliant job because you don't know what you're going to get from one child to the next which makes it really interesting. It's particularly good working with special needs kids because it's so rewarding. People tend to brush them aside, which is awful, but if you can help them it's so worthwhile. It's also good working locally in Larne as we are on call twenty four hours a day seven days a week. If I get a call I have three minutes to get to the lifeboat, which isn't long!

It's becoming more normal for women to join – more and more are applying. I did find, when I first started, that I felt I had to prove myself, to show I could do as much as everyone else. But I think that was more in my mind than those I worked with. They didn't see it like that at all. They see me as one of the lads. I'm also one of the oldest!

Even though I'm in my 50s I don't think about it at all, the good thing is having more experience which gives you an edge. 55 is usually the retirement age but if you are still fit and your eyesight is good you can carry on as long as you want.

I love it as much as when I first started and will keep doing it for as long as I possibly can.

Rosie Swale Pope

Who: Rosie Swale Pope
When: 2nd October 1996
What: Round the World Solo Runner

'I can say there's no ordinary person, there's no ordinary day; every moment of life should be full. Every moment should be a fat moment.'

I'd always been very bad at running, probably because I was very gawky. I was educated by the Protestant Orphan Society, who dressed me in these baggy blue bloomers tied at the top with knots and they nearly always fell down, so I could never run properly. I was very clumsy and awkward; my gym mistress at school used to tell me, 'You'll never amount to anything'.

Despite her words I did many things in my youth. After I married my husband Clive and I had all sorts of adventures. I sailed round Cape Horn, rode horses 3,000 miles across South Chile, and we both went to do a film on the Maya Indians. But it wasn't until I was in my 40s that I started running.

I wanted to keep fit and as I say, I wasn't a good sportswoman but I thought running was the simplest form of sport. You don't need any equipment to speak of and I also like it because it makes everywhere a warm climate; you might be cold when you start but you soon warm up. I joined a club in Tenby where I live and it just went from there. It's quite fun to do things you're not good at, it's also great fun to do things when you're older, because it's a more amusing challenge than it was when you were 17 or 18.

One of my first proper races was the London Marathon which I did for muscular dystrophy, then I thought I would have a go at the Sahara Marathon. After that I decided I wanted to run across Romania as a way of travelling, rather than doing a set race just to see what would happen. I remember standing at the Hungarian border and there was a surly looking policeman standing in front of me. He reached into his pocket and I thought

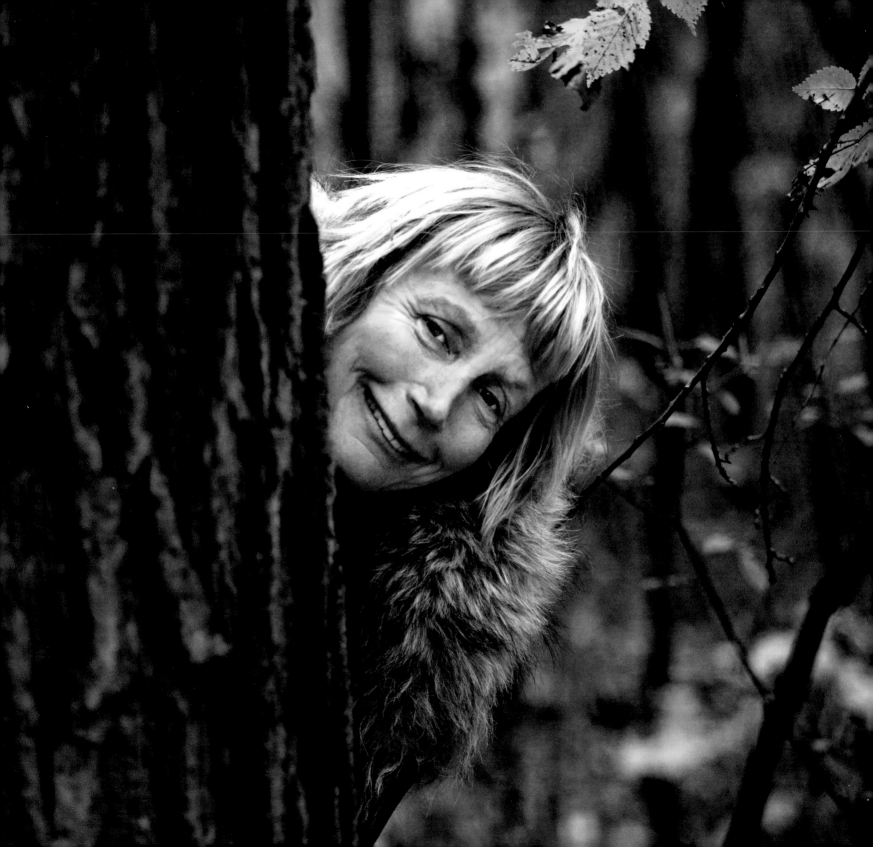

he was going to shoot me or something, but instead he got his hanky out and waved me off. I discovered it was a great way of travelling because everybody talks to you.

When I got back Clive became ill with cancer and I nursed him at home, where he eventually died in my arms. It's strange because we live in a world where everything is about big events; the first man on the moon or whatever, but actually the things that affect us most are things that happen to people all the time – seeing a child smile for the first time, having a baby, being married, passing an exam. Good things happen to millions of people every day and yet it doesn't make their joy any less; it makes it more, because so many have shared the same thing. It's the same with sorrow – just because countless people have relations who have died of cancer, it doesn't make the pain any less – in a way it makes it hurt much more.

You can either become a person who dries up when these things happen or you can do something about it and grab life double for the person you've lost. I decided I would run around the world in honour of Clive, and by way of thanks for my long and misspent life! I spoke to my family and my children who were really supportive. I set off on 2nd October 2003; my 57th birthday. I chose that day because I thought at least I would never forget the date I went.

I started running from my front door in Tenby and figured I'd run where there was the most land. I have a cart called 'The Silver Dream Machine' that I pull behind me with all my belongings in and that's it, it's very simple. I wanted it to be a very low-profile two footed adventure so there's no PR person, no corporate stuff; it's just been me and different people along the way. I've even asked local people to take photos of me, usually as I'm just climbing out of a ditch or something!

Of course, there have been some dangerous moments, like in Russia in the winter when it was –62° and the line between life and death and making it, and not, was incredibly fine. You have to get into a warm place, whether it's in a ditch or the undergrowth and try and get the stove going to heat something to drink. When your body's warm enough through the night you have to take everything to bed with you to dry out for the morning, because you're your only central heating; you're constantly trying to survive.

In the summer the rivers are very dangerous in a place like Russia. I was knocked out once and floated downriver and only made it out alive because I was caught on a tree stump. But people have been very good – I've only been held up at gunpoint on this journey once and at knifepoint once. I've met all types of people that you would never think would be kind, but as long as you say, 'Good morning, how are you?', instead of running away and showing fear it's fine. I think it's insulting to people to show them fear and it's insulting to yourself; so I just say 'hello'. I could be talking to maybe a gang of twenty youths who are armed with knives and guns, they could be very drunk, but as long as you just pretend it's quite normal it's alright. The other side to it is appreciating how much beauty there is around you, like the wonder of sleeping under the stars. I find it very hard to be in a house now; I'm just not used to it.

Then there are the animals, the humans are wonderful but I spend most of my time with the wildlife. You go in the forest every night and the birds chatter along, then there's the squirrels, the deer and of course wolves and bears. I was a bit struck when I first came across them but they are very sweet and never harm you, they're just a bit nosy.

There have been some very touching moments, although not in an obvious way to begin with. On one occasion a man came at me with an axe, bursting from the trees with glazed staring eyes and blood on his axe. I soon found out he was just a woodsman who was having a party which had gone a bit too far and he'd drunk too much vodka. He'd never seen a woman sleeping alone in the forest before and decided that I was the woman for him and invited me to his party. I explained that I was already spoken for and excused myself. He said, 'That's ok, we'll toast your family.' When I woke up the next day he'd left a little parcel for me of saltfish, meat and a little bottle of vodka; just for emergencies.

You're never a stranger, ever. The word stranger doesn't exist, certainly not on the road, just like the word boredom doesn't exist. It gets very lonely, you miss your family because people are

so kind to you and that keeps your feelings raw. You don't become a hard and tough person by running around the world – you become even more of a soft and vulnerable person.

I do miss Clive and I will always love him. It still hurts so much when I think of the pain and how very courageous he was, I can't bear it. But I know he's with me. Sometimes when I'm running I hum his favourite songs and I think that's great, because you know people you love are there forever.

Nobody could go through the forests of Siberia alone for a year and not be changed. I'd say I've changed a great deal. I've become a feral person, I'm very sharp. I can tell you what a person's character is in a minute. I also know other things, inside, like I know more about language without words mainly because of having to – I can tell if a person is dangerous and I can tell if a very unpleasant looking person is actually very charming. But you can't half-trust people. If someone says, 'Leave your bag with me and I'll look after it,' you can't say, 'Yeah, sure but I'll just take my passport out.' It's all about instinct.

I've not done this to prove I'm smart or tough or to test my limitations or anything like that. I'm doing it because it's fun and if it helps save a life I'd be very proud. There are times in life when you've got to do something to contribute because it's really not what you get out of life; it's what you give back. It's become very clear to me that it's not about running around the world, or indeed going to the moon or climbing Mount Everest, it is the adventure. Those adventures, they're fun, but the real adventure is every single day when you wake up, wiggle your toes and think 'ooh a new day'. And you never know what will happen.

I never knew my biggest adventure in life would be pulling a cart for 27,000 miles and that it would begin in my late fifties. It's amazing. The thing is, when you get a little older, it's not the getting older that gets you into trouble; it's the starting to take it easy. People make the big mistake of just putting themselves in the pigeon hole of their years. You should start to do things that push you harder. Life starts at 50, life starts at 60 – it's fun, you know – you can do all types of things. You can fall in love, you can dance on the roof, you can run round the world, you can do anything. That's the way to do it, there's no question of it.

I can say there's no ordinary person, there's no ordinary day; every moment of life should be full. Every moment should be a fat moment.

Emiko Funatso &
Arai Masako

Who: Emiko Funatso & Arai Masako
When: Emiko, 23rd March 1987: Arai, 19th September 1974
What: Hiroshima Survivors & Keepers of the Peace Memorial Park

'I work Tuesday and Thursday and I dance and I drink! I have to do what I want to do. Life is for now.'

EMIKO: In the summer of 1945, during World War II, America wanted to test out their new Atom Bomb. They said it was to stop the war but as many of Japan's major cities had already been destroyed we now know it was just a test, on us and Nagasaki, to see what the effect on a live target was.

ARAI: At 7.10am on Monday 6th August we heard an air raid warning, then at half past seven we were given the all clear so we carried on our morning tasks as usual. At 8.15am the atomic bomb was dropped by the B-29 'Enola Gay'.

EMIKO: I was born in Hiroshima. I was eight when the bomb went off while I was on my way to school. I remember seeing a big cloud of smoke and we escaped down into a cellar. I inhaled lots of smoke and lost my hair. When it was night time, myself and a teacher, who was with me, escaped into a bamboo grove. We spent a few nights there and then went back to my house. It was broken and burned. My mother, father, brothers and sisters died, all apart from one younger sister. She was trapped under a shelf that had fallen on her. She survived and is still alive today.

ARAI: I was 21 when the bomb dropped but there are only some things I can remember; there are many things I have tried to forget too. I heard the engine noise and as we saw the airplanes we pulled the children by the hands and ran to a mountain at the back of the house with a hole in it. My oldest child was three or four and I pulled his hand and we went into the cave. I had a little girl also, who was just 3 months old but I had to leave her in the house. I didn't know what to do, it was terrible. I was in the hole

with my son and we were very scared. The noise around was deafening. I'm not sure for how long we stayed in there. After a while I came out and saw the houses were broken and I ran in to find my baby girl. She was crying, crying really hard. By a miracle she survived and is now 62 or 63. I saw lots of things that I didn't want to see. Even now I can still smell burnt hair and flesh that I smelt burning that day.

EMIKO: For four or five days after it happened the sky was dark red with red smoke everywhere. Around the city the houses were broken and destroyed. There were soldiers screaming, 'Give me water, give me water.' They fell into the river and died from the burns and smoke. I still remember those things. In those days after we didn't have enough food to eat, the Japanese soldiers came in cars and handed out rations of food and clean water. The whole experience was very frightening because we lost our hair, it was scary, and it bothered us. But it eventually started to grow. I don't think it affected me in other ways but I sometimes feel really weird and a bit strange in myself. I also had awful nightmares about it, which I still get sometimes. I feel that life is more precious because of what happened and what we had to suffer.

ARAI: Although we look healthy we have bad throats and we can't sing because it hurts. We are not healthy, it still affects us. We have illness and dizziness and awful stomach problems. In my mind too it gets very dark when I remember.

EMIKO: In the city on that day were around 350,000 people. Thousands of those in the epicentre of the bomb died instantly from their skin being blown off and their insides were melted by the heat. By December 1945 around 140,000 people had died. In the years to follow many more died from long term illnesses like Leukaemia, lung and thyroid cancer.

ARAI: In 1952 the Memorial Monument for Hiroshima was opened in the Peace Memorial Park, which was the epicentre of the bomb. Underneath the cenotaph is a stone coffin where there is a register of all those people who died.

EMIKO: Over the other side of the park there is the Peace Statue, which we clean and we also tend to the gardens. We feel better when we clean the statue. It is a beautiful place and the park has

recovered well. Many countries donated trees to Hiroshima after it happened. So we have lots of wonderful trees that grow here.

ARAI: The Statue is there because of a little girl, Sadako Sasaki, who was two years old when the bomb dropped. Ten years later she got leukemia, and while she was in hospital she was told of an ancient Japanese legend. If she folded a thousand paper cranes the Gods might grant her wish to live. She folded many, many cranes but died before she could reach 1000. The Peace Statue is dedicated to her and all the children who were victims of the bomb. The inscription on it says: "This is our cry. This is our prayer. To create peace in the world." Every time we go to the statue there are thousands of paper cranes there, sent as a symbol of peace from children all over the world. It is a lovely place. I sit under the statue quite often.

EMIKO: I'm afraid I do hate those responsible for dropping the bomb. Because of the war we get angry. I hope we will never have a war again; nuclear weapons should be banned and eliminated.

ARAI: Japan is the only nation to have experienced the damage of the atomic bomb, so never, never should we allow this to happen again. It has taken 60 years for our city to recover and even now we don't know what danger still lies in the earth.

EMIKO: We shouldn't be doing anything to take the youth away from younger people. So many children like me didn't have youth because of the war. History repeats itself. I am proud of the fact that we recovered the city because it was destroyed completely before. The younger generation must know what happened here and pass it on so people never forget, that's all I care.

ARAI: I'd like to live longer if possible, although I have an illness, but I hope to live longer. I would like to reach the other world, heaven, in order. I wouldn't like my children to die before I do and I want to live out the rest of my years being happy, and with the world at peace. That's my wish.

EMIKO: I want to try everything. That would be my philosophy. This is my spirit. Good things are good, bad things are bad; I don't like anything in between. I work Tuesday and Thursday and I dance and I drink! I have to do what I want to do. Life is for now.

Norma Heyman

Who: Norma Heyman
When: 28th March 1987
What: Film Producer

'I pitched 'Dangerous Liaisons' to US production company Lorimar saying that it would be just like 'Dynasty' but with more sex and long frocks. They fell for it.'

I was born in Notty Ash in Liverpool and attended the local Grammar School; although 'attended' may not be the best way to describe it. For a large amount of the time I was playing truant and spent many a geography lesson at the Royal Court Theatre in Liverpool instead. I grew up in a tough working class environment and my only solace was that one of our neighbours worked at the Royal Court Theatre and every Wednesday would give me a free ticket to see a play. I saw some of the greatest performances ever there – Gielgud, Olivier, all the big stars. When I wasn't doing that I was in the local cinema watching films.

Instead of going off to University, much to my parent's dismay, I announced that I wanted to be an actress and went off to Great Yarmouth to work in a rep theatre. Being a simply dreadful actress didn't seem to make any difference to me and I ploughed on and came down to live in London. I did a few adverts and bits of TV, which in those days was always live so it was absolutely terrifying. I gave up acting, before it gave up on me, when I met my husband and had two children. However, a few years later, when my kids were two and three years old, life changed totally and I became a single mother. I had to find a way of supporting them and there was no way I could act, physically or financially, so I started earning money doing some script and book reading from home for my ex-husband's company on a consultancy basis.

Once my children were eighteen and fifteen they didn't need a parent at home all the time so I really didn't know what to do, I had no plans. So I hit a real depression when I was in my late thirties because I wanted to do something useful. Coming from Liverpool, like most women there, I was brought up with a very strict work ethos. At the time I didn't realise what it was to have brought the children up, it's only when I look back now I realise how wondrous it was and that I was so blessed.

It was around then that I read a book called *The Honorary Consul* by Graham Greene. It was wonderful and I spoke to my ex-husband about buying the rights for it. Instead of buying me a suitcase for my birthday, he bought me a two year option on it and that was how I started producing. I didn't really know where to start! I had seen a film called *Savages*, by Christopher Hampton and I thought he was the man to write the screenplay. So I had a script but no finance or backing; I was terrified, I had no idea what I was doing.

We'd heard of an actor called Richard Gere and decided to try him for the main part, so I found out who his agent was and sent the script to him. After about eight weeks the agent called to say Gere liked the script. We still had nothing to go on, apart from a guy from HBO who said he'd buy the rights, so we set about getting some more money. We raised some funds and flew to meet Gere and his agent who said he really wanted to do our film but asked us if we wouldn't mind delaying shooting because Richard had agreed to appear in a low budget production which would only take eight weeks and would we mind? I was silent, which they took to mean I was annoyed, but I wasn't at all, I was just so shocked that not only did he want to do it but they were asking me if I minded waiting so he could be in it! Of course, I agreed and he promised to let me know as soon as he'd finished filming so we could get started. The film he was making was *An Officer and a Gentleman* after which every studio in the land wanted him

in their movies. But he kept his promise and appeared in the film, called *Beyond the Limit,* which also featured Michael Caine and Bob Hoskins. That started my long term collaboration with both Christopher Hampton and Bob who is now my business partner and a great friend. For a first experience, with a film star like Richard, it was really wonderful and taught me some of the most important lessons in my life – loyalty and friendship. I've been so fortunate to have worked with some of the most stunning talents and creative minds who I never would have come across other-wise. I have great friendships as a result and am so grateful and lucky to have had the experience.

Turning fifty was a huge time for me. I had read a book called *Les Liaisons Dangereuses* that I absolutely loved and I knew imme-diately I wanted to make a film of it. I went with Judi Dench to see the play in Stratford and we came back on the milk train both of us deeply in love with the awful villainous 'Valmont'. I saw it twelve times in total and begged the studios in the US to let me make it but they weren't interested in making films of period plays. Christopher Hampton had written the screenplay and after I nagged him relentlessly about it he agreed to give me the screen rights for it. Now I just needed the backing. I went to see the TV production company Lorimar and pitched *Dangerous Liaisons* to them saying that it would be just like *Dynasty* but with more sex and long frocks! They fell for it and we set about making the film with the beautiful Michelle Pfeiffer, Glenn Close and of course, John Malkovich. I remember my 50th birthday because it was at the Oscars and we had a wonderful celebration of being nominat-ed for seven Academy Awards and winning three. I don't even remember thinking of my age at the time; I was far too busy having fun.

Of all the work I've done from *Buster* to *Gangster No 1* and *Mary Reilly*, I'm insanely proud of *Dangerous Liaisons,* because it was such a struggle to get off the ground and was so successful. I'm also very proud to have made an all female film in *Sister My Sister*. When I first started in the industry in the late 70s there were so few women in film production and directing; I remember walking through the bar at Pinewood Studios and a hush would descend, one would have thought I was an alien.

That was one of the reasons myself and five friends founded 'Women In Film and Television' one evening round a dinner table. It's a great organisation for women to meet and swap contacts or information and generally offer a support network. It's been really rewarding and from where we started with just the six of us, we now have 800 members.

WIFT recently gave me a Lifetime Achievement Award which I am extremely pleased but very embarrassed about. I never feel I deserve anything like that because I'm just so grateful to have had such an extraordinary career that gives me so much pleasure; plus of course I don't ever have to act anymore, that's a relief for everyone!

Things have changed a great deal for women now of course and there's been a huge outpouring of female talent in film making which is very pleasing. They also seem far more confident now and at ease in high pressure situations than I remember myself being. I was like a blood hound and wouldn't give up or give way which was not necessarily an attractive quality; I see people now conducting themselves with so much more grace than I ever had.

I think, as I learnt in my forties, you can always do something different if you want to change direction and there are still so many projects I would like to do in the future. One I'm working on at the moment is a stage version of *Mrs Henderson Presents* which was something Bob Hoskins brought to me originally and we made the film but I think it would also make a wonderful musical. So I'm very excited about doing that and even if it doesn't work I'm a great believer in what Samuel Beckett said: 'No matter, try again. Fail again, fail better.' That really is it; I find it very uplifting because it means quite frankly that none of us are perfect.

Baroness Valerie Amos

Who: Baroness Valerie Amos
When: 13th March 2004
What: Leader of The House of Lords

'My parents always encouraged us to challenge things if we thought they weren't right; the very strong belief I have in social justice and equality comes from that.'

I grew up in the countryside in Guyana. Although its culture is very linked to the Caribbean, it's really South American so there are big rivers and forests and savannah, that kind of thing. We lived in the north west of the country in a part called Es Se Quevo on a tiny island in the mouth of the Es Se Quevo river, though when I was a child it felt enormous, of course.

Guyana is a very abundant country, so people don't go hungry there. My parents were both teachers so in that sense we were not poor, we were very respected members of the community and my father had one of the first cars on the island, that kind of thing. Education was very important there so we worked hard at school but then had great holidays. We spent lots of time outside in a country that's very, very tropical.

I think what really stays with me about my childhood was the warmth of my family and the community. It was the kind of place where everybody had a right to say – you should be doing this or you should be doing that. Although as a child it could feel quite constraining, actually it was very warm and loving. Looking back on it, I think it's been an important part of who I am and my development. To have been brought up somewhere which felt very free and open and where I knew everybody and everybody knew me. Although that did mean it was quite easy to get into trouble; if you picked a mango from someone else's tree, you knew about it.

I have a brother and a sister and we are all very close – it's a very close knit family. Obviously we fought and had arguments as children and we still disagree now sometimes. We have very loud arguments about issues, which is part of who we are. In my family somebody will take a position just to be difficult, to see whether or not they can win an argument! But we talk to each other all the time and try and see each other as much as we can.

When I left Guyana I was nine. My father had already been in England for 2 years before that. It was a big adventure coming from one country to another. I don't think I had any idea what we were coming to or what to expect, but there were two kinds of excitement. One about leaving a country I had never left before, but also being reunited with a father that I missed very much. It was very, very different in many ways; the geography and of course the weather, so there was a lot to adjust to. But I think children adapt quite quickly and because our parents were hugely supportive, we did adapt. Thinking about it now it must have felt for them like they were giving up a lot, the lifestyle there and everything. But they were also concerned for their children's future and education and I think people who migrate on economic grounds make some very tough decisions. In many ways it must have felt very lonely for them but they focused on creating the right kind of family environment for us. They ensured that we felt as safe and secure as we could in a new county and that we were confident about who we were and what our contribution could be.

That's been enormously important in my life because I've always had a very strong sense of who I am and what I'm about and a confidence which has come from my upbringing. My parents always encouraged us to challenge things if we thought they weren't right; the very strong belief I have in social justice and equality comes from that.

I remember my first impression of the country was strange. We lived in south east London, just into Kent, so we had a very long drive from Heathrow Airport. We drove through the middle of London and then Peckham and Deptford. It felt dark, grey and a bit drizzly; there wasn't much colour.

The people I remember though were very warm and friendly to us. I don't remember any kind of racial incidents in my childhood apart from when my parents bought their first house and there was an attempt to get a petition not to have a black family move into the street. But it didn't fly – nobody would sign it. I also remember when we went to our very first primary school, when there was streaming in primary schools. My sister and I weren't tested or anything, we were just automatically put in the bottom class. But my mother went to school the following day and made them test us; then we were put into the top class.

I got a place at Townley Grammar School for Girls in Bexleyheath and then went to Warwick University to study sociology. After that I went on to do an MA at the University of Birmingham, in Social Studies. I didn't really intend to get into politics but while I was a student I became quite a vocal advocate for social justice and change. In order to do that, I needed to get myself into a position where I could make a difference. So I got a job working in Equal Opportunities, Training and Management Services in local government and spent time in Lambeth, Camden and Hackney boroughs.

In 1995 I decided to set up my own company, Amos Fraser Bernard. It was a consultancy for change which dealt with many issues in post-apartheid South Africa, including human rights, employment equity and public service reform with the government and other agencies. At the same time I was Deputy Chair of the Runnymede Trust and a Director of the UCL Hospitals NHS Trust; it was quite a heavy work load but then if you really want to make a difference you have to work hard.

I went to work in the House of Lords in 1998 as a Whip and the Government's spokesperson on International Development and then was appointed Parliamentary Under-Secretary for Foreign and Commonwealth Affairs. In 2003 I was chosen to go into the Cabinet as Secretary of State for International Development. I was completely overwhelmed by it really as it was totally unexpected – and I think it took me a week to really realise and recognise what had happened to me.

When after only 5 months in the post the Prime Minister asked me to be Leader of the House of Lords, it was a kind of continuation of that feeling. This is an institution with a very long historical tradition, it's very conservative with a small 'c' and male dominated. It has changed in recent years, but it was quite amazing really.

I immediately thought about the things I had to do; I was appointed late morning on a Monday and Parliament was re-opening that afternoon and I was going to have to be present in the chamber as 'leader'. Only a few hours before that I was Secretary of State for International Development and was focussing on all the things I needed to get through the week in that role, then suddenly I was thinking "wow this is a huge statement", and started contemplating all the things associated with it.

I very often think about what I've done when I'm with my parents because they are incredibly proud – not only of me but of my sister and my brother as well – of everything that we've achieved. I feel it most when I'm with them because of the sacrifice they made. Hopefully for them it has been repaid many times over.

Also whenever there's a debate about immigration and asylum and the contribution that immigrants make to British society, the more I think about the fact that I'm an immigrant. It's really important that people recognise you can come as an immigrant and that the doors can be open for you to make that contribution. Life is not always easy, so that's important. There's obviously a lot of concern about intolerance in our society, and undoubtedly there are elements of that here. But there is also a great deal of warmth and a commitment to values, which is also important and something we should be proud of. As a nation we have both elements but when I look at debates about immigration and asylum, the focus is often on the negative rather than the positive, which is a great shame.

I think my mantra has always been that you should work hard and play hard. I work really hard but I won't, as a result of that, give

up other things. Yes, sometimes it's a bit difficult to get to the show or the movie I particularly want to see, but I won't give those things up. So I will go to a party even if I'm really, really tired, just to prove that I can.

Saying that, I have obviously made sacrifices in the past for my career; but I think if I'd got to a point in my life where marriage was seriously on the cards, I would have done it. I don't think I've been constrained or felt that I couldn't have children or get married because of the job. Where I am now is a result of decisions and choices that I've made along the way and I don't regret those at all.

Besides, I have four nieces and nephews; the youngest of which are 8 and 4 so they get very spoiled, and then I get to send them home to their parents!

I would have to say I love being over 50, but then I've loved every stage of my life. I've never reached a point where I've thought, 'Oh my God, I'm in my 30s or 40s, that's the end of life as I know it.' I'm not one of those who thinks that because I'm getting older I don't want anybody to know about it. I love celebrating birthdays.

There are just so many opportunities for us at this period in time. If I look back at my childhood, my teenage years and even being a young woman, if you looked at someone over 50 you would think of them as old. I guess that maybe people in their 20s might think of people like me in my 50s as old. But I don't feel old, I continue to enjoy life and I think it's important to do that – to recognise there are opportunities and experiences out there you don't have to give up on. To realise you can start something new in your 50s, 60s or 70s and that life is something there for us to experience. Of course, it can be tough and difficult at times but that's part of the learning. I suppose if I had to sum it up I would say three words – never stop learning.

Lynne Franks

Who: Lynne Franks
When: 16th April 1998
What: Author, Entrepreneur and Lifestyle Guru

'I'm at the age where I have the experience but not necessarily the responsibility. I can still go to festivals and sleep in tents, go dancing once a week and date guys – my life has got freer. I never went to festivals when I was in my thirties and forties.'

My early upbringing was in a conventional post-war Jewish family in north London. My parents, and particularly my matriarchal grandmother who lived with us, expected me to attend our progressive liberal synagogue for weekly Hebrew classes and services until I was confirmed at fourteen. When I was very young I was only given allowance money if I'd completed all the chores expected of me, like making my own bed or clearing away the dishes. It certainly instilled the work ethic in me. By the time I was twelve I was working in my dad's butcher shop. Every Saturday and often after school I'd weigh up the meats, cut up the mince, wrap up the barbecue chicken and take the money, in an atmosphere rank with the smell of dried blood on sawdust and hanging carcasses at the back of the shop.

Mother was small and rather fragile looking but, as I watched her moving these huge carcasses and sides of beef around with seeming ease, I was in awe of her strength. She is a highly intelligent woman who, as a schoolgirl before the war, had been determined to be a journalist. In many ways I think I tried to make up for the fact that fate and circumstance had forced her to put aside her ambitions. I was never interested in following an academic path, I spent more time organising school dances in aid of Oxfam. Meeting old school friends years later I was told that I had always been the one to tell them what the latest music was, or the latest fashions. I suppose it was inevitable that I ended up trend forecasting and event organising as part of my PR career.

Ever since I was a teenager I'd been in a hurry to get on with my life. I couldn't wait to leave school at sixteen and go to work but

my mother insisted I do a secretarial course first. She sent me to the best secretarial college around, where I met other north London Jewish princesses, all equally interested in boys, dancing and clothes. I was always obsessed with street styles and trends and from the ages of 15 to 18 went from being a 'rocker' wearing tight jeans, ponytail, high heels and hanging around funfairs with boys in leather bike jackets, to being a north London mod.

After stints working for a solicitors and in an advertising agency PR department – my first real understanding of what PR was – I plucked up the courage to contact the prestigious *Petticoat* magazine, the first teenage girl's weekly. I got a job working as a secretary for Eve Pollard before being promoted to writing a regular page on what was happening in 'swinging London'; a subject I was very well versed in. Perhaps a little too much for my editor's liking. I spent so many nights at trendy clubs that I'd arrive at work every morning absolutely exhausted, so it was suggested my personality might be better suited to PR than journalism. But I still wanted to give it a go and went to work for Freemans, writing articles for their in-house publications. It was a more conservative company where the temptation of parties and glamour was less prevalent.

But I still couldn't resist the allure of the clubs and after two years my boss persuaded me my time might be better served in PR after all. I ended up doing some temp work for a PR guy called Ben Coster and discovered after about 6 months that I quite enjoyed it, particularly when it involved fashion. It was while I was working on London Fashion Week that I came across quite the most exotic

creature I'd ever seen. She was dressed in a brown lurex suit with a matching turban and high heels; her name was Katharine Hamnett. She was in the early stages of her business and needed help with some PR so, putting aside my fears, I made the decision to start up on my own. My boyfriend, Paul, kindly suggested I use his flat as a base and there I began earning £20 a week doing Katharine Hamnett's PR from a battered kitchen table, with a notepad and an answerphone.

My business came on in leaps and bounds and at one point Paul and I were running a trendy fashion shop and PR agency respectively from the same place at Covent Garden. Our Saturday boy was John Galliano, now obviously a top designer, and Mario Testino, now a world renowned photographer, sold our shoes. It was the hub of social activity and partying for the fashionable set in London.

Looking back I'm proud to have done so much to change the face of PR and to progress the people involved in it. A lot of those who worked for me over the years that I trained are out there and their businesses are doing very well, which I'm really pleased about. Also, as well as working with fashionable famous names and high profile businesses, we did a lot of things to do with the environment, promoted various AIDS events and worked with Oxfam on a regular basis. So I always sort of had one leg in the NGO world as well as working in the commercial sector. I've worked for all of them at one time or another trying to make PR more fun, exciting and influential. It wasn't just about getting media coverage, it was about creating events across the country like the search for the 'Brylcreem Boys', teaching people to do hip-hop dancing through the shoe chain 'Dolcis', and all sorts of other fun stuff.

Over the years my company grew and grew, as did my two children I'd somehow managed to find time to have. My one regret now is that I didn't spend enough time with them and they grew up with a string of nannies but, as a working mother and hands on business woman, everything was one big juggling act. Very soon I was in a whirl of chauffeur-driven cars, mobile phones, cocaine, drink and parties. By my early thirties my life was spiralling out of control.

I suppose the epitome of what it was like to be me during those years was portrayed in Jennifer Saunders' series Absolutely Fabulous. When it came out I was really hurt because I was very friendly with the girls and I didn't know they were doing it. Jennifer did it without telling me and I was like, 'Ah, I thought she was my friend.' But I did find the programme hilarious most of the time, and there were loads of coincidences where I wondered how in the hell they knew certain things. Ruby Wax, who was the script editor and who is still a friend of mine, said it was as if there was a connection; Jennifer just knew. There were some things she did that were very much me. Like when Edina would go into the office talking on the mobile to her secretary who was literally just in front of her at the time, I mean, I did that. And passing out by Harvey Nichols; she created some of the funniest scenes that were so similar to things that happened to me. They wouldn't have known but for years we used to have someone do the shopping for us, and then when I started going to the supermarket again myself I'd always have trolleys piled really high. When Eddie did it – to save money, though I didn't do it for that reason – she'd walk round waiting for someone to serve her. That was very funny and not unlike me really.

I suppose it was just a situation she saw from my life, and other people's, put it together in a hotch potch and came up with that character. I realise it was just convenient for the media to say it was me, though Jennifer would always deny it and so would I. The only benefit really about Ab Fab was when I lived in America; I got loads of press because of it. They loved the show and were very affectionate to me as a result.

But after twenty years of Lynne Franks PR, which had been a wonderful but mad merry-go-round of adrenaline, I decided things had to change. I sold my company in 1990 and left it fully in 1992. I was burnt out and Paul, my now ex-husband who was also my business partner, was really pushing me to do it, so I did. That was one of the biggest turning points in my life. In one week I came out of the company, my marriage had split up and I stopped practising Buddhism – I used to chant every day and then I lost my voice, which was very scary. It felt like my whole life was in turmoil and I couldn't do anything about it; I was in tears most of the time. Then the other turning point for me was when my

two best friends died within a couple of years of each other of cancer. These women were my age, in their early forties, were in PR, and had children and they both died of cancer. That was a huge wake-up call for me. It was like; life is so valuable, let's not waste it. That got me to change my life.

I think it's really healthy to constantly reinvent yourself and I was ready to do something different. The first thing I did was chair a women's radio station in London which was brilliant fun. Then in 1995 I put on a big event called 'What Women Want', which was the first ever big public event for women in the UK.

It was to celebrate the Beijing Women's Conference the UN were putting on that no-one really was aware of in England. I didn't know what I was doing and had very little money, but I took over the South Bank and put on two days of seminars and workshops, then a big concert in the evening with Chrissie Hynde. For many women it was the first time they actually got to connect with other women and talk about things they wouldn't normally. We had a massage area and a tantric sex workshop where they could discuss what they enjoyed sexually; things they'd never expressed before – it was a real breakthrough. We even had a nun, Sinead Wilkins from Ireland, who did a blessing. It got loads of press; The Evening Standard's headline was 'Sex, Nuns and Rock and Roll at Lynne's Women's Festival'. I'm very, very proud of that event, everyone said it would be wonderful to do it every year, but I was going through big changes and thought one was enough. Thinking back maybe I should have done more really, but what we did do was fantastic.

I think 'What Women Want' really contributed to women feeling they had a voice in this country. Afterwards I went to Beijing and reported back from there as a journalist and got to understand what was happening to women in societies, from Arab countries to African villages. It was an amazing eye-opener. I started to speak at conferences all over the world, talking about women's changes and working with business people like 'Ben and Jerry's'. It was really about just being part of a community of progressive business people – I could understand that we could make a change through business. On one level I started doing all the women's initiatives, then I looked at business and social change.

Then in 1997, when I was 50, I went to live in the States. I went through a real transitionary period from between about 43 or 44 and 50 where I was discovering who I was and how the world works. I was also on a very deep spiritual journey and I had this feeling that I really wanted to write a book which would be a doorway to teach women some kind of empowerment through enterprise; so the SEED handbook was born.

Writing that was very important, not just in what I wanted to convey to other women, but for myself. I had to find out the essence of who I was because I'd been in the commercial world so long, I didn't know the difference between me as Lynne Franks and Lynne Franks PR. I'd lost touch with who I was and found my whole world just stripping away.

My children were teenagers at the time and it was a hard experience for them too, actually deciding who I was. So I went on a journey – finding out about the world for six years, and I wrote SEED as a result. The idea was to write a book to teach women how to start doing business from a feminine perspective, and feel good about things as a woman, rather than playing the man's game. It was a really revolutionary book at the time and came out in lots of countries all over the world; even now there's nothing else out there like it.

So I came back around 2003 and I think that's when I really started to develop. From being a handbook, SEED evolved into a learning programme we developed over a period of three years and trained women to teach it. We worked with Business Link and the government to get the message across about how important it was for women to succeed and have the confidence to be economically empowered, whether here in the West or in the Third World. That's where I've been putting a lot of energy; it seems I am in my wise-woman phase, which I'm very happy to be. I'm also really enjoying being a grandmother and having babies in my family; I'm at the age where I have the experience but not necessarily the responsibility. I can still go to festivals and sleep in tents, go dancing once a week and date guys – my life has got freer. I never went to festivals when I was in my thirties and forties.

I don't think, as you get older, you should make changes in a way that is contrived, just allow things to happen. It's not about the

doing, it's about the being; don't hold yourself back but don't push yourself either, just go with the flow. The most important thing is not to force yourself to change but to know that there's nothing stopping you. So to know you have the freedom and flexibility, particularly as your children are getting older, if you have them. You know that nothing can hold you back from attaining your dream, as long as you've got your feet on the ground.

For younger women I think it's really important not to feel they have to become like men to achieve that old-style success, but to just stay in touch with their femininity, stay in touch with their feminine side. We've lost a lot of women in the last thirty years who have just become so male that they can't go back. It's never too late, you can always go back.

That's what I teach. I teach women to go back – corporate women included. I've set up a women's network where they've got back in touch with their feminine side. I never lost my femininity when I was running the PR agency but I was just numb, I felt numb from the neck down and I think dancing is what brought it back into my life. It's also good to find silence – I meditate a lot and finding that silent space, that inner space, has also been really important to me.

In my life I think I'm most proud of my kids, definitely. And sticking to my integrity throughout everything I've done – I believe I have anyway. What Women Want, that event, really amazing, and *SEED*. Lots actually, and I think it's an ongoing story. I think I'm totally blessed, my life is full of joy and treasures and I feel I must have done something good in a past life. I have such fun – sometimes there are lonely moments – but there were lots of lonely moments in my marriage. But today I've got some very nice relationships, I'm close to my kids and my mother lives just down the road, she's alive and doing well; It's all good. The weird thing is I used to have teams of people working for me and supporting me when I was younger, and now I've chosen to live a much simpler life, which is far more fulfilling.

Jenny Ori

Who: Jenny Ori
When: 19th November 1990
What: Harley-Davidson Enthusiast

'Harley-Davidsons are loud and they're big. Let's face it everyone has a little bit of wildness in them.'

I was born and raised in Willebroek, Belgium. After the war my mum moved us to Antwerp where we lived until I was 18 years old. We came to America in 1960, actually we were heading for California, but got to Chicago and ran out of money so we decided to stay and I've loved it here ever since.

In 1962 I got married, which unfortunately didn't work out, and since then I've never found anyone I wanted to settle down with. Getting divorced was a huge turning point, I realised I couldn't count on anyone, I had to do everything myself and be accountable for everything, which was a good thing; it made me stronger.

Because I had a child to support I had to start working as soon as possible, so I got a job at a major temporary staffing agency. It was great because, other than just being good with people and having a very basic education, I had no proper skills, but the company liked the way I worked and soon made me branch manager. I really enjoyed the job so in 1984 I found a business partner and we opened our own temp staffing service; we've been running it successfully ever since, which I'm really proud of.

I didn't start riding a bike until I was in my 50s. It came about because my brother was a police motorcyclist and when he separated from his wife I said he could move in with me while he got himself sorted. He had two bikes and on Sundays he used to take me out on the back of them. I just fell in love with it. But that didn't last very long because I had no control, if I wanted to see something I would have to wait for him to decide to stop, and if I wanted to leave somewhere at a certain time I couldn't. He was in charge and I didn't like that. So that's why I decided, at the

age of 53, I would buy a bike and my brother said to me, 'You are too old to be even thinking about riding a bike.' So I said, 'We'll wait and see.' I didn't say anything else but I went out and bought a bike though I didn't have a licence. With the help of some of his friends I took a riding course and I passed. My brother was completely unaware of any of this so when he saw me riding the bike he said, 'Are you crazy?' I said, 'Yeah, but I'm loving it.'

My mom was also partly to blame for me wanting to ride a bike. She was one of my biggest influences and despite being shy herself, she always pushed me forward and told me to go for what I wanted or I'd never get ahead in the world. Sadly she died very young, when she was 56 years old. At the age of 50 I thought, I only have 6 more years to live. But guess what? Hooray! I'm here and I'm going to enjoy it! But I wish my mom was still alive, although she definitely wouldn't approve of my lifestyle I'm sure she'd get used to it.

I spend almost every weekend on my bike in the summer and I take long vacations when I can. One of the best things I do every year is go to the Vietnam Memorial for Veteran's Day, as my brother is a Vietnam Vet. At that time there are probably around half a million bikes that come from across the United States to pay their respects in honour of our veterans. I am the Illinois co-ordinator for this because they have to cross the state so I meet them somewhere along the way. Last year I went to Cheyenne and a few times I've ridden to California to meet them. Then I go all the way over to Washington DC, and then home; it's a 9,000km ride which we do in 18 days. When you

get to the Pentagon and see hundreds of thousands of bikes there, it's the most amazing sight I've ever seen; it's called 'Rolling Thunder'. It was started by a group of Vietnam vets who were pilots and used to fly over 'Nam in a plane called 'Rolling Thunder', and the reason they first did it was as a protest ride because after the war had ended the Government left behind a number of POW's and never asked for them back. There's still 1,800 POW's missing from that war. If they hadn't died in the camps they would have been killed soon after, which is what the guys were protesting about.

My main ambition on the bike is to go to the Isle of Man TT Races, maybe not ride in them but definitely go and experience it; it's the most fascinating thing I've ever seen. Other than that, on my bike I've pretty much done it all. I just love to ride. When the weather is good, and even if it's raining I'll still go out. The main thing I like about it is the independence and the speed and I love having the wind in my face. You pretty much get addicted to riding; it's hard to describe.

What's so special about a Harley? It's a stigma really, like some kind of cult. When the Hells Angels started they were all riding Harley-Davidsons. They're loud, they're big, there's glamour attached to them and, let's face it, everyone has a little bit of wildness in them.

I am very happy that I didn't do this until I was 50, the only thing I'm concerned about as I get older is that I worry what will happen if I have to give it up, but even then I have a plan. I'll just get a trike, or I'll just have to find a guy who'll put up with me, but only as long as I can ride on the back of his bike and tell him when to stop and when to go.

The number 50 shouldn't be scary, I think that being 50 is not the end of your life; far from it. Years ago, people were born old because we were so restricted in what we could do – but not today. If you make up your mind that you can do something go ahead and do it, because it keeps you young. Also you don't always want to hang about with people who are all your age, because you hear a lot of complaints about this and that, and eventually you'll start doing the same thing. So you should hang out with people of all ages and types, that also keeps you young.

There's only one thing I wish I could change. I wish I could have got here when I was younger, so I could have had a better education, but when I arrived here it was just a matter of surviving. There was just my mom, me and my three brothers and we all had to go to work. But it's never too late, because someday I may have to retire and then maybe I can continue my education. My one bit of advice for younger people is to get a good education. Education is freedom and it gives you independence. Also, live day to day, do whatever you want to do before it's too late.

People say riding a bike is dangerous. I say getting up in the morning is dangerous, having a shower is dangerous. People die in the bathtub, but they're not having fun. I'm having fun.

Khom Sokhoeun

Who: Khom Sokhoeun
When: 10th October 2005
What: Medic in De-miner Team for Mines Advisory Group (MAG), Cambodia

'I am happy that I am strong enough to support my family and work hard even though I am small; you don't have to be big to be strong.'

I have worked for 'MAG' since 1996. I started working in the Battambang region, searching and clearing mines, before moving to work in Kampong Cham, clearing Unexploded Ordnance (UXO).

From my experience in both regions there are maybe more than 10,000 mines in these areas. Most of the mines I've come across are in Battambang. In Kampong Cham there are less mines but many more UXO is found.

Throughout Cambodia there are an estimated six million mines and UXO littering the country. The Khmer Rouge were mainly responsible, along with the Heng Samrin and Hun Sen regimes, the Vietnamese, the KPNLF, and the Sihanoukists.

Unexploded ordnance causes most deaths whereas with mines, although they do kill, often the victim will lose an arm or a leg. If a person steps on a mine with their heel, the force of the blast would go up their leg, shattering the bones, probably up to the knee. In most cases they would need their leg amputated at or below the knee – if they can get to a hospital. It is understood that more than 40,000 Cambodians have suffered amputations as a result of mine injuries since 1979. That is an average of nearly forty victims a week for a period of twenty years.

In Kampong Cham province most injuries happen when people are looking for metal to sell. It can earn people who are very poor a great deal of money, so they buy themselves a metal detector to look for it. They search areas that have not been checked and when they hear the noise to let them know something is there, they try to dig it up. They don't realise it is a mine or a UXO so when it is disturbed or picked up it can explode.

The sad thing is that children will often take the cows to the field and when the cow is grazing they have time to play; sometimes they can stumble upon a mine or find a UXO and die or be terribly injured. Many mines are hidden in the forests so people can step on them while they are trying to collect food or firewood.

The experts say at the current rate of progress it could take as many as 100 years to fully clear the mines and UXO from Cambodia. The UN have estimated that it will take nearly 1,100 years to clear all the mines in the world.

The most satisfying thing about my work, whether as a medic or a de-miner, is just knowing that for each mine or UXO we clear, one less person will be killed or injured. It is very pleasing when you have been working on an area of land and can gradually clear it all. Usually more people come and search it again to be completely sure it is clear; then people can start to use the land again to live and work on.

What I also enjoy about it is that we go and educate people both in populated villages and more remote areas. If we can warn people of the dangers we can prevent more injuries. Sometimes the hardest people to get through to are the men who were soldiers. They can be difficult to talk to and don't always want to listen, they will go and dig up UXO's without being afraid of the danger, but we try our best.

The worst thing is that people are so desperate to get food, or firewood, or to find metal to sell, that they still go to uncleared areas even knowing the dangers. But because they are very poor

that's why they take the risk. We try to tell them that they won't be able to provide for their family if they have lost a foot or an arm, or worse. Who will take responsibility for them if that happens?

I came to work for MAG because my husband was killed. It happened a long time after the Khmer Rouge had been overthrown but they remained as a resistance movement up to 1990 and were the cause of much civil unrest. He was a soldier involved in a fierce battle in a forest near the Thai border when he stepped on a mine. I didn't even get to see him because it was in the middle of such terrible fighting and they burned his body straight away. I heard about his death from a messenger when they brought me his bones to bury.

My husband suffered greatly under Pol Pot's regime. He had already been put in a camp for three years before that, so we had not spent much time together. During their reign people who were educated and intelligent or had a high ranking in society were killed so they could not be a threat. The soldiers would come and question people to find out who had an education and a good job. Many of us didn't know about Pol Pot and what they were doing so when they came to ask me about what my husband did I told them the truth; that he was an employee at the airport. Once they found out they split us up and sent him to a camp in a village, far away from anywhere else.

Because he was good and worked very hard they did not kill him, instead they moved him around to other places for work which were even further away; he was gone for a very long time.

After the Pol Pot regime ended I came back to my house in the village and met up again with my husband. But there was still a lot of unrest and fighting going on and he had to escape with some others near to the Thai border where he was killed. I was so sad; it was a terrible time for me and our children.

MAG had a policy to provide jobs for widows and amputees of mine and UXO victims, so that was how I came to work for them. It means a great deal to me to work for them because of how he died and I remember him every day.

My work is everything to me, we were very poor and now I can provide for my children and hope they can get a good education and good jobs for the future. But mainly I want to continue my work until there are no more mines and UXOs in Cambodia.

It is very good that there are many women who work for MAG and it is increasing all the time. When I first worked here there were only six of us and now there are 30.

I think that if you believe in yourself and can achieve something by yourself, it's good. I like to be able to support myself and not have to rely on help from other people; I can earn my own money and support my children. MAG gave me a great opportunity so I just want to work hard and do a good job for them.

I look at people who have a good education and get good jobs in offices and places like that and I want my children to do the same. If they can get a high level of education, they can achieve good things in their future and have a better life. That is my dream.

Women at the age of 50, especially the women in Cambodia, should never lose hope, they have to be strong. The strength comes not only from our bodies but from our hearts, so we have to keep going for ourselves and our children. I have been a widow for 16 years without support from a husband or parents, just me and my children. But I am happy that I am strong enough to support my family and work hard even though I am small; you don't have to be big to be strong.

Dame Edna Everage

Who: Dame Edna Everage
When: 19th December 2006
What: Mega-Star

'I am just actually approaching 50 – although approaching it unfortunately from the wrong direction.'

Actually I would see myself as a giga-star rather than a mega-star. In fact, one wonders really how much higher up the ladder I can climb – it's worrying really.

But I'm really looking forward to going back to Australia and re-discovering my roots. In the meantime there are still so many places I haven't done my beautiful shows in. I'm a stage actress really, only occasionally television, and I'm so adored in America, not in Iceland however, or Sardinia, or Patagonia. I'll have to break into the Patagonian market.

If I'd had my life again I would do two things; I'm afraid I would have married a different man, and I would have had my navel knotted differently. I have an outie you see but I would rather have had an innie. Unfortunately I think I was a bit hastily knotted, I've always worried it might unravel one day. I also believe we all have past lives, so I am living life again… just other people's. I've been all sorts of wonderful people. I enjoyed being Anne Hathaway, married to Shakespeare. I wrote most of the plays of course. I was tax deductible in those old Elizabethan days. I was Lady Macbeth – that was horrible. I was also Virgina Woolf. Although she drowned. That was before I learnt to swim, so I made sure when I was born in Australia that I would learn swimming very early in life. What a life I had then. It's funny but I've never been anything obscure. I've always been very high profile.

I always follow the example of Edith Piaf, who was a woman idol, of course too old for me, I never met her, she said, 'Je ne regrette rien.' That's an old expression darlings meaning I don't regret anything.

I have always felt that 50 is the most attractive age for a woman and I am living proof of this. I am just actually approaching 50 myself – although approaching it unfortunately from the wrong direction.

A woman of 50 is out of the rat-race; she does not have to compete for the attentions of the men folk and if she is lucky, she is a widow. I don't mean to sound callous, but husbands do seem to drop off the twig earlier than their wives and however much we might have adored them – as I did my Norm – they do begin to get on our nerves, especially if we have a career. If you just look at a bus full of widows on tour in Europe or America you will have never seen such a group of happy ladies, their late husbands' watches glinting on their chubby wrists.

My advice to you younger ladies is don't fight the ageing process. Don't struggle against it – there's nothing more tragic than mutton dressed as lamb. I dress like a mature woman. I wouldn't wear certain things – I don't wear jeans – I'm proud of my legs! The advice I would give anyone is to laugh – learn to laugh because that's when you use those little muscles which you only very rarely use on any other occasion.

I keep myself feeling young by looking at my audience, you see they aren't getting any younger and my audience is my public. I'm never going to retire – retirement I think is ageing. I also very occasionally watch my appetite – I eat plenty of cake.

My life's philosophy has always been 'put your family last'. Children, and for that matter, invalid husbands, never thank you for your sacrifices on their behalf. If you have been given a

wonderful gift of talent and beauty as I have, you owe it to Dame Nature to make the most of it even if it means neglecting your family. I don't call it neglect anyway; I call it Liberation, allowing them to develop as best they can without parental interference. The fact that all of my children are gravely dysfunctional is something that they must take responsibility for themselves.

What would the world, indeed posterity think of me if I had given up my life of International Megastardom, caring and sharing, to muddle around in Melbourne taking ungrateful family members to rehabs and costly therapists? The answer is obvious darlings and I am grateful for the wisdom and insight which 50 years upon the world stage has brought me. It's no coincidence Possums that I am the climax of this tasteful volume.

This book is also in honour of all the wonderful women in our lives.

There are lots of people we would like to thank in the making of this book. We are forever grateful to everyone we came into contact with who helped us along the way, pointed us in the right direction, organised our schedules, or even just showed enthusiasm and encouragement – that's what kept us going.

Firstly we would like to thank all the women who took part. We feel extremely lucky to have met and spent time with you, you were every bit as amazing and inspirational as we'd hoped. We came to the conclusion fairly early on that it would be a life changing experience; it was, we now feel we have the elixir of life.

Huge thanks go to our families and friends for their constancy, support, help and enthusiasm. And of course for listening to us bang on about the book for 2 years without complaining of 'book fatigue'. We love you all very much.

Special thanks goes to Dove, without their sponsorship and enthusiasm this book would have remained a dream.

To name but a few:

Virgin Atlantic for some wonderful flights and the best in-flight movie system EVER! The Metropolitan Police, Médecins Sans Frontières, Irena Kuszta, Born Free Foundation, National Federation of Women's Institutes, Red Hat Society, Borehamwood & Elstree Times, Stagecoach Cambridge, Hertsmere Worknet, Crew of 'Phantom of the Opera', Her Majesty's Theatre, Lord Graham, Patricia Mevans, Aled Lewis, Richard Dobbs, Indira Flack, Kylie Holmes, Kelly Preedy, Hannah Taylor, Sharron Lovell, Ann Burke, Martin Colyer, Kylie Clark, Gretchen Cummings, Elisabeth Cochrane, Richard Kumah, Esther Asiri, Rosmond Eshaun and Rachel Lekman

Northern Ireland
RNLI Station & Lifeboat crew of Larne

India
Dr Kerin Modi

China
Shanghai Women's Federation

USA
Bert Ulrich – NASA
Swingers Café – LA for fantastic Chilli and a whole evening gawping at Keanu Reeves
Doc Burch
Dan Wayne
Jonathan Blair
Susan Sarandon's hair and make-up courtesy of Genivieve Herr & Algene at Sally Harlor
Kelli Nowinsky

US Virgin Islands
For a memorable night with the Red Hat Society ladies

Japan
Mr. Ueda, Shinko Fujii, Kuya Hiroko

Cambodia
MAG Head Office staff, Yean Maly

Thanks also to Sophie Turner-Laing, Mark Aldridge and Tracey's colleagues in the Sky Movies production department for their patience and understanding during the production of the book and putting up with her unsociable behaviour throughout! Daniel Bougourd and Sherry Hodder for their support and expert knack of spotting typos and bad grammar. Alison Hobden, Sherry and Lou Friend for their transcribing talents and Mark Lowe for being a computer whizz – it would never have come together without you.

**For enquiries or renewal at
Quarles Campus LRC
Tel: 01708 462759**